The ECCENTRICS and Other AMERICAN VISIONARY PAINTERS

ABRAHAM A. DAVIDSON was born in Dorchester, Massachusetts, and attended the Boston Public Latin School. He holds an A.B. from Harvard College in Architectural Sciences, an A.M. from Boston University in Art History, and a Ph.D. from Columbia University in Art History. Currently he is Professor of Art History in the Tyler School of Art at Temple University in Philadelphia.

Mr. Davidson is a photographer and won the Group 17 prize for photography at The Detroit Institute of Arts in 1969. He has also had one-man shows in Philadelphia and other places. His articles have appeared in *ARTnews, Art in America, Artforum, American Quarterly,* and *Art Quarterly,* among others; and he is the author of *The Story of American Painting* (1974).

The
ECCENTRICS
and Other AMERICAN
VISIONARY
PAINTERS

ABRAHAM A. DAVIDSON

A Dutton Paperback

E. P. DUTTON | NEW YORK

For information contact:
E. P. Dutton, 2 Park Avenue, New York, N.Y. 10016

Library of Congress Catalog Card Number: 78–55775

ISBN: 0–525–47500–1

Published simultaneously in Canada by Clarke, Irwin & Company Limited, Toronto and Vancouver

Designed by Mort Perry

10 9 8 7 6 5 4 3 2 1

FIRST EDITION

Contents

Illustrations

Color plates (*following page 138*)

Black-and-white illustrations

ILLUSTRATIONS / xi

I should like to thank Frank Goodyear of the Pennsylvania Academy of the Fine Arts, Philadelphia; Edward J. Nygren of the Corcoran Gallery of Art, Washington, D.C.; and William H. Truettner of the National Collection of Fine Arts, Washington, D.C., for their help with certain points in my research. Dr. Elizabeth Cropper, my colleague in Temple University's department of Art History, read the manuscript and cleared up some inconsistencies. Dr. Miles Orvell of Temple University's American Studies Program discussed some of the comparisons with nineteenth-century literature with me, as did Karen Hadalski. Fred Rosenzweig and others gave me access to archival materials in the Free Library of Philadelphia.

The project's completion was ensured by a one-semester sabbatical leave allowed by Temple University in the Fall/Winter of 1976/77, and the university subsequently also provided a research grant that helped to defray expenses for travel and photographs.

Foreword

There are two kinds of taste, the taste for emotions of surprise and the taste for emotions of recognition—HENRY JAMES

To express the thought and not the surface of it.—ALBERT PINKHAM RYDER

"The emotions of recognition," a phrase so aptly and so characteristically turned by Henry James, would refer to the rational and lucid art of classicism or to American realism of the nineteenth century equally well.

However, "American realism of the nineteenth century" is perhaps a redundant statement to people who might constitute a majority and who think of American and realism as synonymous in any case. For it does seem that realism has been a national benchmark of American art since the eighteenth century, when John Singleton Copley was its most representative and elegant practitioner, to the present day when realism, in many different modes, is once again the focus of public interest. And it does seem to fit the American character and temperament. It fits the American love of the real, the tangible, the palpable. It fits a people who are straightforward, pragmatic, and who prize, in their art and architecture, the virtues of simplicity and clarity and directness. In those categories would be found the American Palladianism of Thomas Jefferson and Peter Harrison and painting from Charles Willson Peale through Thomas Eakins.

Yet, that is obviously too simple. There is, as the cliché would have it, another side of the coin. There is, as James has said, "the taste for

emotions of surprise." Romanticism is a style that is the other side of the coin of American realism and has been an important part of American art from the beginning. If Copley painted *Paul Revere,* he also painted *Watson and the Shark* (Museum of Fine Arts, Boston), which anticipated the great French Romantic movement by several years. As a style the movement reflects the intuitive, the enthusiastic, the humorous, and the exaggerated. Where realism, and most certainly classicism, might speak to the mind, or to the intellect rather, romanticism speaks to the emotion. As such it appears to be more complex, or perhaps more dense and, in addition to humor, it deals as well with the darker side of life—with anguish and death, as in the writing of Melville, Hawthorne, and Poe. Romanticism in painting, too, seems to have closer ties with literature, and much of the inspiration for subject matter is derived from Shakespeare, the Bible, and poetry in general. "To express the thought," Albert Pinkham Ryder had said; and Ryder certainly figures as one of the most representative of a group of artists that ranges from Washington Allston through John La Farge.

Professor Davidson has chosen to delve further into the general category of romanticism and study the work of those artists he feels are painters of fantasy and/or whom he feels are of a truly visionary stature. He isolates those artists who "appear to be caught in the midst of a dream rather than based on palpable reality." There is Ryder, of course, and the humorous fantasy of John Quidor, the exoticism of Elihu Vedder, and John La Farge. Professor Davidson looks at the Swedenborgianism of George Inness and considers the strange world of Thomas Wilmer Dewing, who, in his ambiguous treatment of stylish Edwardian women, produced a kind of genteel Surrealism.

Although there is a danger of applying twentieth-century concepts to eighteenth- and nineteenth-century painting, the artists discussed should be emphasized and many of the lesser known figures deserve the extra consideration given here. The subject in general is fascinating and thought provoking, and Professor Davidson has indeed endeavored "to express the thought and not the surface of it."

RICHARD J. BOYLE
Director, Pennsylvania Academy of the Fine Arts

Introduction

What started out as a survey of fantastic painting in nineteenth-century America has ended up, because of lack of space and because of my own interests, as a survey of visionary painting of the same period. The broad definitions of American *fantastic painting* and *visionary painting* are identical: that is, paintings from around 1800 and on into the twentieth century in which the scene appears to have been caught in the middle of a dream rather than being based on palpable reality. But while all visionary paintings are fantastic, not all fantastic paintings are visionary. I think that this is more than an academic distinction. By visionary paintings I mean those fantastic paintings in which the conjured-up world seems to have been more deeply felt, is more authentic, more integrated, more deeply moving than it is in the merely fantastic paintings, in which there seems to have been a good deal of obvious contrivance or a tongue-in-cheek attitude leading to what, by today's standards, may be taken as "kitsch." Among the painters who ought to be included in the second grouping are William Holbrook Beard, Thomas Buchanan Read, Cassius Marcellus Coolidge, Emanuel Gottlieb Leutze, and even Martin Johnson Heade.[1] More

[1] Nineteenth-century kitsch, while fantastic like a lot of visionary art, is fantastic in completely different ways, and ends up being laughable, never deeply moving. Often what we have are simply curiosities. I could cite more examples than those that follow.

William Holbrook Beard (1824–1900) painted animals in human clothing. His *Gwine to Eat It All Myself* (1894), in the Childs Gallery in Boston, is a picture of three little bears, the one with the lemon holding it off for himself. His *Bears Carousing* is in the Historical Society of Princeton, N.J. In something of the same idea, Cassius Marcellus Coolidge (1844–1934), after his trip to Europe in 1873, became a portraitist of dogs dressed in clothes, whose life-style mirrored that

nineteenth-century fantastic painting was produced in pragmatically oriented America than has been generally acknowledged by the notable American art historian Edgar P. Richardson, by Barbara Novak and other scholars.[2]

Following my prejudices and inclinations, I have wound up with a group of artists some of whom are not too well known (Erastus Salisbury Field, William Page, William Rimmer, Thomas Wilmer Dewing), some quite obscure (George Fuller, Robert Loftin Newman), and

of the successful middle-class humans of his time. His *New Year's Eve in Dogville* is a picture of canine party carousers ringing in the New Year; in the *Station and Four Aces* the dogs are playing at cards. He signed a contract with a publishing firm, Brown and Bigelow, who turned out hundreds of thousands of copies of his dog genre subjects as advertising posters, calendars, and prints. Reproductions of Coolidge's work can be found in *American Heritage* 24, no. 2 (1973): 56–59.

Emanuel Gottlieb Leutze (1816–1868), of *Washington Crossing the Delaware* fame, turned out what must be some of the most, if not the most, insipidly pompous and rhetorical literary paintings and allegories in nineteenth-century American art. Examples are the *Angel Hovering Above a Battle Scene* (1864), in the Gallery of Art of Baltimore's Morgan State University; *The Poet's Dream,* in the Pennsylvania Academy of the Fine Arts; and *The Knight of Sayn and the Gnomes* (c. 1849), which is taken from a German ballad in which Kuno of Sayn can win Ermengarde, the daughter of a squire, if he can successfully ride his horse up the rocky cliff to her father's castle. In that latter painting the stalwart Kuno is accompanied by cute little gnomes, who look as though they came from Walt Disney's *Snow White. The Knight of Sayn* is in a private collection in Albuquerque. Even Martin Johnson Heade (1819–1904), renowned for his Luminist landscapes around Newport, R.I., and for his paintings of South American flora and hummingbirds, could turn out kitsch such as his painting of a studio in which there is a painting on an easel and a little gremlin. This is in the Knoedler Galleries in New York and is reproduced in *Antiques,* January 1976. This painting was not a momentary aberration for Heade, for other versions of *Gremlins in the Studio* are in the collections of Sotheby Parke Bernet, Inc., and Dr. and Mrs. Irving F. Burton of New York. These were painted from about 1850 to 1870. Thomas Buchanan Read's (1822–1872) *Painter's Dream* (1869), in The Detroit Institute of Arts, is a picture of the painter asleep, with his dream of a luscious recumbent nude wafted by four little winged putti filling some three-quarters of the canvas.

None of these or other examples of kitsch are included in my text. They are, I feel, curiosities, and mainly of historical interest and are really of less intrinsic importance than the art of the visionaries, who, when they are fantasts, are fantasts of another order. I say something here of American kitsch so that the work of the visionaries, which will be presented in the text, will—I hope—be all the more appreciated.

[2] In her *American Painting of the Nineteenth Century* (New York: Praeger Publishers, 1969), Novak writes, for example, that, "after Allston, the dream was, to a large extent, suspended until the last quarter of the century" (p. 239). In writing of La Farge, she speaks of "the small chapter of American Gothick that had originated with Allston" (p. 260).

others ranging from the somewhat familiar (John Quidor, Edward Hicks, Elihu Vedder, John La Farge, George Inness, Ralph Albert Blakelock) to the well known (Benjamin West, Washington Allston, Thomas Cole, Albert Pinkham Ryder).

Most of these American visionaries lived and painted throughout the Northeast. Ryder (1847–1917) resided in New York City, settling there around 1870 after he left his native New Bedford, Massachusetts. So did Blakelock (1847–1919), after his western journey of 1869 to 1872 and before his confinement in the Middletown State Hospital for the Insane in Middletown, New York, from 1899 until 1916, three years before his death. So did Quidor (1801–1881), who had come from Tappan in New York State, not far from the home of Washington Irving, whose writings served as the basis for most of his work. So did the Southerner Newman (1827–1912), who was born in Richmond, Virginia, and who, after two trips to Paris in the early 1850s and a five-year stint in the Conferedate Army, resided there fairly continuously from 1865 until his death, in 1912, by asphyxiation due to gas that had escaped from his room heater. Dewing (1851–1938), born in Boston and educated at its art school, moved to Albany, then studied in Paris from 1876 to 1879, whereupon he moved to New York City. Inness (1825–1894), who had come from Newburgh, New York, opened studios in New York City in 1856 and 1876, before and after his three trips abroad (in 1847 to Rome and Florence, in 1850 to Italy and Paris, and from 1870 to 1874 to Rome and Paris).

Cole (1801–1848), born in Lancashire, England, emigrated to Philadelphia in 1819, when he was eighteen, then settled in the village of Catskill in 1832 upon his return from a trip abroad. Hicks (1780–1849), the itinerant preacher, moved about Bucks County, Pennsylvania.

Massachusetts could claim Field (1805–1900), who was born in and spent most of his life about Leverett, near the Connecticut border, though from 1826 to about 1840 he traveled as an itinerant artist through Massachusetts, Connecticut, and eastern New York. Massachusetts could also claim Allston (1779–1843), who, after having returned from England and the Continent in October 1818, where he had been for fourteen of the last seventeen years, lived and painted in Boston until 1830 and then in Cambridge until his death. The English-born Rimmer (1816–1879), who had been brought by his family to Nova Scotia at the age of two and then to Boston in 1826, resided until his

death (except for a stint from 1866 to 1870 as director of Cooper Union's School of Design for Women, in New York) mainly in Randolph, Massachusetts, just southeast of Boston, moving also through the towns about Boston, such as Worcester and Lowell. Fuller (1822–1884), born in Deerfield in the northwestern part of the state, practically due north of Springfield, maintained a studio in Boston before and after his retirement from painting, during which he farmed in Deerfield from around 1860 to 1876.

But West (1738–1820), born in Springfield Township, outside Philadelphia, settled in England in June 1763, where he was to enjoy remarkable success as chief painter to King George III and as president of the Royal Academy of Arts, London, from 1792 to 1805 and from 1806 to 1820, and remained there until his death. Vedder (1836–1923) also spent most of his working life abroad, traveling to France and Italy in 1856 and settling permanently in Rome in 1865, returning to America only for an occasional commission, though some of his most significant painting was done when he stayed in New York City from 1861 to 1865. La Farge (1835–1910), like Vedder born in New York City, after a trip to Paris in 1856, a stint at William Morris Hunt's Newport studio, and a second trip to Europe in the early 1870s, produced his most compelling visionary painting as the aftermath of his voyage to the Far East, which he undertook in 1886. Page (1811–1885), with Inness, was the most traveled of the visionaries. After beginning to prepare for the ministry, he stayed in New York from 1835 to 1843, in Boston from 1844 to 1847, again in New York from 1847 to 1849, in Rome in the 1850s, with visits to Paris and London, and from 1860 in New York; Eaglewood, New Jersey; and Tottenville on Staten Island.

Authentic visionary painting, as distinct from fantastic curiosities, was like a small stream, meandering slowly beside the two great torrents of nineteenth-century American painting, the one realist, the other insipidly ideal. Indeed, of the fifteen painters I have enumerated, West, Cole, Field, Page, Inness, Dewing, and La Farge can be considered visionaries for only part of their career or in only a selected number of works. Nonetheless this should in no way diminish for us the stature of all these men: Each of them in his way, whether in a few canvases or in many, pursuing the image in his mind's eye, produced an art that was arrestingly individual for its time. I should like to believe that each of them could sense the preciousness of that inner world that he was able to externalize; but, sadly, seldom is there the record of

this conviction. For some of them, especially the eccentric visionaries, we will see that that inwardness, which was their strength as artists, brought forth a heritage of loneliness and alienation.

We shall find that both the subject matter and the manner of rendering of the visionaries vary widely and that what counts is the mood, the aura the painter succeeded in transmitting. There is a great gamut between the hybrids and monsters of Vedder and the fashionably attractive but otherwise ordinary women of Dewing, between the large, vague, heavily built-up cloud or landscape forms of Ryder and the puppetlike, minutely textured exotic animals of Hicks. But there is always the quality of dream—this is what holds these works together—even though there are a variety of responses engendered in us, a very wide range of shadings of feeling from painter to painter. How unlike, for example, are the still, but unsettling reverie of Allston's *Moonlit Landscape* (1819) and the awesome turbulence of West's several versions of his *Death on the Pale Horse* and Ryder's *Jonah* (c. 1885); or the terrifying unfulfillment of Rimmer's *Flight and Pursuit* (1872) and the bountiful splendor of Field's *Historical Monument of the American Republic* (c. 1876).

These painters, beyond their American provenance, belong to the broader international confraternity of fantasts, numbering such as Bosch, El Greco, Blake, Goya, Moreau, and Redon, artists of whom they were either unaware or hardly aware and whom they certainly did not attempt to emulate. The fact that Hicks and Field have been classified, as well, as primitives (a stylistic category only) in no way deters me from including them among the visionaries. Some of these American visionaries have been treated at length in monographs and in the scholarly literature; but although there have been books on nineteenth-century American landscape, genre, still life, and even marine painting, there has not been a single one on visionary painting, one that could bring these artists together under one cover.[3] I hope I have

[3] However, there are an article and several exhibition catalogues dealing with several of the visionaries. William C. Agee's "Nineteenth-Century Eccentrics and the American Tradition," *Art News Annual* 32 (1966): 131–148, was most useful in helping me formulate my ideas for this book. Two exhibition catalogues that proved enlightening were *Art and the Excited Spirit: America in the Romantic Period, March 15 to May 14, 1972*, catalogue (Ann Arbor: University of Michigan Museum of Art, 1972), which contains a checklist of an exhibition organized by David C. Huntington, which consisted of 128 works, including 10 of Allston, 15 of Cole, 1 of Hicks, 1 of Quidor, as well as some of Eakins, Homer, and Church; and

made a contribution in doing this, even though I do not treat individual painters with the same thoroughness that they are given in the monographs.

I have formulated certain categories as a working hypothesis: *visionaries of the spectacular* to encompass the painters from 1800 to 1850; *subterranean visionaries; visionaries of "the normal,"* in whom the visionary characteristics are the most understated; and *cosmic visionaries.* Categories bring both an order and a rigidity to a viable, fluid reality; these categories are intended to bring as much as possible of the former and as little as possible of the latter. In some cases, such as Ryder the same artist, I feel, can fit into more than one of these classifications. I have tried to use the final chapter of this book as a framing element, in which I trace the ongoing visionary stream into the twentieth century. If at the end the reader does not know these painters thoroughly, I hope, I expect that he will have some appreciation for them, some knowledge of their struggles, and some awareness of their contributions.

Seascape and the American Imagination, June 10 to September 7, 1975, catalogue (New York: Whitney Museum of American Art, 1975), which focused on Copley, Allston, Cole, Lane, Homer, and Ryder.

1

The Beginnings of American Visionary Painting, 1800–1850: Visionaries of the Spectacular

American visionary painting of about 1800 to 1850 differs, as a whole, from what comes afterward. It is louder, more Cecil B. De Mille-ish, more assertive, more self-conscious. The chosen scenes, at a quick glance, do not appear to be "normal"; for we find in them cloud-prancing horses (West's *Death on the Pale Horse*), haloed guardian angels (Cole's "Voyage of Life" series), writing within space (Allston's *Belshazzar's Feast*), and a number of other miraculous effects. Certainly, scenes in much visionary painting after 1850 do not appear "normal" either, but with Vedder, Rimmer, and La Farge the imagery is inverted, esoterically personal, sometimes disturbingly remote, whereas the artists before 1850 deal with grand themes, sometimes culled from the Bible or from popular literature. And much of the painting after 1850 asserts itself as visionary only after our reflection, such as the forest pictures of Blakelock, the early landscapes of Ryder, the late landscapes of Inness from 1884 to his death in 1894, the charming genre pieces of Newman, and the fashionable drawing-room pictures of Dewing. In short, there is the awareness after 1850 that the uncanny, the ghostly, the surreal may lurk within the ordinary-seeming. As to the visionary painting before 1850, it can be so senti-mentalized and, in general, so rhetorical that it is saved only by the utter sincerity of the artist from the high kitsch to which the pomp-ousness of its theme and the grandiloquence of its treatment might have led it.

The beginnings of the American visionary painting, with its pre-ponderance of subjects that are, in themselves, calculated to shock, astonish, and overwhelm, must be seen within the context of international romanticism. If Allston is at the headwaters of the American visionary stream in painting, then the expatriate Benjamin West (1738–1820), who influenced him directly when he first came to England, must be regarded, from the standpoint of his late work, as its distant source. Conscious of the changes being brought about in English aesthetics by Edmund Burke's (1729–1797) pronouncements on the sublime[1] and the acclaim being accorded artists who based themselves on Michelangelo's turbulent figures—for example, James Barry (1741–1806), William Blake (1757–1822), and Henry Fuseli (1741–1825)[2]—West, wishing to keep up with the times, gave up the edifying pictures of the late 1760s and 1770s, with their sober, dignified, self-controlled figures, usually taken from the stories of the ancient Greeks and Romans, and concentrated instead on supernatural accounts from the Old and New Testaments. There were accompanying changes of style. The *Agrippina Landing at Brundisium with the Ashes of Germanicus* (1768) has the quality of bas-relief: The planes are clearly delineated, and the figures in the foreground stand as though on a shallow stage. But in the various versions of the *Death on the Pale Horse*, the *Conversion of Paul* (1786), and the *Archangel Gabriel* (1798), there are flashes of light and dark; the space, no longer boxlike, is now mysteriously immeasurable; and the people and, when they appear, the animals are sometimes fierce and always unconstrained.

West undertook the visionary not out of inner compulsion but in premeditated response to the fashion, or part of the fashion, of his day. He made four versions, differing in size, in medium, and somewhat in details, of his *Death on the Pale Horse*,[3] which is based on the terri-

[1] Edmund Burke, *A Philosophical Enquiry into the Origin of Our Ideas of the Sublime and Beautiful* (London, 1757).
[2] I became aware of the impact of Michelangelo on the art of Blake, Barry, Fuseli, and other European artists of the eighteenth century from the lectures in Prof. Robert Rosenblum's course in neoclassicism and romanticism, which I attended in 1961 as a graduate student in Columbia University's Department of Art History and Archaeology. See also, for the place of West within the European art of his time, Robert Rosenblum, *Transformations in Late Eighteenth Century Art* (Princeton, N.J.: Princeton University Press, 1967).
[3] Besides the very large painting (1817) in the Pennsylvania Academy of the Fine Arts, there are the drawing of 1783 (retouched in 1803), in the Royal Academy of Arts in London; the first oil sketch of about 1783; and the second oil sketch of 1802, in the Philadelphia Museum of Art.

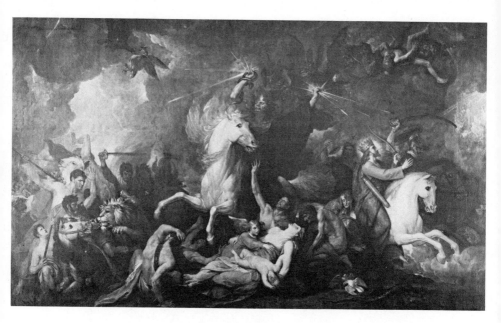

Benjamin West: *Death on the Pale Horse*. 1817. Oil on canvas. 14′8″ x 25′1″. The Pennsylvania Academy of the Fine Arts, Philadelphia; Academy Purchase.

fying account in Revelation 6:8: "And I looked, and behold, a pale horse: and his name that sat on him was Death, and Hell followed with him. And power was given unto them over the fourth part of the earth, to kill with sword, and with hunger, and with death, and with beasts of the earth." Visionaries responded to the temper of their times in one way or another, but West, as Grose Evans has shown, purposefully set about fitting some of his later work to Burke's writings on the sublime, not simply in a general way, but detail by detail.[4] For Burke, the sublime had its sources in terror, obscurity, power, darkness, vastness, infinity, and so forth. Corresponding with this, West veiled Death in obscurity, used darker colors, and conveyed infinity by the measureless depth of the composition. Burke held that sublimity springs from the instinct for self-preservation; in the lower center of West's painting a family huddles together, the father vainly raising his arm against Death's oncoming white charger. Burke wrote of horses "whose neck

[4] Grose Evans, *Benjamin West and the Taste of His Times* (Carbondale, Ill.: Southern Illinois University Press, 1959), pp. 60–81.

is clothed with thunder, the glory of whose nostrils is terrible, who swalloweth the ground with fierceness and rage"; and that could be an apt description of Death's charger, so prominent in the center of the painting, emerging from a thunderstorm. (Probably the horse's head in the east pediment of the Parthenon in the Lord Elgin Collection served as the visual model.) *Death on the Pale Horse* is but the most spectacular of many paintings of the terrible sublime that West completed; and others fitting that category had been planned by him for a gigantic Chapel of Revealed Religion that was supported by George III, which, unfortunately, was never brought to fruition.[5]

Benjamin West: *The Deluge (The Waters Subsiding After the Deluge)*. c. 1791. Wash drawing. 9″ x 12¹¹⁄₁₆″. Museum of Fine Arts, Boston; Given in memory of John Hubbard Sturgis by his daughters.

Among those was a painting, now lost, titled *The Deluge (The Waters Subsiding After the Deluge*, c. 1791), based on the account of the flood in chapter 7 of Genesis; but the small signed wash sketch for it in the Boston Museum of Fine Arts reveals that in spite of the presence of the ark, West's conception served as the model for Joshua Shaw's

[5] For an intelligent attempt at a reconstruction of this chapel, see J. D. Meyer, "Benjamin West's Chapel of Revealed Religion: A Study in Eighteenth-Century Protestant Religious Art," *Art Bulletin* 57 (June 1975): 247–265.

(1776–1860) *Deluge* (c. 1813), a frightening painting within the category of the sublime long believed by leading scholars to be by Washington Allston or by a close follower.[6] The final version of the *Death on the Pale Horse* (1817), an enormous canvas (14¾′ × 26′), completed when West was seventy-nine, stands at the head of the main staircase of the Pennsylvania Academy of the Fine Arts. Upon seeing it the first few times—always immediately upon turning a sharp corner after the steep climb—I was always struck by its sheer size and the awesomeness of the conception of mankind's plagues as heroic but implacable horsemen (hardly a new conception, but always astounding). With the passage of time, my admiration for West's ambition and organizational skills has remained unabated; yet the attitudes of the figures now seem frozen, or at least carefully posed, and the whole effect strikes me as being a bit too purposefully spectacular for the painting to be the stuff of which dreams are made.

Painted three years later in that same spirit of vast scale (in this case, nearly 23½′ × 11½′) and accommodating an obviously frightening theme was Rembrandt Peale's (1778–1860) *Court of Death* (1820), now in The Detroit Institute of Arts. The painting was meant as an illustration to a well-known poem titled "Death," by Bielby Porteus Bishop (1731–1808), of London, which read in part:

> Deep in a murky cave's recess,
> Laved by Oblivion's listless stream, and fenced
> By shelving rocks and intermingled horrors,
> . . . the Monarch sits
> In unsubstantial majesty.

When Rembrandt Peale was in London in 1802–1803 with his brother, Rubens, to exhibit the two mastodon skeletons unearthed by his father, he studied briefly under West and considered—but rejected—the fearsome crowned rider of West's pale horse as the model for his own image of Death. Instead, Peale's Death became a rather passive, mysteriously shrouded seated figure, at whose feet a struck-down young man lay and to the sides of whom a whole cosmogony of allegorical figures—twenty-one in all—appeared, some kneeling, some standing,

[6] For information on Shaw and the scholarship on the controversy surrounding the attribution of *The Deluge*, see Albert Ten Eyck Gardner and Stuart P. Feld, *American Paintings; A Catalogue of the Collection of the Metropolitan Museum of Art* (Greenwich, Conn.: New York Graphics Society, 1965), pp. 130–133.

Rembrandt Peale: *The Court of Death*. 1820. Oil on canvas. 11'6" x 23'5".
The Detroit Institute of Arts, Michigan; Gift of George H. Scripps.

some running. The preparations were painstaking. The artist used
corpses as studies for some of the postures, and he had relatives and
friends pose for the various figures: His father became Old Age; his
brother, Raphaelle, the young man struck down; his friend John Neal,
a warrior; his infant daughter, Emma Clara, the naked orphan to the
right; his other four daughters—Rosalba, Angelica, Virginia, and Au-
gusta—Faith, Hope, Virtue, and Pleasure, respectively.[7] The murky
tonalities of grays and greens, and the specterlike figures within the
grotto setting, some of whom are illuminated by torchlight, make for
an effective somberness. From the beginning, the painting attracted
throngs, and it made Rembrandt Peale's reputation. In the year of its
completion, it was exhibited in the Senate Chamber in Albany (where
a senator fell dead one day upon entering the exhibition). Ministers
frequently referred to it in their sermons. During the first thirteen
months the painting was on tour, it was seen by thirty-two thousand
people and earned more than nine thousand dollars. The *Court of*

[7] From a pamphlet by Rembrandt Peale, *Peale's Court of Death*, 1845. The
corpse was "painted from the genuine article, loaned for the purpose by the medi-
cal college." See Charles Coleman Sellers, *Charles Willson Peale, II: Later Life,
1790–1827* (Philadelphia: American Philosophical Society, 1947), p. 330.

Death and the studies for it were Peale's only ventures in a visionary vein. He was primarily a portraitist, and the notables whose faces he painted included Thomas Jefferson and George Washington. He popularized his idealized "porthole" portrait of Washington and late in life made capital of his claim that he was the last surviving artist for whom Washington had sat.

Neither Benjamin West nor Rembrandt Peale saw any contradiction between representing on their canvases an unreal vision (although this was achieved, as we've seen, in a quite deliberate fashion through the use of literary sources and posed models) and pursuing their success in worldly affairs. Thus, they were very different from the visionary eccentrics after 1850 or so, who pursued their inner visions as solitaries, not only shunning the company of contemporary painters but sometimes sticking out like a sore thumb because of their bizarre behavior, unkempt appearance, and so on. West, by contrast, was president of the Royal Academy and an intimate of George III (nominally England's most powerful political personality, in spite of his recurrent fits), and through his enviable position guided artistic policy, even as his own taste was shaped by the times. After meeting Napoleon in 1802 in Paris and seeing the support the French dictator gave to the arts, he petitioned before a number of prime ministers for an English national museum of art. Visiting American artists, including Charles Willson Peale (1741–1827), Gilbert Stuart (1755–1828), John Trumbull (1750–1831), Washington Allston (1779–1843), and Samuel F. B. Morse (1791–1872), when in London, made it their point to see West, either for tutelage or merely for guidance. On the other side of the ocean, Rembrandt Peale left his mark on civic affairs. He was one of the founders of the National Academy of Design, New York, in 1826, succeeded Trumbull to the presidency of the American Academy of Fine Arts in New York, and established a museum and gallery in Baltimore. Inheriting his father's scientific interests, he demonstrated at his Baltimore Museum the use of gas for lighting and was a founder in 1816 of the Gas Light Company in Baltimore, the first commercial gas company in America.[8]

How utterly lamentable those aristocrats would probably have found Albert Pinkham Ryder to be, who, in the last two decades of his

[8] Charles H. Elam, ed., *The Peale Family: Three Generations of American Artists* (Detroit: The Detroit Institute of Arts and Wayne State University Press, 1967), p. 101.

life, walked the back streets of New York, bedraggled, by night. Growing increasingly famous as an artist, Ryder the man became more remote, almost legendary, like someone people were never sure really existed.[9] One of the few actively to seek out his company in the last years was the Lebanese-American writer, mystic, and occasional artist Kahlil Gibran (1883–1931), who left a moving account of him in 1915, when he was sixty-eight:

> I found him on a cold day in a half-heated room in one of the most poor houses on 16th street. He lives the life of Diogeneus, a life so wreched [sic] and so unclean that it is hard for me to discribe [sic]. But it is the only life he wants. He has money—all the money he needs —but he does not think of that. He is no longer on this planet. He is beyond his own dreams.[10]

Ryder attended an exhibition of Gibran's work in December 1914; reportedly, that was the first exhibition he had seen in eight years. Gibran is supposed to have said to his friend, mistress, and collaborator, Mary Elizabeth Haskell:

> he received K. [Kahlil Gibran] in the room of an old English lady of eighty—because his own room was too cold. He sleeps at 16th street on three chairs with old clothes on them. . . .
> "He made me ashamed of being clean," Kahlil confessed. "He is so gentle and courteous—'may I take it for you?' he said when he saw my portfolio, though he uses his hands with such difficulty . . . has no will of his own . . . no skill for contact with people."
> When K. had finished drawing him, he took the picture and looked at it. "So carefully," K. recounted, "it was a great revelation to me—such looking—as if he were looking to see what life was in it."[11]

Of the visionaries of the spectacular, only Washington Allston (1779–1843) claimed for himself a special kind of sensibility that set him off, as an artist, from other men. Yet his many years abroad in the

[9] According to Elizabeth McCausland, Marsden Hartley (1887–1943), the early Modernist, before leaving for Europe in 1912, lived for around eight years on the same street in New York as Ryder without realizing this. This is all the more remarkable since for some of this period Hartley modeled some of his landscapes on Ryder's paintings. (Interview with Elizabeth McCausland, April, 1962.)
[10] Jean Gibran and Kahlil Gibran, *Kahlil Gibran: His Life and World* (Boston: New York Graphics Society, 1974), p. 281.
[11] *Ibid.*, p. 282.

company of such rarefied spirits as Samuel Taylor Coleridge (1772–1834) indicate that he needed a suitable ambience in which his creative gifts could be fostered.[12] When Allston spoke of his own uniqueness and the uniqueness of the artist, of how the artist reacts and how he elicits responses, he sounded like a pioneer physiological psychologist, someone like Gustav Theodor Fechner, Wilhelm Wundt, or even John Locke, describing feelings and states of mind as though they were hypothetical constructs. William Dunlap (1766–1834) recorded Allston's appreciation of the great Venetians as follows:

> They [paintings of Titian, Veronese, and Tintoretto] addressed themselves, not to the senses merely, as some have supposed, but rather through them to that region (if I may so speak) of the imagination which is supposed to be under the exclusive domination of music, and which, by similar excitement, they cause to teem with visions that "lap the soul in Elysium." In other words they leave the subject to be made by the spectator, provided he possessed the imaginative faculty.[13]

In his *Lectures on Art and Poems* (1850), Allston wrote of moral attributes and intellectual faculties, of "a law of mental pleasure," of a poetic truth "which may be said to exist exclusively in and for the mind, as distinguished from the truth of things in the natural or external world."[14]

This in contrast to Ryder, who didn't hold his feelings out to be looked at and described. Instead, with him there was the utterance of *what* he felt rather than a long account of *how* he felt: "Have you ever seen an inch worm crawl up a leaf or twig, and then clinging to the very end, revolve in the air, feeling for something to reach something? That's like me. I am trying to find something out there beyond the place on which I have a footing."[15] Predictably, in behavior and in dress there was never in Allston anything of the abandon there was, later, in Ryder (and this can be said of all the visionaries of the spectacular);

[12] Edgar P. Richardson, *Washington Allston: A Study of the Romantic Artist in America* (New York: Apollo Editions, 1967), especially pp. 109–115.

[13] Quoted by William Dunlap, *A History of the Rise and Progress of the Arts of Design*, vol. 2 (1834; reprinted in 3 vols., Boston, 1918), pp. 162–163.

[14] Washington Allston, *Lectures on Art and Poems* (New York, 1850), pp. 11–12, 79. For a good discussion of Allston's theories, see Richardson, *Allston*, pp. 157–173.

[15] Lloyd Goodrich, *Albert P. Ryder* (New York: George Braziller, 1959), p. 22.

and this indicates, too, I think, or goes hand in hand with, the rhetoric or staginess or conscious striving for effect in some of Allston's paintings. A contemporary, writing of him in 1838, when he was almost sixty, observed that he was "struck by the dignity of his figure and by the simple grace of his manners: his dress was rather careless, and he wore his own fine silver hair long and flowing; his forehead and eyes were remarkably good, the general expression of his countenance open, serious, and sweet, the tone of his voice, earnest, soft, penetrating."[16]

But we need to keep in mind that Allston, through his tortuous system of aesthetics, provided a defense that could have been used by all the American visionaries after him. Stated most simply, he argued that it is more valid for the artist to use his imagination as a springboard for his art than to use the world he perceives through his senses ("Trust to your own genius, listen to the voice within you, and sooner or later she will make herself understood not only to you, but she will enable you to translate her language to the world, and this it is which forms the only merit of any work of art."[17] Each mind, for Allston, was different from every other; and originality lies in the individual's ability to produce images corresponding to the feelings that are his alone. Invention consists both in new combinations of known forms and in taking fragments of those forms. To increase the powers of one's mind (and from this would come the ability to exercise the imagination), Allston urged that the artist read as extensively and as persistently as the poet. His own private library must have been one of the most impressive in America before the Civil War, containing, besides novels, histories, and political writings, the aesthetics of the empiricists (Edmund Burke and Richard Payne Knight), the neoclassicists (Anthony Ashley Cooper, third earl of Shaftesbury, Sir Joshua Reynolds, Henry Fuseli), the organicists (Samuel Taylor Coleridge and Immanuel Kant), as well as color theories (George Field's *Chromatics, or an Essay on the Analogy and Harmony of Color,* etc., 1817).[18] Of his 197 catalogued paintings, nearly a third involve themes drawn from litera-

[16] Anna Jameson, "Washington Allston," *Athenaeum* (London), 1844, pp. 15, 39. Quoted in Richardson, *Allston,* p. 179.
[17] Advice he gave to another painter; quoted in Jared B. Flagg, *Washington Allston, Life and Letters* (New York, 1892), pp. 198–199.
[18] Elizabeth Johns, "Washington Allston's Library," *American Art Journal* 7, no. 2 (November 1975): 32–41. Contains an itemized list of the works in Allston's library.

ture—the Bible (19 paintings), Shakespeare, Milton, Scott, Spenser, Washington Irving, Coleridge, and various classical sources—all books known to be in his library. The scenes were not chosen indiscriminately. Allston sought tableaux from the Bible, for example, that, when illustrated, would astonish or amaze the viewer rather than instruct him morally. We may be certain that Allston was not a passive reader; true to his theories, he wished to arouse in the viewer of his paintings something of the emotional reactions that a particular passage of literature brought forth within his own imaginings. The result in the biblical pictures was an invoking of the spectacular through themes having to do with the miraculous, or the suspension of natural laws. A few of the titles in themselves are revealing: *The Dead Man Revived by Touching the Bones of the Prophet Elisha* (1811–1813); *The Angel Releasing Saint Peter from Prison* (1812); *Jacob's Dream* (1817), where angels ascending to and descending from heaven are shown; *Saul and the Witch of Endor* (1820–1821); *Elijah in the Desert* (1818), where Elijah is miraculously fed by the ravens; and *Belshazzar's Feast* (1817–1843), the story of Daniel and the prophetic handwriting on the wall.

Besides reading, Allston felt that one's early experiences, when vivid, stimulate the creative imagination (somewhat along the lines of the concept of the unconscious, in the terms of the psychologists to come a century later). From his South Carolina childhood up to the age of six, he recalled to the historian Dunlap, he used to make little men and women out of stalks of wild ferns and would be terrified by tales of witches and hags, and these memories remained with him.[19]

After graduating from Harvard in 1800, he admired Fuseli's illustrations (1776–1777) for John Boydell's (1719–1804) Shakespeare Gallery, which he had seen in Charleston, then set sail for England in May of 1801. It was the beginning of many years away from America. In London, Allston was completely taken by West's sketch for the *Death on the Pale Horse* (1783), declaring that "no fancy could have . . . more happily embodied the visions of sublimity" and that "it is impossible to conceive anything more terrible."[20] He arrived in Paris with the painter John Vanderlyn (1775–1852) in November 1803 and left there in the spring of 1804, crossed the Alps, and reached Rome in early 1805 by way of Siena. Rome then must have seemed tremen-

[19] Dunlap, *History of Arts of Design*, pp. 152–153.
[20] Quoted in Flagg, *Washington Allston, Life and Letters*, p. 43.

dously exciting for the young American. There was an international society of artists: the German colony gathered about the neoclassical painter Asmus J. Carstens (1754–1798); the Danish, about the neoclassical sculptor Bertel Thorvaldsen (1768–1844). Allston visited the Roman collections of art with Washington Irving (1783–1859), who was himself then considering becoming an artist, and absorbed the beauty of the surrounding Italian landscape. There he met Coleridge, with whom he roamed the Sabine Hills in early 1806; it was the beginning of a lifelong attachment.

The years 1808 to 1811 were spent in Boston, but America could not nourish his spirit; and Allston left for England again, this time with Samuel F. B. Morse. Mainly in London from 1811 to 1818, he met the painter of architectural fantasies John Martin (1789–1854) and was introduced by Coleridge to William Wordsworth (1770–1850). In Boston and Cambridgeport (Cambridge) from 1818 until his death in 1843, he took part in the cultural life of his community, associating with Henry Wadsworth Longfellow (1807–1882), the painter Thomas Sully (1783–1872), and the sculptor Horatio Greenough (1805–1852). Allston continued, though, to feel uncomfortable with America beyond Boston and Cambridge, and because of this and his distaste for President Andrew Jackson, he refused a commission to decorate the rotunda of the Capitol in Washington.

He painted his *Moonlit Landscape* in 1819, his first full year back in America. In this remarkable visionary painting, there is no trace of the accouterments of the spectacular. The intrusion of the tiny shadowy figures—a group of three who have stopped to speak with a horseman—lend an air of brooding mystery to the silent nightscape. At the same time, the slow movement of the serrated clouds about to cover the moon (looking forward to a similar motif in Ryder) hints at the potential for change, even violence, within the now stationary figures. The hills and mountains and the sliver of land upon which the figures stand have the look of Italy rather than America: This could be the Tiber, with its distant profiles of the Alban Hills. Allston, who remembered so vividly the effects of his childhood experiences in South Carolina, apparently has relied here, too, on the provocative power of his memory, for he must have based this painting on a memory image of Italy, where he had been more than ten years earlier.

A recurring theme running through current European romantic novels, poetry, and painting was cataclysm dealing with the spectacu-

lar destructions of mighty bygone empires. English specialists of this genre included especially John Martin, whose subjects included the fall of Babylon, the fall of Nineveh, Belshazzar's feast, the destruction of Herculaneum, and the Great Day of Wrath. Another was, to a lesser extent, the great William Turner (1775–1851), who painted *The Fifth Plague of Egypt* in 1800 (actually he was thinking of the seventh plague) and, pushing his subjects up to the present, *The Burning of the Houses of Parliament* in 1835, recording the event of October of that year. The most famous poem on this theme must be Percy Bysshe Shelley's (1792–1822) terse "Ozymandias" (1818), of fourteen lines:

> *I met a traveler from an antique land*
> *Who said: Two vast and trunkless legs of stone*
> *Stand in the desert . . .*
> .
> *And on the pedestal these words appear:*
> *"My name is Ozymandias, king of kings:*
> *Look on my works, ye Mighty, and despair!"*
> *Nothing beside remains. Round the decay*
> *Of that colossal wreck, boundless and bare*
> *The lone and level sands stretch far away.*

But nowhere in Europe in the first half of the nineteenth century was the idea of cataclysm, or the idea that history was made up of violent and dramatic endings and beginnings, so popular and widespread as it was in the United States, the inhabitants of which were well aware that their country marked a new order where no European civilization had been, that their houses now stood where, quite probably within their own lifetime or within the lifetime of their parents, there had been (from their point of view) only savages.

To note with a two- or three-sentence summary for each all the books, stories, and poems that appeared in this country dealing with cataclysm as their central theme would take far more space than I have at my disposal. Still, some of the major ones ought to be mentioned. William Ware's (1792–1852) *Zenobia, or, The Fall of Palmyra* appeared in 1827; Edward Maturin's (1812–1881) *Montezuma, The Last of the Aztecs,* described with relish the violence attending the conquest of Mexico, in 1833; and on the same subject, Robert Montgomery Bird's (1806–1854) *The Infidel, or, The Fall of Mexico,* in 1835. Of this type, but not tied to an actual historical event, and more fantastically conceived, were such short stories of Edgar Allan Poe (1809–1849) as

"The Fall of the House of Usher" (1839). Sumner Lincoln Fairfield (1803–1844), in poems and novels from 1822 to 1832, speculated, in part, that the Indian mound builders of Ohio and New York had descended from previous superior civilizations destroyed by catastrophic events. His *Last Night of Pompeii* (1832) was literally stolen by Edward Bulwer-Lytton (1803–1873) and somewhat recast into his own very popular *Last Days of Pompeii* (1834).

Religious revivalism and even some aspects of science were forged of a similar spectacular catastrophist mold. In his *Book of Mormon, An Account Written by the Hand of Mormon Upon Plates Taken from the Plates of Nephi* (1830), Joseph Smith (1805–1844) claimed that the New World had been peopled by a wandering tribe of Israelites under the leadership of the Patriarch Lehi, who had set out for America when warned, about 600 B.C., of the impending destruction of Jerusalem. Lehi's sinful son, Lehiman, was the progenitor of the American Indians; and from his good and faithful son, Nephi, stemmed the Nephites, a peaceful, virtuous people. Constant warfare between the two groups resulted in the annihilation of the Nephites, the last of whom, Mormon, buried his records in a hill. These were finally unearthed by Joseph Smith, following the instructions of the angel Moroni, who appeared to him in a vision. The most successful of the millennialists was one William Miller (1782–1849), who found clues in the Bible indicating that the world would end in the spring of 1844. When the thousands upon mountain tops who were awaiting the Coming of the Lord were disappointed, the date was pushed up to October 22, 1844. This time three times the number of people congregated, many dressed in white; but when nothing happened, the strength of the Adventist movement waned. The catastrophist viewpoint prevailed among geologists, who saw the earth's history as a series of violent changes; it was eminently plausible, as well as being luridly colorful in the romanticism of its implied violence. Besides, it was a viewpoint able to bridge successfully the gap between the biblical account of Creation, which held that the world was but a few thousand years old, and various excavations, which seemed to prove empirically that profound changes had occurred in the earth since earliest times. Edward Hitchcock (1793–1864), president of Amherst College, was prominent among the many clergymen who identified geological eras with the successive creative acts of God.[21]

[21] See my "Catastrophism and Peale's 'Mammoth,'" *American Quarterly* 31, no. 3 (Fall 1969): 620–629. Reprinted with a few changes as "Charles Willson

Washington Allston: *The Prophet Jeremiah Dictating to the Scribe Baruch.* 1830. Oil on canvas. 89¾" x 74¾". Yale University Art Gallery, New Haven, Connecticut; Gift of S. F. B. Morse.

Against the backdrop of catastrophism, we would expect that many visionary paintings of the spectacular would have come to focus on the great imagined cataclysms of the past—and such indeed was the case. Among Allston's visionary paintings are *Miriam the Prophetess* (1820), who is shown singing her song of triumph over the destruction by water of Pharaoh's armies; *The Prophet Jeremiah Dictating to the Scribe Baruch* (1830); and two studies and the very large canvas of *Belshazzar's Feast.* The two figures in the *Jeremiah* are rather static, with the pose of the prophet derived from Michelangelo's *Moses,* which Allston, according to Irving,[22] had especially admired in Rome in 1805. Thus, the cataclysm of Jerusalem's destruction is implied through the prophet's dictation. The artist was drawn to the chapters

Peale's 'Exhuming the First American Mastodon': An Interpretation," in *Art Studies for an Editor: 25 Essays in Memory of Milton S. Fox* (New York: Harry N. Abrams, 1975), pp. 61–75.

[22] Coming to Rome from Sicily, Irving first met Allston early in the spring of 1805, and the two rambled about Rome visiting art collections in villas and churches. A detailed account of these visits may be found in Washington Irving, *Spanish Papers, Biographies and Miscellanies,* 2 vols. (New York, 1866), II, pp. 143–150.

(45–51) in the Book of Jeremiah concerning the prophecies of the successive destructions of Egypt (which would be smitten by Babylon's King Nebuchadnezzar), the Philistines (whose cities, Tyre, Sidon, and Gaza, would be overrun by the Egyptians), Moab, Edom, the Ammonites, Damascus, Israel, and finally Babylon itself. Chapter 45 begins

> The word that Jeremiah the prophet spoke to Baruch the son of Neriah, when he wrote the words in a book at the dictation of Jeremiah, in the fourth year of Jehoiakim the son of Josiah, King of Judah: "Thus says the Lord, the God of Israel, to you, O Baruch: you said, 'Woe is me! for the Lord has added sorrow to my pain; I am weary with my groaning, and I find no rest.' Thus shall you say to him, thus says the Lord: Behold, what I have built I am breaking down, and what I have planted I am plucking up—that is, the whole land."

Washington Allston: *Belshazzar's Feast*. 1821. Oil on canvas. 12′⅛″ x 16′⅛″. The Detroit Institute of Arts, Michigan; Gift of the Allston Trust.

Allston's *Belshazzar's Feast* (1821), picturing the great columns of a supposedly ancient Mesopotamian palace, an awed king, courtiers,

musicians, and a majestic Prophet Daniel, took its literary source from the Book of Daniel, chapter 5, with its tale of the Babylonian king's great feast. As accounted there, the fingers of a man's hand miraculously appeared writing "on the plaster of the wall of the king's palace, opposite the lampstand" the words *MENE, MENE, TEKEL,* and *UPHARSIN* (shown in the painting as a blaze of light in the upper right-hand corner). Daniel interpreted the words: "Mene, God has numbered the days of your kingdom and brought it to an end; Tekel, you have been weighed in the balances and found wanting; Peres, your kingdom is divided and given to the Medes and Persians" (24–28). The huge canvas (approx. 12′ × 16′) was begun by Allston in 1818 and was worked on in Boston from 1820 to 1828, taken up again from 1839 to 1843, and then left uncompleted at his death, even though ten wealthy Bostonians had subscribed one thousand dollars each to buy the painting. Allston called *Belshazzar's Feast* "the tormentor of my life," and some historians have seen in his inability to finish it a symbol of the paralysis of the American artist in the first third of the nineteenth century who chose to deal with the imaginary. This is not entirely fair because Allston, in other of his works (smaller, to be sure), and a few other artists in theirs, did bring visionary paintings to a successful conclusion. And Allston was not so isolated as all that in his taste: *Belshazzar's Feast* reflected a widespread American interest in the cyclical processes of history marked by terrible cataclysms.

In visionary painting of the spectacular nowhere are such cyclical processes more bombastically visualized—and one might say more intelligibly, too, since it is easy to scan from painting to painting—than in Thomas Cole's (1801–1848) "The Course of Empire" series (1833–1836). The first in the progressional sequence, *The Savage State,* is a wild, almost desolate mountainscape (tepees can be seen in the distance) through which a wild white hunter with a bow chases a stag. The second, *The Arcadian or Pastoral State,* is a more benign mountainscape (the mountains are rounded rather than peaked) containing stately oaks in the foreground against one of which a bearded philosopher peacefully leans, and, in the middle ground, templed hills, where two friends greet one another. *The Consummation of Empire* is a kind of paean to the Greek Revival style in architecture, then coming into favor among the wealthy and fashionable, with tier upon tier of temples. This painting is pretty much a realization of Cole's rhetorical

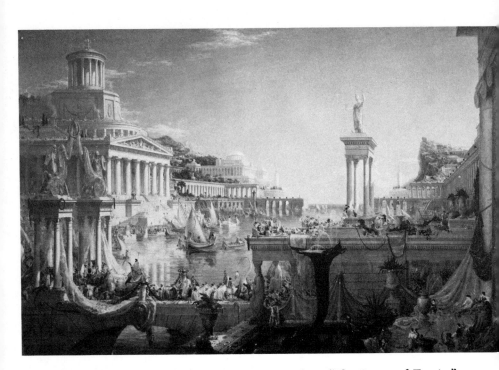

Thomas Cole: *The Consummation of Empire* from "The Course of Empire" series. 1836. Oil on canvas. 51" x 76". The New-York Historical Society, New York.

conception, as conveyed to his patron, Luman Reed (1787–1836), in a letter, September 18, 1833: "[The third state is to be] a noonday—and a great city girding the bay, gorgeous piles of architecture, bridges, aqueducts, temples—the port crowded with vessels—splendid processions, &c.—all that can be combined to show the fullness of prosperity."[23] In the *Destruction*, everything is being wrenched violently apart: The waters of the once tranquil harbor now churn before the Viking-like boats filled with invading warriors; one of the landing warriors assails a woman who is scampering up a great outdoor stairway, another carries a burning torch, as the populace, a frantic mob, tries chaotically to flee; in the right foreground, a headless statue of a

[23] Quoted in Louis Legrand Noble, *The Course of Empire, Voyage of Life, and Other Pictures of Thomas Cole* (Cambridge, Mass.: Harvard University Press, 1964, reissue of the 1853 edition), p. 130.

warrior lunging and brandishing a shield sets the tone for the debacle. This picture reminds me a little of the crashing climax of the last sentence of Edgar Allan Poe's (a visionary with words) "Fall of the House of Usher," which was to appear three years later: "While I gazed, this fissure rapidly widened—there came a fierce breath of the whirlwind—the entire orb of the satellite burst at once upon my sight—my brain reeled as I saw the mighty walls rushing asunder—there was a long tumultuous shouting sound like the voice of a thousand waters." In *Desolation*, the ships and the people are gone, and the once stately temples are ruins. The harbor is like a stagnant lake. In the foreground there is a great Corinthian column, isolated, supporting nothing; atop it a bird has made its nest. Cole saw the series as illustrating what history had taught him and explained to Reed that "the philosophy of my subject is drawn from the history of the past, wherein we see how nations have risen from the savage state to that of power and glory, and then fallen, and become extinct."[24]

Cole painted his "Course of Empire" series, and other elaborate allegorical reconstructions having to do with the passage of time, after his return from a stay abroad from 1829 to 1832. That trip changed the direction of his art. Previously he had produced stormy landscapes, from which figures were absent or in which they were only incidental to the effect of the whole (in spite of their thematic importance), as in the *Expulsion from the Garden of Eden* (c. 1827–1828), in the Boston Museum of Fine Arts. Returning to the land of his birth as a celebrated artist at only twenty-eight, Cole settled down first in London and visited John Constable (1776–1837) and John Martin (whose influence can be seen in *The Consummation of Empire* and the *Destruction*). Next he reached Paris in 1831, then stayed for a year and a half in Italy, where he found Raphael totally admirable. It was in Italy that the idea for the "Course of Empire" series first occurred to him.

Shortly after his return to America in November 1832, he settled in the village of Catskill, New York, because he found he could not stand the crowds and clamor of a city. From there he made frequent exploratory forays, which served also as sketching expeditions, into the still-unsettled countryside that he loved. Cole saw then, beyond ques-

[24] *Ibid.*, p. 129. Contemporary reviewers who saw the *Course of Empire* exhibited in New York in 1836 insisted that the portended doom was intended for the nations of the Old World, which had undergone a longer past than America. Edgar Allan Poe, *Tales of Terror and Fantasy* (New York: E. P. Dutton, 1973), p. 145.

tion, what he had suspected before his trip, that the most salient feature of the American landscape (as compared with the European) was its wildness. In civilized Europe, he pointed out, "the primitive features of scenery have long since been destroyed or modified—the extensive forests that once overshadowed a great part of it have been felled—rugged mountains have been smoothed, and impetuous rivers turned from their courses to accommodate the tastes and necessities of a dense population."[25] The American mountains still had their dense forests. Water was a characteristic feature of the landscape (which Cole knew). The lakes of New York—George, Champlain, Otsego, Seneca, and "a hundred others"—and those about the White Mountains of New Hampshire were unrippled, reflecting their surroundings in mirrored stillness. The New Hampshire lakes, especially about Franconia Notch, were for Cole unlike anything in Europe, "chosen places of tranquility." On the other hand, besides Niagara, "where the sublime and beautiful are bound together in an indissoluble chord," there were numerous other waterfalls. And so on. If the "Course of Empire" series can be seen to have some basis in the realities of history, *The Titan's Goblet* (1833), in The Metropolitan Museum of Art, New York, seems wholly phantasmagorical. But the painting derives from Cole's frequent rumination that most of America, physically, was unmarked by a European past. *The Titan's Goblet* is about a terrain (presumably referring to America) whose past is shrouded in myth, a terrain inhabited in some bygone era by a race of giants. The connection with the idea of catastrophism is there: At some point, presumably before history, the giants (suddenly and violently?) disappeared. At least one bit of evidence of their existence remains: an enormous goblet, now ossified and perched upon a mountain range. The present inhabitants have no idea what it is; they cannot really see it for its size. Unconcernedly they gather at its base and sail their boats upon the waters collected, now a lake, within it. Moreover, some scholars have held that there is the double image of the goblet's stem and a tree trunk, which can indeed be made out, and that Cole took the idea for the painting from a Norse legend dealing with a Tree of Life called

[25] Thomas Cole, "Essay on American Scenery," *American Monthly Magazine* (new ser.), 1 (1836): 1–12. Quoted in *American Art 1700–1960: Sources and Documents*, ed. John W. McCoubrey (Englewood Cliffs, N.J: Prentice-Hall, 1965), p. 102.

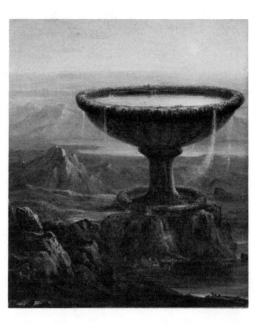

Thomas Cole: *The Titan's Goblet*. 1833. Oil on canvas. 19⅜″ x 16⅛″. The Metropolitan Museum of Art, New York; Gift of Samuel Avery, Jr., 1904.

Yggdrasil.[26] Such a source is, at best, questionable. No matter. In dovetailing in *The Titan's Goblet,* the images of a lake and a goblet filled with water and of a goblet stem and a tree trunk, Cole was the first American painter to use the device of the double image. He thus bridged the centuries between such early practitioners of the device as Hieronymus Bosch (c.1450–1516) and Giuseppe Arcimboldo (1527–1593), and a number of twentieth-century painters, including Salvador Dali (b.1904), Pavel Tchelitchew (1898–1957), and M. C. Escher (1898–1972).

In his other paintings where he intended to show the changes wrought by the passage of time, Cole recaptured neither the élan (which was there with all the rhetoric) of the "Course of Empire" series nor the surreality of *The Titan's Goblet.* There is the pair of paintings

[26] This notion is an early one, first appearing in the sales catalogue of the collection of John M. Falconer, which contained *The Titan's Goblet.* Its correctness seems to have been taken for granted by Howard S. Merritt. See Howard S. Merritt, *Thomas Cole,* catalogue (Rochester, N.Y.: Memorial Art Gallery, University of Rochester, 1969), p. 29.

of 1838 in Amherst College entitled *Past* and *Present*. In the former (reflecting consciousness of the start then taking place of the Gothic Revival style in architecture) is a movie-set-looking castle before which a tournament between two knights is being watched by a large crowd of nobles and peasants. In the latter, in the same place there is the same castle, now in ruins and grown over with weeds, and instead of the audience, there is a lone shepherd tending his flock. What intervened between the two scenes? Famine? War? Plague? A large-scale movement of people to a more strategic location? This is left to the viewer's imagination, who is led to the inescapable conclusion, most likely familiar before seeing the paintings, that things change with time, nothing lasts forever. Cole might have been moved to choose a medieval setting by a visit to New York City the previous year: Being erected in the southern part of Manhattan was the first American college based on a medieval design—New York University, which was designed by Ithiel

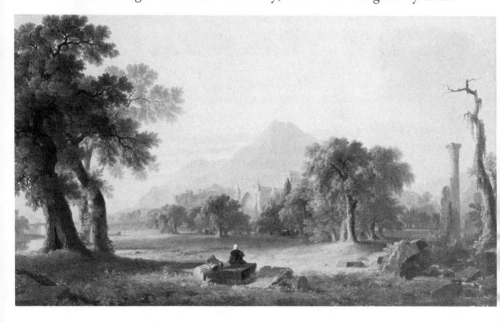

Asher B. Durand: *The Evening of Life.* 1840. Oil on canvas. 49½″ x 83¼″. National Academy of Design, New York. Photograph: Frick Art Reference Library, The Frick Collection, New York.

Town (1784–1844), Alexander Jackson Davis (1803–1892), James H. Dakin, and others. The *Past* and *Present* probably induced Asher B. Durand (1796–1886), Cole's friend and, like him, a leader of the so-called Hudson River school of landscape painting, to paint in 1840 a complementary pair, *The Morning of Life* and *The Evening of Life*. A young shepherd beside a Greek temple and two lovers conversing to the left at the foot of a tree represent the former; and an old shepherd with his back to us (presumably the same shepherd, now aged) beside a Gothic church and a broken column in the foreground, the latter. This was a solitary venture into allegory for Durand, whose landscapes are generally more faithful to the scene than Cole's, which are really amalgamations of several locales.

Cole could have seen the succession of civilizations materialized before him, in a sense, through the variety of architectural revivals being spewed forth. Ithiel Town, a leading architectural revivalist,[27] commissioned Cole's *Architect's Dream* (1840), then objected in a letter of May 1840 because instead of "an almost exclusively architectural subject of great size . . . I wish the landscape to predominate—the Architecture, history, etc. to be various and subservient or mainly to enrich a very bold and richly various landscape." Town was right to feel dissatisfaction, or at least discomfort: He must have seen in Cole's marvelous vision of style upon style pushed to the breaking point, Egyptian, Greek, Roman, Moorish, and Gothic—and bearing a close resemblance to actual buildings of the time, as Edmund Bacon has recently shown[28]—a slight to his own profession, which was not universally deserved. For all the shimmer of the various buildings, Cole has presented a nightmarish situation, more recognizable to us today, probably, than to the American of 1840, a situation of which Town, I think, was aware: an environment so crowded that there is little place in which to move, a country that has become like a machine too com-

[27] Later, in 1837, he collaborated with Alexander Jackson Davis, James H. Dakin, and others in executing one of the first medieval designs for an American college, that for New York University at Washington Square.

[28] Through photographic comparisons, Bacon has shown the closeness of the classical building in Cole's picture to Strickland's Bank of the United States in Philadelphia of 1818, and of the Gothic building to Upjohn's Trinity Church in New York of 1844–1846 (after the completion of the painting). See Edmund Bacon, "New World Cities: Architecture and Townscape," in *American Civilization*, ed. Daniel J. Boorstin (New York: McGraw-Hill Book Co., 1974), p. 204.

plexly overladen to work. No historian, so far as I know, has considered this meaning. But what could the title *Architect's Dream* signify other than a desirable situation for the architect, as Cole believed the architect saw it, namely, one illustrious commission after another until the horizon is obscured? Let us remember that in late 1832 or early 1833 Cole had settled in the village of Catskill to avoid the situation of this painting.

To reveal history's cataclysms, Cole used, in his "Course of Empire" series, fallen bodies, fleeing mobs, ruined buildings (which appeared also in the *Present*), and so on; and, implying these cataclysms, buildings in a variety of architectural styles in the *Architect's Dream*. The Irish-born James Hamilton (1819–1878) revealed them, on the other hand, through what were then the most modern means—by attempting to simulate through the choice of colors and the handling of paint the disintegrative process itself. For him, little vignettes, so important to Cole, came to have no interest. John I. H. Baur has called him a Roman-

James Hamilton: *Last Days of Pompeii*. 1864. Oil on canvas. 60⅛″ x 48⅛″. The Brooklyn Museum, New York; Dick S. Ramsay Fund.

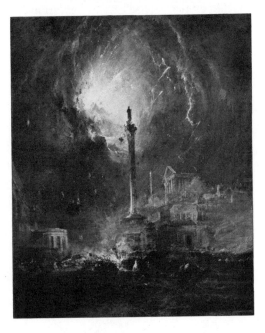

tic Impressionist.[29] While visiting England from 1854 to 1856, Hamilton studied the work of the English landscapists James Baker Pyne (1800–1870), Clarkson Stanfield (1793–1867), and especially Turner[30] (who had influenced Cole, in a different way, twenty years earlier in the "Course of Empire" series). Back in Philadelphia, he became widely known as "the American Turner," for now the waves and ships' sails of many of his marines were partially dissolved in light. His *Last Days of Pompeii* (1864), in The Brooklyn Museum, based on the Edward Bulwer-Lytton novel, is an explosion of light and color. The buildings, which can hardly be made out, are disintegrating before the burst of light in the upper part of the painting. Jagged yellow and orange streaks in the upper right are like bits of flying, burning debris. The bituminous blacks and browns at the bottom remind one of charred, smoldering wood. Filled with swirls and blotches of color

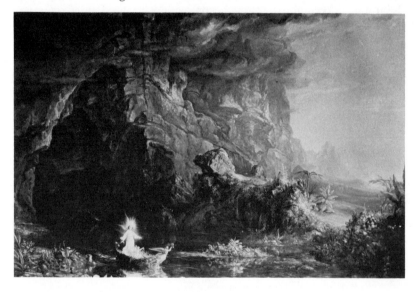

Thomas Cole: *Childhood* from "Voyage of Life" series. 1839. Oil on canvas. 52″ x 73″. Munson-Williams-Proctor Institute, Utica, New York; Purchase.

[29] John I. H. Baur, "A Romantic Impressionist: James Hamilton," *The Brooklyn Museum Bulletin* 12 no. 3 (Spring 1951): 1–9.
[30] Arlene Jacobowitz, *James Hamilton*, catalogue (New York: The Brooklyn Museum, 1966), pp. 22–26.

representing in large part nothing discernible, this nearly abstract painting (though done fourteen years after my chosen end point of 1850) was one of America's most effective visions of the spectacular.

Cole had used the catastrophic framework for the life of the nation or society in the "Course of Empire," and he readily adapted it for the life of the individual in his four-part "Voyage of Life" series, conceived in 1836 and executed in 1839–1840. Here Cole is simultaneously at his most pretentious and at his most insipid. The series has at its base some vague christological content through which the journey through life is teleologically traced. The symbolism is quite dense, with a cave standing for "the mysterious Past"; a stream of water for "the Stream of Life"; the turbulence or calmness of the stream and the state of the weather for the difficulty of life at various stages; and the ocean for the end of life or that "to which all life is tending." *Childhood* is full of promise: A laughing infant accompanied by his haloed guardian angel is in a boat smoothly issuing out of a cave into the rosy morning light. In his copious descriptions accompanying the exhibition of the paintings in 1840,[31] Cole observed that the Egyptian lotus found in the foreground among other luxuriant foliage "is symbolical of Human Life." In *Youth,* the cave is nowhere to be seen; the current moves a bit faster; the angel is now on the shore and waving the youth in the boat onward. The youth sees in the sky a Taj Mahal sort of cloud structure, "emblematic of the day-dreams of youth, its aspirations after glory and fame." In *Manhood,* the landscape is bare, the stream tempestuous, the weather stormy, and the guardian angel sits afar off in the clouds. The voyager, now cast adrift, standing shakily in his boat, clasps his hands in prayer. To really enjoy the flavor of these histrionics, we should read something of Cole's descriptions. Here, in part, is what he wrote of *Manhood:*

> Trouble is characteristic of the period of Manhood. In Childhood there is no cankering care; in Youth no despairing thought. It is only when experience has taught us the realities of the world, that we lift from our eyes the golden veil of early life: that we feel deep and abiding sorrow; and in the picture, the gloomy, eclipse-like tone, the conflicting elements, the trees riven by tempest, are in the allegory; and the Ocean, dimly seen, figures the end of life, to which the voyager is now approaching. The demon forms are Suicide, Intemperance, and Murder,

[31] When the series was exhibited at the American Art Union Memorial, New York, in 1848, the descriptions Cole had proposed to accompany the paintings were included in the catalogue.

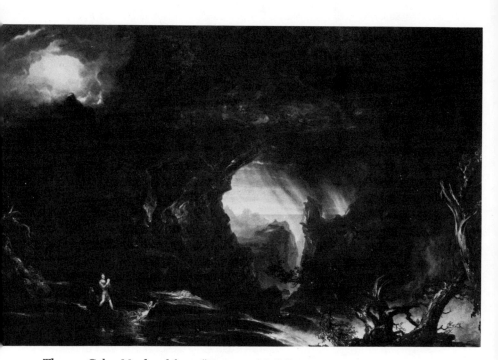

Thomas Cole: *Manhood* from "Voyage of Life" series. 1840. Oil on canvas. 52" x 78". Munson-Williams-Proctor Institute, Utica, New York; Purchase.

which are the temptations that beset men in their direst trouble. The upward and imploring look of the voyager, shows his dependence on a Superior Power, and that faith saves him from the destruction that seems inevitable.

Finally, in *Old Age,* the "midnight Ocean" has been reached. There are no clear boundaries now, only the dim outlines of a distant shore. A light gleams through an opening in the heavy clouds, and it is at this that the voyager, now an old man accompanied by the returned guardian angel, gazes in rapture. "The chains of corporeal existence are falling away," explained Cole in his descriptions, "and already the mind has glimpses of Immortal Life."

Cole considered his allegorical series to be the most significant aspect of his work. Most critics and practically all the public at large who knew the range of what he had done preferred the pure landscapes (and, on the whole, they were right). Cole, feeling himself

rebuked, returned to Europe in 1841, where, in Rome, he worked on a second version of the "Voyage of Life" series and on a series titled "The Cross and the World," which he never completed. Back in America the next year, he sank even deeper into his mountain isolation. As his health worsened, he grew depressed and felt that he had been "forgotten by the great world, if ever I was known!"[32]

The ideal figure with whom to cap off this account of the beginnings of visionary painting and its persistent concerns with catastrophism is Edward Hicks (1780–1849), who was more famous in his own day as a Quaker preacher than as an artist. If Cole, especially in the "Course of Empire" series, was drawn to the dialectical or cataclysmic stages of the process in the rise and fall of a society, then Hicks was fascinated by the possibility of the end point of that process. Between about 1825 and 1849 he is supposed to have painted nearly one hundred versions of the *Peaceable Kingdom,* of which at least forty exist today. These pictures of quaint animals, domestic and fierce, cohabiting are based on the wonderful vision of the Old Testament Prophet Isaiah: "The wolf also shall dwell with the lamb, and the leopard shall lie down with the kid; and the calf and the young lion and the fatling together; and a little child shall lead them./And the cow and the bear shall feed; their young ones shall lie down together; and the lion shall eat straw like the ox" (11:6–7). This vision, for Hicks, was the paradigm of the perfect society, in which normally warring factions would be able to get along. And this perfect society, hopefully, was to take root in America—the Delaware River is recognizable in several of the *Kingdoms*—and was to draw its inspiration from a just society that had been founded in 1682 near Hicks's own home in Newtown, Pennsylvania, when another Quaker, William Penn, had made his "treaty" with the Indians. Hicks commonly inserted a vignette of this in the background of the *Kingdoms* and recast Isaiah's prophecy in a most charming way to pay homage to it:

> The wolf with the lambkin dwells in peace
> > his grim carnivorous thirst for blood will cease;
> The beauteous leopard with his restless eye,
> > shall by the kid in perfect stillness lie;
>
> The calf, the fatling and young lion wild,
> > shall all be led by one sweet little child;

[32] Quoted in James Thomas Flexner, *That Wilder Image* (New York: Dover Publications, 1970), p. 50.

The cow and the bear shall quietly partake
 of the rich food the ear and corn stalk make;

While each their peaceful young with joy survey
 as side by side on the green grass they lay;
While the old lion thwarting nature's law
 shall eat beside the ox the barley straw.

The illustrious Penn this heavenly kingdom felt
 Then with Columbia's native sons he dealt,
Without an oath a lasting treating made
 In Christian faith beneath the elm tree's shade.

Sometimes a few lines of these verses would be painted on the four sides of the frame; in Yale's *Peaceable Kingdom of the Branch* (1825–1830), Hicks quoted from the original Isaiah passages. This lettering was not too difficult for one who had been trained as a sign painter.[33] Something of the sign painter's art is evident in the rendering of the animals, which look like the wooden figures on the sides of houses or barns or those making up parts of weather vanes.

Although, as a Quaker, Hicks was insulated from the larger society, the broader backdrop of his *Kingdoms* existed beyond his immediate world. To what extent he was aware of the actual attempts being made to establish utopian groups is not known, but I don't think it too far-fetched to surmise that some inkling of their existence penetrated the consciousness of the Quaker community. It is certainly undeniable that a rash of energy was devoted to them in the second quarter of the nineteenth century, the very period when Hicks was painting his *Kingdoms*. America then believed steadfastly in the plasticity of human nature. In the late 1830s and 1840s more than thirty communities basing themselves on the teachings of the French socialist François Marie Charles Fourier (1772–1837) were established.[34] The Fourierites desired social organizations where men's fundamental passions (usually stifled) could be channeled to the good of all. Labor would regain

[33] Hicks was painting street signs in 1805, and more elaborate ones, such as tavern signs and those on coaches, by 1811, for which he received from $10 to $25 for a complete job, with insignia or picture and lettering. Hicks became widely known for his sign painting. See Alice Ford, *Edward Hicks: Painter of the Peaceable Kingdom* (Philadelphia: University of Pennsylvania Press, 1952), pp. 21, 28, 60–61, 82–83, 92, 97, 107.

[34] For my familiarity with America's nineteenth-century utopian communities I am indebted to Prof. Arthur M. Schlesinger, Jr., whose course in American intellectual history I took in 1956 as an undergraduate at Harvard.

its lost dignity, as every man would be assigned the task that he desired and to which he was best suited. Populations were strictly governed: The standard unit was the phalanx, consisting of 1,620 persons.[35] Injustice would be removed; no longer would there be the oppression of one class by another. The most famous of the Fourierite communities was Brook Farm, near Boston, which had originally been founded by a group of New England Transcendentalists and other intellectuals. Ultimately the Fourierites envisioned a society at large governed by their principles and blessed by illimitable brotherhood. Somewhat earlier the English socialist and philanthropist Robert Owen (1771–1858), in 1824, had founded a community based on his ideals at New Harmony, Indiana. An ardent champion of the more equitable distribution of society's wealth, he advocated common kitchens and nurseries, and buildings arranged in the form of parallelograms. New Harmony led to a dozen similar ventures.[36] Hicks's *Kingdoms,* of course, had nothing to do with the teachings of Fourier or Owens, but he shared with them their dreams of brotherhood and peace.

Nonetheless, the mere presence of various ideal communities through parts of the eastern and what was then the central United States cannot explain Hicks's persistence with his theme of the Peaceable Kingdom. Even the peace-loving attitude of the Quakers, although a contributing factor, cannot provide the full explanation. Nowhere else in the history of the spectacular, indeed in all of American visionary painting, is the same subject painted one hundred times. No. The main explanation for Hicks's obsession with the subject must lie with Hicks himself. He was a man distraught, overwhelmed by his sense of guilt and unworthiness, a man, in short, who sought his own "peaceable kingdom." Left motherless at the age of one when his mother died on October 19, 1781, the day of the British surrender at Yorktown, he was taken into the protective household of the Quaker

[35] Fourier had the naïve notion that people would always be found who would do the repugnant work gladly. Like other utopian thinkers, Fourier underestimated the lure of the new economic expansiveness, and his dream of the total reorganization of American society never came close to realization. The longest surviving of the Fourierite communities was the North American Phalanx, situated on 673 acres. One of the reasons for the eventual failure of the phalanx was that the members were not united by any sort of all-consuming faith, scriptural or otherwise.

[36] New Harmony itself failed after only two years. People paid more attention to Owens's antireligious views than to his programs for the rationalizing of current social organization. Along with a number of high-minded intellectuals, New Harmony attracted indolents and hangers-on.

David Twining. While growing up, Hicks equated evil with any sort of frivolity and pleasure, even of the most innocent kind. He kept remonstrating with himself that he did not keep sufficient check on his instincts, that he gave himself up to abandon. On one occasion he was aghast that he found himself in a large group dance, and ran headlong out of the house to get away.[37] At the age of twenty he joined the Society of Friends and married. Around this time he declared a new serious intent following a narrow escape from death.[38] In 1819 he was told to travel by, he believed, the "Heavenly Shepherd," who out of beneficence wished to rescue his health, which was being destroyed by the grind of work. Thus summoned, Hicks undertook a three-thousand-mile journey on horseback through New York State and parts of Canada.[39] In his subsequent sermons, such as that preached in 1837 in Loudoun County, Virginia, he urged that the congregation reign over their baser instincts, just as the Apostle Paul, through the grace of God, had overcome his own choleric constitution.[40] As for himself, Hicks believed that he was an insignificant sinner. "I have nothing to depend on," he wrote in his memoirs in the last year of his life, "but the mercy and forgiveness of God, for I have no work of righteousness of my own. I am nothing but a poor old worthless insignificant painter."[41] His *Residence of David Twining, 1787* (1845–1848), in the Abby Aldrich Rockefeller Folk Art Center, painted a few years earlier, is a nostalgic re-creation of a yearned-for peaceful childhood: In the foreground, before a comfortable farmstead, seven-year-old Edward Hicks stands at the knees of his foster mother, Elizabeth Twining, upon

[37] Ford, *Edward Hicks,* p. 17.

[38] A few months before he turned twenty-one, he took ill while riding from Philadelphia to Bucks County in a snowstorm. When restored to health by a Dr. Fenton, "he was so overwhelmed with 'pain and remorse' that his 'appearance changed from a sanguine to a melancholy cast' which was never to leave him." As a result of his illness, Hicks became even more serious, humble, and inward than before. *Ibid.*, pp. 16–17.

[39] The trip led by way of York, Canada, through Niagara (Niagara Falls appears in some of the paintings), then through Troy, Cooperstown, Newburgh, and across southwestern New York and northeastern New Jersey and back to Newtown. *Ibid.*, pp. 32–37.

[40] The sermon, held at the Goose Creek Meeting House, was published by Hicks nine years later, in 1846, under the title "A Little Present for Friends and Friendly People in the Form of a Miscellaneous Discourse by a Poor Illiterate Mechanic."

[41] Edward Hicks, *Memoirs of the Life and Religious Labors of Edward Hicks, Late of Newtown, Bucks County, Pennsylvania, Written by Himself* (Philadelphia, 1851).

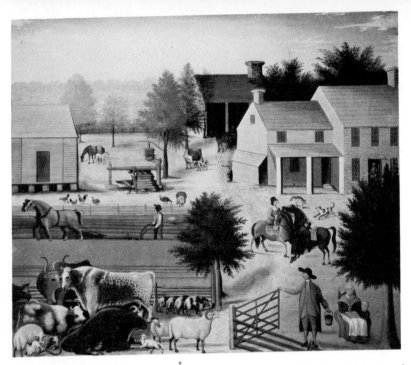

Edward Hicks: *The Residence of David Twining, 1787.* 1845–1848. Oil on canvas. 27″ x 32″. Abby Aldrich Rockefeller Folk Art Center, Williamsburg, Virginia.

whose lap a Bible lies open. He described her in his memoirs as "just such a woman as is described in the last chapter of Proverbs. . . . How often have I stood, or sat by her, before I could read myself, and heard her read, particularly the 26th chapter of Matthew."[42]

The compositions of some of Hicks's Kingdoms were derived from paintings of Richard Westall (1765–1836), which were commonly found as engravings in contemporary Bibles. In one of these, the early *The Peaceable Kingdom of the Branch,* at Yale, the child holds in his right hand the branch, which signifies the line of descent coming out of David and leading to the Messiah or Christ, as it was believed to have been foretold in Isaiah 11. Included is a tiny vignette of Penn's "treaty" with the Indians, placed below Virginia's Natural Bridge. The somewhat later Kingdoms reflected the schism of 1827, which rent the Quaker community; this had been brought on when the followers of

[42] *Ibid.*

Elias Hicks (1748–1830), Edward Hicks's cousin, withdrew and founded a Yearly Meeting of their own, apart from the Orthodox. Edward Hicks followed his cousin's group, who believed that the "Inner Light," rather than belief in the Bible and the sacrificial death of Jesus, was the real source of salvation.[43] In *The Peaceable Kingdom with Quakers Bearing Banners* (c.1832), also at Yale, the figure with the handkerchief in the forefront of the pyramid of Quakers is Elias.[44] At the apex of the pyramid stand three great early Quakers—George Fox, the English founder of the Society of Friends and the formulator

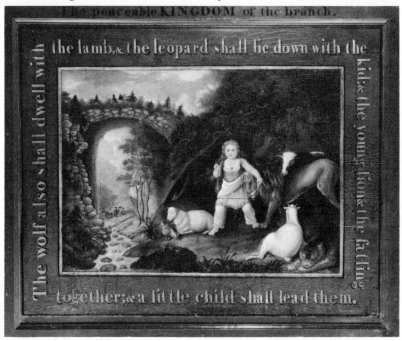

Edward Hicks: *The Peaceable Kingdom of the Branch*. 1825–1830. Oil on wood. 36¼" x 44⅞". Yale University Art Gallery, New Haven, Connecticut; Gift of Robert W. Carle.

[43] For an argument rejecting the importance of Christ's Crucifixion for the seeker after salvation, see Elias Hicks, "A Doctrinal Epistle Addressed to W−B−I−, First Month 15, 1820" (Philadelphia, 1824).

[44] Frederick Tolles was the first to identify the figure from a silhouette of Elias that was circulated in 1830. See Eleanore Price Mather, "A Quaker Icon: The Inner Kingdom of Edward Hicks," *Art Quarterly* 36 (Spring–Summer 1973): 88.

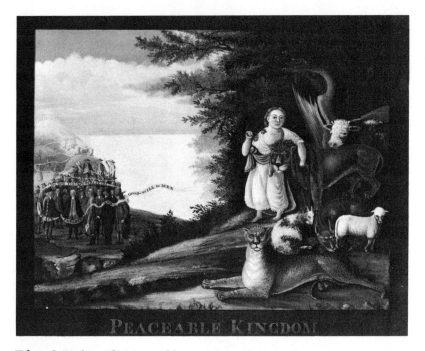

Edward Hicks: *The Peaceable Kingdom with Quakers Bearing Banners.* c. 1832. Oil on canvas. 17½" x 23½". Yale University Art Gallery, New Haven, Connecticut; Bequest of Robert W. Carle, B.A., 1897.

of the doctrine of the "Inner Light"; William Penn with his arms out-stretched; and Robert Barclay, who had explained the meaning of the term *Quakers* as being synonymous with "tremblers."[45] Standing on top of the mountain behind the Quakers are the Apostles, shining radiantly in the clouds. From the mid-1830s, Hicks used the Kingdoms to portray psychological archetypes. There is a concentration on the animals' humanlike faces, which reveal a variety of temperaments and dispositions. New animals, such as the leopard and the bear, appear.[46]

[45] "There will be such a painful travail found in the soul, that will even work upon the outward man, so that often-times, through the working thereof, the body will be greatly shaken, . . . And from this the name Quakers, i.e. Tremblers, was first reproachfully cast upon us." Robert Barclay, *An Apology for the True Christian Divinity,* proposition 11, section 8 (London, 1765), pp. 358–359.

[46] The earliest Kingdoms drew the animals only from verse 6 of Isaiah's prophecy, whereas the later ones draw from verses 7 and 8 as well.

Instead of bearing the symbolic branch, the child now, as an act of reconciliation, attempts to yoke together animals that would normally be hostile. In the *Peaceable Kingdom* (1844) in the Abby Aldrich Rockefeller Folk Art Center, they are the young lion, the calf, and the fatling.

Hicks's animals look like dolls, or, at times, like pictures cut out of signs. Because the lines describing them are so sharply etched and there is little modeling, because there is improper geometric perspective and hardly any atmospheric perspective, and because the approach seems so direct and unsophisticated, he is commonly called a primitive painter. So, too, are Erastus Salisbury Field and, more recently, "Grandma" Moses. Moreover, the idea of lions, leopards, and other animals running about wild in the Pennsylvania or New York or New Jersey countryside is utterly bizarre. So Hicks's art, no less than that of other painters of this book, can be classified as visionary. But like works of West, Allston, Cole, Durand, and Hamilton, Hicks's art, in spite of its "primitivism," deals with large, cosmic ideas presented spectacularly. With them it was the birth and death of cities, nations, civilizations, even humanity (West's *Death on the Pale Horse*). With him, it is the eventual peaceful coexistence of all peoples. Hicks's belonging to a special community within America should not keep us from seeing what his art had in common with the other visionaries of the spectacular during the first half of the nineteenth century. There is something instantly appealing, or at least intelligible and innocent, about the conviction that history follows orderly and predictable patterns. The orderly catastrophic view of history was rarely presented in painting after the secession of the South and the terrible debacle of the Civil War.

2
The Visionary Eccentrics

The other twelve painters of this book before my last framing chapter—Quidor, Page, Rimmer, Ryder, Blakelock, Vedder, Field, Newman, Fuller, Dewing, Inness, and La Farge—I call the *visionary eccentrics*, and I do this for two reasons. First, their work, coming wholly or in part after that of the visionaries of the spectacular, or after 1850, is more eccentric for its time, no longer flowing out of the large reservoir of international romanticism nor accommodating itself to the widespread interest in cataclysmic themes. Their work interrelates less in theme; and each artist, I find, draws more out of himself than previously. Quidor's career straddles 1850, and the course it takes is particularly illuminating because his early work like the constantly illustrated *Money Diggers* (1832) is mawkish and farcical beside, say, the foreboding "Tom Walker" paintings (c.1856). All that will be the concern of the next three chapters. Second, and this is the concern of this chapter, most of these artists personally were either eccentrics in action or thought or isolates, to some extent.

When I began this study, I asked myself whether these painters of dreamlike scenes would exhibit any special traits of personality or at least would prove to be unworldly and ill-adjusted for their time. I wondered further whether there would be a gradient of eccentricity. Some of these painters, Page, La Farge, Dewing, and Field, were not consistently visionary, whereas Inness was a visionary for roughly the last fifth of a fifty-year career. Dewing, Newman, and Fuller were not

as blatantly visionary as, say, Rimmer or Ryder: Would I find their behavior correspondingly less bizarre? What I discovered, from the first, unfortunately, was that, except for Vedder, there is nothing like a diary or autobiography left by them, and, except for Vedder, Inness, and Page, no extensive collection of letters or anything that can be considered a substantial revelation, in words, of the inner man. All that can be relied upon for most of them, except for some scattered remarks, are the opinions and observations of others. For Fuller, Newman, Dewing, Field, and Quidor, there is not much even of that. In general, we don't really get to know these men well; they remain out of reach, tantalizingly so. Yet, in spite of all this, something of a picture of their outward behavior does emerge.

Kahlil Gibran's account of the elderly Albert Pinkham Ryder (1847–1917) in 1915 as a sort of mystic seer has already been cited. Such a reaction can be attributed partially to Ryder's nearly total withdrawal toward the end of his life, partially to his unkempt, shaggy appearance and nearly crippled condition then (Gilbran recalled: "He takes steps about two inches long. . . . He is sixty to sixty-four and seems eighty to ninety."[1]), and in large part to Gibran's propensity to find mystics regularly. But Ryder never had been a run-of-the-mill Middle American person of the late nineteenth-century variety. Though he did like company—through the 1880s and into the 1890s he would regularly entertain his friends at Sunday night dinners—he always lived alone, in poverty (even while his paintings were selling), and in extraordinary slovenliness and had no concern for practical affairs. One of his closest friends was the sea captain John Robinson (we need to remember that Ryder grew up in New Bedford, Massachusetts, when that city prospered from the height of the whaling industry), who had known him since 1883, two years after he gave up his dependence on his family and set up his studio in the Benedick Building on Washington Square East, until his death in 1917. Robinson was struck by Ryder's unceasing generosity and concern for others. He recalled that Ryder would share his money with tramps. Ryder also felt profound sympathy for living beings in distress, as was evident when he crossed the Atlantic in 1887 on Robinson's boat. When gulls became entangled in the lines of the kites Robinson's two nephews were flying, Ryder, after freeing the birds, vented his anger on the boys and kept

[1] Jean Gibran and Kahlil Gibran, *Kahlil Gibran: His Life and World* (Boston: New York Graphics Society, 1974), p. 282.

them from flying kites anywhere on the ship during the entire voyage. (Could this incident be connected with the undated *Dead Bird* in the Phillips Collection, Washington, D.C.?) Once, when a maid cleaning the apartments in the Benedick badly smudged the face of Mary Magdalen in one of his paintings, he was more concerned with the woman's unhappiness than with the damage caused. As for himself, Ryder required few physical comforts. He seems to have had little fear of physical harm, for he would prowl about the dangerous Wall Street area at night in spite of many warnings. "I don't think these people are as bad as they are made out to be," he said. He sought the company of children, who felt comfortable with him as well: Robinson recounted that on visits he would leave the adults, hardly saying a word to them, and play with the children on the floor.[2]

Ryder was little concerned with his appearance and with the state of his clothing. The part-time painter William H. Hyde (1858–1943), who met him first in 1873, two or three years after his arrival in New York when he was living with his father, Alexander, at 348 West Thirty-fifth Street, described him as "one of the most simple men I have ever known . . . a dreamer, and quite impractical . . . ," and observed that "his clothes were always just clothes and in no sense adornments." Hyde added that Ryder came to art classes smelling from the stables.[3] Forty years later, in 1913, Walt Kuhn (1880–1949) escorted him as a famous painter about the Armory Show, yet Ryder appeared as "a poor old fellow with rheumy eyes, dirty, and grimy, wearing highly polished black shoes."[4] Anyone visiting Ryder was amazed at the condition of his lodgings. Robinson found that in his Benedick apartment all the chairs were piled up with all sorts of rubbish. In 1891 or so, after his stay at the Benedick, Ryder moved to the hotel of his brother, William, the Albert, on West Eleventh Street, and then to 308 West Fifteenth Street. Here matters got even worse. Now there was only a single winding path through the rubbish, leading from the door to his easel and from there to his bath, which was full of discarded clothes. On the

[2] John Robinson, "Personal Reminiscences of Albert Pinkham Ryder," *Art in America* 13 (June 1925): 176, 179–187.
[3] William H. Hyde, "Albert Ryder as I Knew Him," *The Arts* 16 (May 1930); 596–599.
[4] One of a number of reminiscences of American painters who first met Ryder around the time of the Armory Show. Quoted in Aline B. Louchheim, "Ryder Seen by Marsden Hartley, Walt Kuhn, Yasuo Kuniyoshi, Reginald Marsh, Kenneth Hayes Miller," *Art News* 46 (November 1947): 28–31.

Albert Pinkham Ryder: *Self-Portrait*. c. 1883. Oil on canvas. 6″ x 4½″. Fleischman Collection, New York. Photograph: Kennedy Galleries, New York.

Washington Allston: *Self-Portrait*. 1805. Oil on canvas. 31¹¹⁄₁₆″ x 26⁷⁄₁₆″. Museum of Fine Arts, Boston; Bequest of Miss Alice Hooper.

left side of the room, among the boxes, was a pile of broken furniture. On the couch stood a keg of coal, so that he wouldn't have to walk far for fuel. The wallpaper fell in strips like waving flags, and the plaster was falling out of the wall.[5] Ryder stayed at West Fifteenth Street for about fifteen years, and there is no evidence that he ever complained or tried to move. He declared that "the artist needs but a roof, a crust of bread and his easel, and all the rest God gives him in abuandance."[6]

Is it even necessary to add that Ryder was a man who lived within himself, who drew sustenance from himself, a dreamer? A comparison between his *Self-Portrait* in the Fleischman Collection, New York, dating, from the apparent age of the sitter, from about 1883, when Ryder was around thirty-five, and that of Washington Allston, painted in 1805, when he was twenty-six, is instructive. Ryder's eyes look out at the viewer unseeing; rather, it would be better to say they see out but look inward. The somewhat younger Allston is conscious of his well-bred good looks and tousled hair; he looks coolly out at the viewer, and in his eyes there is something of both daring and disdain.

This is as good a place as any, I think, right after Ryder, to provide some information about the little known Robert Loftin Newman (1827–1912). Like Ryder, Newman never married. He and Ryder lived at the same time at the Benedick—Newman roughly from 1882 to 1892 —as did other bachelor artists; and they had several friends (Wyatt Eaton, Francis Lathrop, William Morris Hunt, John La Farge, Albert Groll) and patrons (John Gellatly, Thomas B. Clarke [1843–1911], William T. Evans, Sir William Van Horne, William Macbeth) in common. They even worked together on a triptych of a seascape, painted on the wood of a cigar box.[7] And Newman, in his way, was as impracti-

[5] F. Newlin Price, "Albert Pinkham Ryder," *International Studio* 81 (July 1925): 282–288.

[6] Quoted in Lloyd Goodrich, *Albert P. Ryder* (New York: George Braziller, 1959), p. 26.

[7] Boime and Landgren agree that Newman and Ryder lived at the Benedick at the same time but differ about precisely when. Boime, without citing evidence, writes that Newman "had been there since the late seventies, probably moved after returning from a trip abroad in 1882." Albert Boime, "Newman, Ryder, Couture, and Hero-Worship in Art History," *American Art Journal* 3 (Fall 1971): 13. Landgren asserts the opposite, namely that Newman moved there *after* his European trip of 1882, and cites as evidence a letter from a man who had rooms adjoining Newman's. Marshal E. Landgren, *Robert Loftin Newman 1827–1912* (Washington, D.C.: Smithsonian Institution Press, 1974), p. 62 and n. 70 on p. 114. A picture of the cigar-box triptych of 1898 can be found on p. 71. It is in the collection of Mr. and Mrs. David Orr of New York.

cal and unworldly as Ryder. The editor Samuel A. Chapin described him as "a very old man [he was then only sixty], as irresponsible as a child in all practical matters, but with an appealing sensitive poet's face that awakened all one's better nature and sympathies."[8] Through the 1880s and 1890s he was given financial support and care by such friends as the painter Wyatt Eaton (1849–1896) and Nestor Sanborn. This from Sanborn two years after Newman's death: "In late years this job [care and support] fell into the hands of Mrs. Sanborn and myself and my wife made two exhibits for him realising several hundred dollars, but instead of conserving his little capital he would be off to Europe with high imagination only to write us that he was strapped and must be brought back again."[9] But, unlike Ryder, he was, wrote Sanborn, "an immaculately clean man."

Newman, in everything but friends and talent, was an ill-adjusted failure, or at least not a success (for he ventured little), who was always on the move, from America to Europe, and then, after the Civil War, from one place in New York City to another. It is not farfetched to surmise that as a displaced Southerner he was haunted by the travail of the Civil War, which he suffered at first hand. Twenty years Ryder's senior, he was born in Richmond, Virginia, and for five months in 1850 studied in the Paris atelier of Thomas Couture (1815–1879), newly famous for his *Romans of the Decadence* (1847). He returned four years later, and was introduced to Jean François Millet (1814–1875) by his friend William Morris Hunt (1824–1879). Then, from 1854 until 1864, when he was conscripted into the Confederate Army at thirty-seven, he lived with his mother in Clarksville, in northwestern Tennessee. He had made a little money painting portraits and even offered to give drawing lessons without remuneration. Once in the army, he tried desperately to stay out of combat: He wrote Jefferson Davis twice to be appointed as a military painter, then sent the secretary of war a letter from his doctor advising that he was incapacitated for military duty. Finally on January 17, 1865, he was made part of the Army of Northern Virginia under Lee, when the war was almost over. Next he spent a year in Baltimore, where he painted political banners, and was in Nashville in 1872–1873, where he failed in his attempt to establish an academy of fine arts.

In New York, sometime in the mid-1870s, he worked for a while

[8] Landgren, *Newman*, p. 49. As Landgren observes, Chapin was then only twenty-eight, so Newman might have appeared older to him.
[9] *Ibid.*, pp. 58–59.

for a stained-glass designer but couldn't keep at it. Fortunately for him, a painter more than twenty years his junior, Wyatt Eaton, befriended him and cared for him until his (Eaton's) death, in 1896; whereupon the sculptor Daniel Chester French (1850–1931) and a few other patrons supported him in exchange for a set contribution of several paintings each year. Somehow Newman managed several trips to Europe, including one in 1882 (when Ryder and J. Alden Weir also went, but not with him) and another in 1908, when at eighty-one he was set up in a small house outside Paris by one of French's students. He was described by his host's wife as "spoiled, demanding, and very hard to live with." Once, probably in the 1890s, he was sent to a "home" in Yonkers, "but he stayed there only one night and went back happily to his own ways."[10] In 1900 Newman moved to 250 West Fourteenth Street, and in 1906 to a studio at 19 East Twenty-third Street, which Sanborn described "as bare of properties as a barn."[11] After his return from his last trip abroad, in 1909, he moved to a rooming house at 243 President Street in Brooklyn, and from there, on March 30, 1912, "carrying little . . . in the way of baggage—a few old picture frames, a straw valise, a shawl strap and six paintings,"[12] he moved to 206 East Eighteenth Street in Manhattan. He was found there the next morning dead by asphyxiation from gas escaping from a heater.

Ralph Albert Blakelock (1847–1919), whose pictures were sometimes confused in the critical literature with those of Ryder, did not live alone. Hardly! His being saddled with the support of a wife and eight children (another died in infancy) and being therefore always desperately in need of funds brought on a breakdown in 1891, which was triggered off by an argument with a collector over prices. The Blakelocks lived at the poverty level: Sometimes they were forced to move—from Harlem to Brooklyn—because of arrears in the rent. Blakelock painted his wife as a haggard, piteously worrisome woman. His own excesses undoubtedly must have contributed to his difficulties. For example, he would dress in sashes and long strings of beads and trinkets and carried an old dagger[13]—most likely as reminiscences of his Western journey.

[10] *Ibid.*, p. 58.
[11] *Ibid.*, p. 59.
[12] Obituary, *New York Sun*, April 1, 1912.
[13] Letter from Mrs. Ralph A. Blakelock to Robert C. Vose. Quoted in Lloyd Goodrich, *Ralph Albert Blakelock Centenary Exhibition*, catalogue (New York:

Ralph Blakelock: *Portrait of Mrs. Blakelock.* c. 1876. Oil on canvas. 20¼″ x 16¼″. M. H. de Young Memorial Museum, The Fine Arts Museums of San Francisco, California; Gift of Mrs. T. Edward Hanley.

His father, Dr. Ralph Blakelock, had been a competent home-opathic physician who was said to have had a "reputation for eccen-

Whitney Museum of American Art, 1947) p. 31.

tricity." Our Ralph Blakelock (the twelfth to bear the name) was born the same year as Ryder, with whose work his was linked and, at times, confused,[14] and was described, as a young man, as being "of a nervous temperament and very imaginative."[15] Physically he was of extremely slight build. His father encouraged him to study medicine, but he could not take the discipline involved. In September 1864, he entered the Free Academy of the City of New York (now City College), started off very well, ranking in the top fifth of his class, then dropped off in his studies, and left in February 1866 (he would have been graduated in 1869). In 1869, when he was twenty-two, Blakelock embarked on an adventurous three-year journey to California, crossing Kansas, Colorado, Wyoming, Utah, and Nevada. He kept an itinerary and made hundreds of drawings, some of which indicate that he also reached Mexico, Panama, and Jamaica (he would have had to have crossed the Isthmus of Panama by boat). The great event that took place at the beginning of the journey in May 1869 was the "wedding of the rails," the driving of the golden spike at Utah's Promontory Point to link together the rails of the Union Pacific leading from Omaha and those of the Central Pacific leading from San Francisco. Settlements were then few and far between through the Great Plains and the Pacific Coast. Even so, Blakelock avoided the small railroad towns to spend a lot of his time among Indians.[16] For all the wondrousness of it, this was the behavior of a man who had been a misfit back home in the East. Blakelock's journey was the fermenting influence on his subsequent art. He internalized its memories. It haunted him always.

Back in New York, Blakelock, as mentioned, suffered poverty. His best friend, the painter Harry W. Watrous (1857–1940) practically supported him for a while. The breakdown in 1891 was followed by others, culminating in an especially severe one in 1899, brought on, again, by the matter of money: A collector warned him that if he would not accept the offered price, less would be offered the next time. Shortly after that, on September 12, 1899, he was taken to the Long Island Hospital

[14] One critic wrote of "Mr. Rider [*sic*] and his pupil Blakelock," with Blakelock being "a gentleman whose 'raison d'être' is to give Mr. Rider the importance of being a 'school.' The school in this case is Blakelock." *Art Amateur* (April 1870): 90. Quoted in Goodrich, *Blakelock*, p. 23.

[15] *Ibid.*, p. 9.

[16] J. W. Young, *Catalogue of the Works of R. A. Blakelock and Marian Blakelock* (Chicago: 1916).

at Kings Park, then was transferred to the Middletown State Hospital for the Insane at Middletown, New York, where he remained almost continuously until his death, in 1919. In a letter of 1908, his wife recalled with a feeling of powerlessness, in a melancholy and resigned tone: "For a long time I thought that he was merely worrying because he was so unfortunate. No one would buy his pictures and he was very downcast. I thought if fortune would only favor us he would be himself again, but at last we were obliged to have him taken away. . . . Still as he was, as I thought harmless, and as he always retained his love for me and the children, I didn't like the idea of having him taken away."[17] Apparently the dagger Blakelock carried about frightened people. While confined, his only persistent and recurrent delusion was that he was extremely wealthy. Other than that, he was reported to be quite sane. He would paint tiny landscapes on paper of the size, shape, and color of paper currency, and he inscribed these with enormous sums—as high as one million dollars.[18] He continued to paint on whatever was available, paper, cardboard, even window shades. Physically, he remained well enough (though the weight of this small man remained between seventy-six and ninety pounds). One day in 1916 he was allowed to come to New York City to attend an exhibition of his work. That day he recalled vividly his experiences in the Rockies. He visited Grand Central Terminal and The Metropolitan Museum of Art, where he identified many paintings; then stopped off at the Woolworth Building, where he happily rode the elevator up and down. He was released on September 5, 1916. For part of 1918 he lived in a private sanitarium in New Jersey, then returned to Middletown. In July 1919 he was released again, this time under the care of a Mrs. Adams, who looked after him in the Adirondacks, near Elizabethtown; and it was there that he died the next month.

I cannot think of a more ironic figure than Blakelock in all the annals of American art. Shortly after his confinement, the prices paid for his work rose—and rose and rose—until in 1904, five years after he had been taken away for an outbreak over the difference with a dealer

[17] Young, *Catalogue*, p. 31. She goes on to say: "I was never afraid of him but at last the doctors said it was unsafe to have him at home, that it was absolutely necessary to have him taken away."

[18] Goodrich, *Blakelock*, p. 38. His condition was diagnosed as dementia praecox, a vague and not too helpful diagnosis roughly corresponding to schizophrenia, which is no more definite.

of a few dollars, one of his paintings sold for $3,100. Nine years later, while he was pathetically painting his own money, Sen. William A. Clark of Montana paid $13,900 for his *Moonlight* (c.1890). Let the reader, accustomed to the news of millions being paid for a Velázquez or a Leonardo or a Rembrandt or a Jackson Pollock, reflect what that meant then—the highest price ever paid for the work of a living American artist.[19] When that was happening, Mrs. Blakelock was living in a dilapidated shack near Catskill (Cole's haunts some seventy years earlier) on an income of $50 per year and couldn't find the money to pay for transportation to visit her husband. Three years later, in 1916, the record set by Senator Clark was broken when the Toledo Museum paid $20,000 for Blakelock's *Brook by Moonlight*. We can only speculate. If Blakelock could have held out for a few years more, would he have been favored by fortune, as his wife put it? Or were the coveted prices that were finally paid brought on, in large part, by the sensationalism of the confinement, which in turn was caused by their longtime absence?

Of our twelve visionary eccentrics, Ryder, Newman, and Blakelock would surely have seemed the most flagrant outsiders to the casual observer, the most extravagant curiosities. But not everything lies on the surface. Others, functioning ostensibly acceptably within the workaday world, were haunted by strange obsessions. Such was the case with William Rimmer, George Inness, and, to an extent, William Page.

William Rimmer (1816–1879) had been possessed throughout his upbringing and early manhood—and who can say for sure how long beyond that?—by a fantastic and compelling legend of a royal birth, which was nurtured by his father, Thomas. The truth of this legend was never doubted by him and his brother, Thomas, Jr. The elder Rimmer insisted that he was the son of Louis XVI and Marie Antoinette and was, therefore, the rightful heir to the French throne. He told how he had been smuggled out of France in 1794, brought to South Lancashire in England, where he had been educated as a prince, and then denied the throne because of the ascendancy of Napoleon and the subsequent support given to the last king's brother, Louis XVIII, by the Russians and English. In exasperation he married a lower-class Irish woman and left for the New World, reaching Nova Scotia in 1818, when William was two. Then he came to Massachusetts by way of northern Maine,

[19] *Ibid.*, p. 35.

lived awhile in Hopkinton, and settled in Boston in 1826. He kept his family in virtual seclusion because he feared assassination attempts by Talleyrand and his secret agents. He made his living through cobbling and did not reveal his identity to the world but educated his sons by himself, preparing them to be ready if some day they should be kings. He made them silver flutes and taught them French, some Hebrew, geography, music, ornithology, mathematics, and painting. In his last years, when he was being taken care of in Concord, he was aided financially by Ralph Waldo Emerson (1803–1882). He died in 1852 after raving through the night. His son William went on to become an excellent anatomist, teacher, painter, and, above all, sculptor; and his plaster *Dying Centaur* of 1871 (not cast in bronze until 1906, twenty-seven

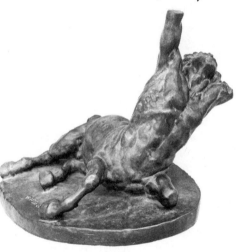

William Rimmer: *The Dying Centaur*. Plaster cast: 1871; posthumous bronze casting: 1906. H. 21½″. The Metropolitan Museum of Art, New York; Gift of Edward Holbrook, 1906.

years after his death), with its portrayal of the anguish of a being half-man and half-animal, must derive, in good part, out of the strangeness of his haunted past.[20]

[20] Our chief source on Rimmer is Truman H. Bartlett, *The Art of William Rimmer: Sculptor, Painter, and Physician* (Boston, 1882). Bartlett writes especially movingly on Rimmer's early life and youthful struggles. This observation should enhance our appreciation of the *Dying Centaur:* "The idea of struggle against a stern fate, so common in his drawings, is the inevitable outcome of that conflict with outward circumstances which he knew so young" (p. 5). The piece was made in odd hours in 1871 without the employment of a model. In his teaching, Rimmer insisted upon a knowledge of the principles of anatomy before drawing from the life model (p. 146).

William Rimmer took a large part in the support of the family in his late teens, and by the time he was twenty-one had earned money as a typesetter, soap maker, lithographer, and sign maker. Thereafter, the manysidedness of his life, however fascinating and rich, seems to indicate a certain lack of center. Partly because of poverty, but mainly out of his own sense of alienation, he chose to reside not about the Back Bay, or the Beacon Hill section, or any other part of downtown Boston, where he would have had the opportunity to meet other artists, but in regions peripheral to the main part of the city: In 1845 he lived in Randolph; in 1847, in southern Boston; from 1848 to 1850, in Randolph again; in 1855, in Chelsea, which like southern Boston was the home of a lot of recent Irish immigrants (some of them comprising a tough, and even dangerous, element); at the end of 1855, in East Milton, where he could cut granite in the nearby quarries; and in 1863, again in Chelsea. He was even more peripatetic in his teaching stints. His subject was drawing and anatomy. He taught at the Boston Studio Building and in a private gymnasium on Tremont Street in 1861; at the Lowell Institute in 1863; at Harvard in 1865; at Cooper Union's School of Design for Women, which he headed, from 1866 until his dismissal in 1870 (he lived then in New York, of course); at the National Academy of Design, New York, and Worcester's Technological Institute in 1871; in Providence, Rhode Island, in 1872; at night in Chelsea in 1874; and in the newly established Fine Arts School of the Boston Museum in 1877.[21] He remained in America continuously, from the time his father had left Nova Scotia; while other serious American sculptors gathered in expatriate enclaves in Italy to study original works, he relied on the antique casts he found in the Boston Athenaeum. Perhaps because of this, his sculpture hasn't the self-conscious pretentiousness of Hiram Powers (1805–1873), Thomas Crawford (1813?–1857), William Wetmore Story (1819–1895), and others from around the time of the Civil

<hr>

[21] Rimmer was appreciated by most of his students and was especially popular among his women students. Daniel Chester French, who studied with him early in his career, remained indebted. See Michael Richman, "The Early Public Sculpture of Daniel Chester French," *American Art Journal* 4, no. 2 (November 1972): 98–99. Bartlett includes estimates of his students, who are not named. Most are complimentary, but this interested me especially: "By his marked sensitiveness and extraordinary standard of judging men he lessened the number of his friends, and put himself voluntarily at variance with that courteous charity, that, by common consent and the necessity of common existence, keep society together. He put . . . the world at defiance." Bartlett, *Art of Rimmer,* p. 140.

War. In the *Falling Gladiator* (1861), which he made in clay, he caught in the staggering athlete a difficult involuntary action of the kind none of his countrymen would even remotely attempt.[22] To support his art, he attended the sick from about 1840; he was a mainly self-educated physician, who had taken some tutoring from Dr. A. W. Kingman, of Brockton, Massachusetts, and who stood as an observer in medical dissecting rooms. Besides this, he invented an unbreakable trunk, a new type of gunlock, and various other devices, from which he realized no money. And all the while he must have brooded over his own tragedies no less than over the thwarted hopes of his father, for his three sons had died in infancy.

In part because he avoided the snobby eating clubs of the Boston Brahmins and in part because his sculpture lacked the icy staginess then in vogue among the moneyed classes, he secured no important commissions beyond the *Alexander Hamilton* (1865) for Boston's Commonwealth Avenue (one of his least interesting pieces). He lost out to an artist who was a club man for a memorial to W. T. G. Morton, the Boston dentist who discovered anaesthesia. His model for the figure of Faith to be placed on top of the National Monument to the Forefathers, in Plymouth, was not accepted. He exhibited his paintings so seldom that few knew he painted. Rimmer was stubborn and single-minded and attracted few close friends (although his students appreciated him), quarreling bitterly in the end with William Morris Hunt, Boston's most famous painter, with whom he had maintained a long and close association. After his death, one of his students, the famous sculptor Daniel Chester French, remembered him in a letter to the wife of the sculptor Thomas Ball with these words: "The poor long-suffering doctor! His was an unhappy and unsuccessful life. He just missed being great."

George Inness (1825–1894) was a devoted husband and a good parent, and himself the son of a prosperous grocer, who, unlike Rimmer's father, had no wild legends to bequeath. He was a genial, talka-

[22] So unconventionally spontaneous did the *Falling Gladiator* (1861) appear that when it was exhibited in the Paris Salon of 1863, Rimmer was accused of having cast from the living model, as the piece was around life size. The same charge would be made fifteen years later against Rodin (1840–1917) when he exhibited the *Age of Bronze* (1877), but there the position was not as difficult as Rimmer's athlete falling over backward.

tive man who attracted company. *Energetic* is an adjective used often to describe him by those who had associated with him. His paintings sold well during the last two decades of his life, when he achieved a good measure of fame. He was careless of money, though not to Ryder's point of total unawareness. The story is told that he once left a huge wad of bills with a friend because he was going into a tough neighborhood. When he returned, he did not mention the money. Hours went by. Finally the friend felt obliged to remind Inness, who carelessly dropped the wad in his pocket without bothering to inspect it.[23]

I don't intend here to outline in any detail Inness's career, his several trips abroad, and his movements within this country; all this can be studied in several monographs, the most recent by Nicolai Cikovsky, Jr.[24] This is because only his paintings from about 1884 to his death, in 1894, those that can be called visionary, are of interest to us. The two things that strike me most about Inness's history are the condition of his health and his religious absorptions. As to the former, Inness was sickly all his life and suffered from epilepsy. A fervent Abolitionist, he tried to enroll in the Union Army (as contrasted with Newman, who tried to stay out of the Confederate one), but was not taken. As to the latter, through the period of 1884 to 1895, and beginning a few years earlier, Inness was a devoted adherent of the precepts of the Swedish mystic Emanuel Swedenborg (1688–1772) to the extent, reported the historian-critic Montgomery Schuyler, of believing unquestioningly in the manifestations of mediums.[25]

Inness's mother had been a "zealous Methodist" and his stepmother "an equally zealous Baptist."[26] His son, who wrote his biography, relates that while in Eagleswood, New Jersey (a suburb of Perth Amboy), he searched for a suitable religion. This would have been during the early 1860s, after he had left the Baptist Church. One Sunday he entered a Methodist Church with his son, soon became agitated, perspired profusely, and turning, said to him: "Come, Georgie [the biographer, George, Jr.], let's get out of here. We made a mistake

[23] John A. S. Monks, "A Near View of Inness," *Art Interchange* 34 (June 1895).
[24] Nicolai Cikovsky, Jr., *George Inness* (New York: Praeger Publishers, 1971).
[25] Montgomery Schuyler, "George Inness: The Man and His Work," *Forum* 18 (November 1894): 311.
[26] *Ibid.*, p. 303.

and got into hell."[27] Shortly thereafter he renewed an acquaintanceship of fifteen years earlier with William Page, who was also living in Eagleswood. And it was Page who first introduced Inness, around 1866, to the teachings of Swedenborg,[28] according to which there exists a spiritual, invisible world, fundamentally different from, yet resembling, the world perceived by the senses. Swedenborg claimed that God had chosen him to see the other world almost daily and that he would converse with the angels and spirits into which men had become transformed. In the late 1870s Inness's interest in spiritualism became all-consuming. In a long, rather rambling, and somewhat unintelligible letter to his daughter, Nellie, written on February 13, 1877, he set forth what is the longest elucidation of his religious views to have appeared in print. Here is an excerpt showing his curious intermingling of Christian doctrine and spiritualism:

> I perceive from your question that you are beginning to think, in fact that your spiritual faculties are beginning to unfold, and that you are now experiencing your first temptation, which is to leave the ideas in which you have been educated because you fear that they may disturb you in the enjoyment of your natural desires.
>
> Every individual man or woman born into this world is an off-shoot of that Infinite Mind or Spirit which we call God. God creates in us sensation, and through it we are made conscious of the world we live in. . . . Now the center of all life is the Lord Himself, the mystery of whose existence is the mystery of our own, and which will gradually unfold itself to us as we learn to subject our natural impulses to ideas of use and make them eventually our delight and the consequent center of our spirit life, which then becomes one with the Lord Himself. This unfolding of intelligence in us takes place in varying degrees to eternity, and is a great source of happiness or unhappiness, as we are obedient or disobedient to the truth which we know; for this truth becomes in us the voice of conscience, which cannot be disobeyed with impunity. Now what the spirit sees is not the truth, but only an appearance of truth. For instance, we say the sun rises and the sun sets, but this is not true except as an appearance, and so it is with every fact of the natural world. The truth is the Lord Himself, Who creates and controls all which is thereby made to appear to us.[29]

[27] George Inness, Jr., *The Life, Art, and Letters of George Inness* (New York, 1917), p. 61.

[28] *Ibid.*

[29] *Ibid.*, pp. 199–200.

Inness's funeral was presided over by the Reverend J. C. Ager, a Swedenborgian minister who had been his longtime friend. In keeping with Inness's own beliefs, the eulogy contained a long oration dealing with mysticism that lasted for hours. The reporter covering the event for the *New York Herald* quoted from the eulogy: "From God emanates a divine sphere which appears in the spiritual world as a sun, and from the spiritual sun again proceeds the sun of a natural world."[30] I find the story of Inness's death instructive, not because there was something apocryphal about it (we cannot know how long the body was lying in its spot or when the sun began to sink) but because the friend speaks as though the apocryphal were simply usually connected with Inness. And again the image of the sun figures prominently:

> Toward the end of his life he was seized by an unconquerable desire to see the sunset again from the Bridge of Allan, and his relatives, reluctantly giving way to his wish, took him to Scotland. The journey was long and tedious. They arrived in the late afternoon, with hardly time to prepare for the evening meal. Inness would not wait, but must needs go at once to his favorite spot. Time passed, the meal was over, and still he had not returned. Anxiety took the place of inquiry, and his companions began a search, and finally found him on the bridge—dead! His face was toward the setting sun, his last wish gratified.[31]

The short of it is that with his conversion to Swedenborgianism, Inness became a religious fanatic. We see this not from his son's biography so much as from the more unprejudiced opinions of others. It was reported that in the last years "he frequently gave way to fits of depression and melancholy, much to the alarm of his friends."[32] Without more elaboration, the writer of Inness's obituary in the *New York Evening Post* ventured that "with more mental balance . . . he would have been the greatest landscape painter of any time or people."[33]

The instrument of Inness's conversion, William Page (1811–1885), had studied painting at a very early age with Samuel F. B. Morse at the National Academy of Design. Then in 1828, when he was seventeen, he turned to religion for a career: He entered the Phillips Academy at Andover, Massachusetts, to train to become a Presbyterian min-

[30] *New York Herald,* August 24, 1894.
[31] Quoted in Frederick Stymetz Lamb, "Reminiscences of George Inness," *The Art World* 1 (January 1917): 250–252.
[32] *New York Tribune,* August 20, 1894.
[33] *New York Evening Post,* January 5, 1895.

ister. That leaning proved short-lived. Later he turned to an extraordinary sort of spiritualism, which he combined with his elaborate theories of art dealing with proportions and other matters. Also, before he was twenty-one, he married the beautiful Lavinia Twibill, who was so overwhelmed by his theorizing that she ran off and became pregnant by someone who talked less. Undaunted, Page married the beautiful and still younger Sarah Augusta Daugherty (who was only eight or nine years older then his oldest daughter), who later, feeling herself neglected, ran off with a certain Count Cerelli. Sarah had been described by one correspondent as "certainly the handsomest woman I have ever seen."[34] James Russell Lowell (1818–1891) said Page "drank a woman's soul in one draught."[35] (I can think of no more erotic painting by a nineteenth-century American than his *Cupid and Psyche*, 1843.) In September 1856, Page, not to be outdone, became engaged again before he was divorced from Sarah, to Sophia Candace Stevens Hitchcock, a practical woman much interested in the arts; and he began his portrait of her standing before the Colosseum as his wife in 1860 in Rome and finished it in 1861 in New York.

Page was in Boston from 1844 to 1847, and in New York until 1849. From 1849 until his return to the New York area he lived in Rome and Florence and was an intimate of James Russell Lowell, the Brownings, and other well-known writers and artists of the Anglo-American colonies there. This was when he was absorbed by both Swedenborgianism and a spiritualism of a more tawdry kind, for he participated readily in sessions around the table and believed steadfastly that he received communications from spirits beyond the grave. At these séances, "spirit writing," produced by someone either in a trance or guided by a medium, was in vogue: At least once, Page believed he had been written to by his dead mother.[36]

[34] Letter from the writer Robert Carter to the *Boston Daily Advertiser*, June 25, 1875. Quoted in Joshua C. Taylor, *William Page: The American Titian* (Chicago: University of Chicago Press, 1957), p. 70. Sarah drew a lot of gossip. In Florence she was interested in several Austrian officers. The children were then being cared for in America. After the affair with Count Cerelli came to an abrupt end when she could not get out of Italy because of red tape, Sarah considered entering a nunnery. Then, supported by a wealthy American, she went on the stage. Next she married Peter B. Sweeney, a stalwart of the "Boss Tweed Ring."

[35] Letter from Lowell of September 15, 1856, mentioned in Taylor, *Page*, p. 156. Lowell argued against Page's entering upon a third marriage, ostensibly because he was not suited as a constant mate.

[36] *Ibid.*, pp. 133–134. Taylor writes that many pages of spirit writing were found among the Page papers, belonging to the Page family.

William Page: *Mrs. William
Page* (*Sophia Stevens Hitch-
cock*). 1860–1861. Oil on can-
vas. 60¼″ x 36¼″. The Detroit
Institute of Arts, Michigan;
Gift of Mr. and Mrs.
George S. Page, Blinn S. Page,
Lowell B. Page, and Mrs.
Lesslie S. Howell.

In August 1851, in Florence, Page was living immediately below
Inness, but the two men did not then have much to do with each other.
The year before, Page had been introduced to Swedenborgianism by
the expatriate American sculptor Hiram Powers, and he lost little time
in pursuing it to fantastic conclusions. In Swedenborg's writings the
term *use* denotes the forming principle whereby matter reveals the
active workings of divine love. The entire physical development of the
individual is the resultant of active moral forces, and the body grows in
accordance with an inner impulse that is spiritual in origin. From this,
Page contended that the work of art, like the living body, should be-
come a functioning creation in its own right, a kind of natural object,
and not simply a copy of something beyond itself.[37] Thus, there was
to be a continuum between art and life, as there was, for Page, between
the living and the dead. Page argued that the color of a painting was to

[37] *Ibid.*, pp. 229–231. In this respect the artist's function becomes the earthly
counterpart of the divine creative process. See p. 222.

shine forth, to vibrate as though it were a living force pushing forth from beneath the restraint of the canvas. Like nature in its endless diversity, the painting should keep the attention of the eye in endless activity:

> As every object in nature is inexhaustible to our contemplation, so in true art this inexhaustible quality is to be rendered. And even the language of art is not thoroughly learned until the painter can bid you look into the painted space in vain to find a resting place for the eye; like Noah's dove on her first flight returning back to the ark for rest, so should the eye penetrate forever for the bottom of the unfathomable depth, thereby suggesting the infinite space which forever opens before us in that last as well as greatest work of God.[38]

Among the means he used to make the painting appear to be pulsating with life, Page drew veins not with a blue pigment but with a dark red line, corresponding to blood, and then covered that with glazes to represent "the light color of the skin and the coating of the veins."[39] Along with his pronouncements on color and chiaroscuro (he especially admired Titian's color, which drew the eye to penetrate below the surface to discover the source of life), Page advocated a system of proportions that he derived from Revelation 21:12–17. In these passages there are found the physical descriptions and measurements of the Heavenly Jerusalem. Basing himself on Swedenborg's theory of spiritual correspondences, he seized on verse 17, quoting it as follows: "And he measured the wall thereof, an hundred and forty and four cubits, according to the measure of a man, that is, of the angel." This quotation, appearing in Page's article of 1879 entitled "The Measure of Man," was accompanied by drawings of the human figure on a grid of squares, twelve units to the side.[40] Page showed that this scheme could apply

[38] *Ibid.*, p. 233.

[39] James Thomas Flexner, *That Wilder Image* (New York: Dover, 1970), p. 157.

[40] William Page, "The Measure of a Man," *Scribner's Monthly* 17 (1879): 894–898. The article appeared two years after Page was pretty much incapacitated through illness and may have been in part compiled or at least heavily edited by Sophie. In the article, Page states that the idea for his system first occurred to him in 1853. Setting out the figure according to a proportional system based on a grid dates far back in the history of art. See "The History of the Theory of Human Proportions as a Reflection of the History of Styles" in *Meaning in the Visual Arts* by Erwin Panofsky (Garden City, N.Y.: Doubleday Anchor Books, 1955). Panofsky traces his history from the Egyptians and ancient Greeks through medieval times up to Leonardo and Dürer.

William Page: *Self-Portrait*. 1860. Oil on canvas. 59″ x 36″. The Detroit Institute of Arts, Michigan; Gift of the Page Family.

as well to casts of the "Theseus" and "Ilisus" from the Parthenon. Actually, he had missed the meaning of the crucial verse from Revelation by assuming that the measure of the angel, like that of man, was one hundred forty-four cubits—or the number of squares in his grid. (The New International Version of the New Testament has the verse mean something else: "He measured its wall and it was 144 cubits thick, by man's measurement, which the angel was using.")

Thus it was that Rimmer, Inness, and Page, though communicating to a degree with the artistic community about them, as well as with others, and by all accounts not flagrantly outlandish in their behavior or in their dress, constructed strange realms in the world of their imagination.

With George Fuller, Erastus Salisbury Field, and Thomas Wilmer Dewing especially, and nearly as much with John Quidor, almost nothing has come down to us in the way of personal anecdote. We know next to nothing of what they said and thought, how they dressed, and how they behaved with their friends, neighbors, associates, family. I've searched in vain for mention of some excess, some extravagance or aberration, something in word or thought that would enable me to point to them and say: See how eccentric these visionary painters were in their lives! But there are glimmers, hints of things. Did I find them simply because I was looking for them, because I would "fit my theory" with anything available? Such it may be with Fuller and Dewing, but not, I am convinced, with Quidor.

Fuller (1822–1884), born in Deerfield, in the northwestern part of Massachusetts (south of Greenfield), became part of the art life of Boston and New York, and then went abroad in 1859. We do not know precisely how that trip affected him. We do not know what change took place within him. There is no word of condemnation, no proclamation of any kind. There is only this fact: In 1860, when he was thirty-eight, after he returned from his trip, Fuller retired to a farm near Deerfield, to a self-imposed exile more drastic than that undertaken by Rimmer in his flights to the outskirts of Boston, and remained there continuously until 1876, painting little. Why did he do this? What made him renounce his contacts, his chances for professional advancement? He is quoted as having written this in a letter: "I feel sometimes strangely separated from art in my present occupations. But I shall never feel that my time is being lost. Mother Earth has such a strange hold over me. I am given over to the demons of plowing and draining, hoping to come out of it some day and look upon a smiling landscape which I have helped to form. The future is so dim we amuse ourselves in it and manage the shapes nicely.[41]

When Fuller "emerged" in 1876, he set up a studio in Boston, and from then until his death, in 1884, he painted his best pictures. The strange part of this was that his leaving the farm was not premeditated but had been forced upon him by a failure of the tobacco crop in 1875.[42]

[41] *Centennial Exhibition of the Works of George Fuller,* catalogue (New York: The Metropolitan Museum of Art, 1923), p. xi.
[42] *Ibid.*

I can offer the reader nothing of note about Dewing (1851–1938), who with Inness painted America's strangest Impressionist pictures. Where he lived, with whom he studied, his admiration of Vermeer and Whistler, whom he met in 1895, are matters of record.[43] What he was like is not. His absorption in his work has been noted, and that is all: "At his studio by half-past eight, he sits there for ten months of the year, every day as long as the light lasts, sitting hunched and doubled up, in a low chair despite his enormous size, so that he shan't see the tops of things too much. And here, with beauty as his whole preoccupation, he gives it to us in one more picture, and yet one more; conscientiously studying his carefully selected virtue all the time."[44] A man of enormous size "with beauty as his whole preoccupation." No one of his time was more sensitive to the nuances of women's fashions, could more adeptly catch the way the woman of breeding, perhaps of pretensions, could—or better, should—carry herself. In his studio he kept a supply of dresses for his models.

As is by now obvious, there is no apt social environment to breed a visionary. Nothing could have been further from the glittering fashionable world of Dewing than the small-town existence of Field (1805–1900). But no less than Dewing, Field himself, Field the man, eludes our grasp.

There are no reports of eccentricity concerning Erastus Salisbury Field. Like his predecessor Edward Hicks, he has been classified as a "primitive" or "folk" painter. Unlike Hicks, he was not a Quaker or a devotee of any religious group or sect; but his extravagant religious pictures could have been in part inspired by the religious enthusiasm sweeping the country in 1858 and 1859.[45] Field turned to religion for consolation following the death of his wife in 1859.

Still, the bizarre innocence of his literary scenes may be attributed at least in part to the insularity of his surroundings for most of his life. Nonetheless, among a good number of nineteenth-century folk artists

[43] Royal Cortissoz, *American Artists* (New York: Chas. Scribner, 1923), pp. 47–56. Nelson C. White, "The Art of Thomas W. Dewing," *Art and Archaeology* 27 (June 1929): 253–261.

[44] Ezra Tharp, "T. W. Dewing," *Art and Progress* 5 (March 1914): 161.

[45] Field was then ready for a new direction in his art, since his portrait business had been severely damaged by the expanded use and improvement of daguerrotypes. Mary Black and Jean Lipman, *American Folk Painting* (New York: Potter, 1966), p. 173.

Hicks and Field created the most entrancing, and it would seem most deeply felt, dreamworld. We can but wonder what Field thought and felt. Only his paintings are left to us—which is plenty. He and his twin sister, Salome, were born and brought up in the tiny town of Leverett, Massachusetts, a town filled with their cousins.[46] In 1824, at the age of nineteen, he traveled to New York to study with Morse; this was a year or two before Page studied with him. Field and Page probably never crossed paths. In 1825 Field returned to Leverett, and thereafter, until about 1840, he worked as an itinerant portraitist through central and western Massachusetts. He was, in effect, a resident artist to a number of isolated towns. In 1841 he was living in southern Manhattan, within sight of the Trinity Church cemetery. In 1848 he was called home to run his father's farm. The big exotic pictures and religious extravaganzas, such as *The Garden of Eden* (c.1865) and the *Death of the First Born* (c.1870), date from the late 1850s. Mary Black speculated that this impressionable folk painter may have been moved to extend his repertoire by what he had seen in New York more than a decade earlier. She pointed out, for example, that in 1842 in the Park Theater in lower Manhattan the first sacred drama in America was produced, "The Israelites in Egypt or the Passage of the Red Sea."[47] (The *Death of the First Born* as well as Field's *Israelites Crossing the Red Sea*, 1865–1880, deal with the Israelites' escape from their Egyptian bondage.)

We can surmise a bit more about John Quidor (1801–1881). From the little we know of him we may conclude that he was irascible and antisocial, no lover of his fellow creatures and probably little loved

[46] At Leverett's first census, in 1790, fifteen years before Field's birth, there were only eighty-six houses, inhabited by eighty-seven families. This comprised 524 free whites and 1 other freeman. New York was three days away; Boston, two; and few of Leverett's inhabitants visited either. Mary C. Black, "Rediscovery: Erastus Salisbury Field," *Art in America* 54, no. 1 (January–February 1966): 49.

[47] Black also points out as having made an impact on Field a five-mile panorama of a voyage around the world, which was exhibited at the Minerva Gardens during Field's stay in New York. *Ibid.*, p. 51. This could have had some impact on the architectural fantasies within some of Field's biblical paintings. All of this, of course, is speculation. Black might have said something more of New York. Broadway was even then becoming the most famous street in America. The corner of Broadway and Fulton Street, where stood the Barnum Museum and a number of fashionable shops, was the Times Square of the period. The most direct artistic sources are paintings of the Englishmen John Martin and Richard Westall.

in turn. We are led to this from the reports and reactions of those he knew.

Quidor was the oldest of the visionary eccentrics: He was born in the first month of the first year of the nineteenth century, four years before Field and a decade earlier than Page. When he was ten, his schoolmaster father brought the family from the shores of the Hudson to New York City. For four years, from 1818 to 1822, he served an apprenticeship with the portraitist John Wesley Jarvis (1780–1840), who obviously did not care for him. A report of 1828 goes that Quidor "was maltreated by his master, while on the contrary Mr. Inman [Henry Inman, 1801–1846, his fellow pupil] was indulged to excess."[48] Quidor promptly brought suit against Jarvis for failing to comply with the terms of the apprenticeship. This must be the first suit ever instituted in America by an art student against his teacher. Recently the records of the litigation have been uncovered: A trial was held in 1823, and Quidor was awarded $250 in damages.[49] He made the bulk of his living thereafter by painting signs and the figures on banners and on the bodies of fire engines, and through his business dealings; whereas the Washington Irving paintings comprised his love and his avocation. He did attract two young pupils, the portraitist Charles Loring Elliott (1812–1868), and Thomas Bangs Thorpe (1815–1878); and he was little more caring with them than Jarvis had apparently been with him. In a passage in Elliott's obituary it is stated, relating to his studies under Quidor: "In all the time we were with Quidor . . . I do not remember of his giving us anything but easel room and one or two very common engravings to copy."[50] Also in Elliott's obituary there was

[48] Recorded originally by Quidor's friend the sculptor John I. H. Browere. Thomas S. Cummings, *Historic Annals of the National Academy of Design* (Philadelphia, 1865). Quoted in John I. H. Baur, *John Quidor* (Utica N.Y.: Munson-Williams-Proctor Institute, 1965), p. 9.

[49] Baur, basing himself on the account of Thomas Bangs Thorpe, writes erroneously that Quidor lost the case. New evidence has subsequently been uncovered. On May 31, 1823, Quidor was awarded $251.35: To the damages were added costs and charges of $51.29 and—*mirabile dictu*—court costs of 6 cents. Damages of $2,500 had been sought. Quidor was fortunate in that Inman, normally a friend of Jarvis, surprisingly appeared as a witness on his behalf. See Ernest Rohdenburg, "The Misreported Quidor Case," *American Art Journal* 2, no. 1 (Spring 1970): 74–80.

[50] Col. T. B. Thorpe, "Reminiscences of C. L. Elliott," reprinted in pamphlet form from *The Evening Post*, n. d. (probably c.1868). Quoted in Baur, *Quidor*, p. 11.

a brief description of Quidor as he had been in 1830 when he was Elliott's teacher. We are told that he would stay away from his studio for days and weeks at a time, and that his "rooms were without adornment of any kind; a coat of primitive dust lay undisturbed on the window sills and the mantelpieces and the floor was checkered and dirty. A long bench and two or three dilapidated chairs comprised the furniture of the room."[51] He would lie full length on his bench, which he used as a couch. Not very much to go on, but still the rudiments of a picture of a rootless man, often on the move.

We also know that Quidor married around 1828 and that he speculated in western lands from 1823. Around 1837 he was buying and selling land in Illinois and had set up a studio in downtown Quincy.[52] In 1840 he bought a farm in Illinois but lost it in 1843, when, by not farming the land, he failed to live up to the obligations of the terms. He drank habitually, and once he was so upset because he could not get liquor that, in a rage, he threw a deed into the fire.[53] By 1851 he was back in New York, where he lived until 1869, when he retired to the home of his eldest daughter in New Jersey. His son, Thomas, when corresponding with his family while in the Union Army, mentioned his father only twice, merely to ask whether he was "still the same."

John I. H. Baur has suggested, and John Wilmerding has agreed, that Quidor saw in Washington Irving's character of Rip Van Winkle, as set forth in *The Sketch Book* (1819), a reflection of his own alienation.[54] Staying within the confines of the character as delineated, he tellingly stressed certain aspects of him. In the *Return of Rip Van Winkle* (1829), in the National Gallery, the newly awakened Rip, back in the town where he grew up, points, in bewilderment at the surrounding crowd laughing at him, toward a young man, off by himself, slouching against a tree. Quidor has taken Irving's short phrase, "that's me yonder," and made it the point around which the scene revolves. The entire passage from Irving reads as follows:

[51] *Ibid.*
[52] David M. Sokol, "John Quidor, Literary Painter," *American Art Journal* 2, no. 1 (Spring 1970): 69.
[53] *Ibid.*, p. 72. To get this information Sokol interviewed Quidor's grandson. Quidor's drinking alienated his family.
[54] Baur, *Quidor*, p. 14. Also see John Wilmerding, "Peale, Quidor, and Eakins: Self-Portraiture as Genre Painting." in *Art Studies for an Editor* (New York: Harry N. Abrams, 1975), pp. 297–298.

In the midst of his bewilderment, the man in the cocked hat demanded who he was and what was his name? "God knows," exclaimed he, at wit's end; "I'm not myself—I'm somebody else—that's me yonder—no—that's somebody else got into my shoes—I was myself last night, but I fell asleep on the mountain, and they've changed my gun, and everything's changed, and I'm changed, and I can't tell what's my name or who I am."[55]

Ten years after this painting of Rip searching for his identity, in *Rip Van Winkle: At Nicholas Vedder's Tavern* (1839), in the Boston Mu-

John Quidor: *Rip Van Winkle: At Nicholas Vedder's Tavern*. 1839. Oil on canvas. 27¼" x 34¼". Museum of Fine Arts, Boston; M. and M. Karolik Collection.

seum of Fine Arts, where an earlier phase of the story is illustrated, the same man (same features, same costume) is again standing apart,

[55] Washington Irving, "Rip Van Winkle: A Posthumous Writing of Diedrich Knickerbocker," in Charles Neider, ed., *The Complete Tales of Washington Irving* (Garden City, N.Y.: Doubleday & Co., 1975), p. 12.

lonely, slouching against the tree. Ignored by the carousers, this time the man has been made into the figure of Rip himself. Though not a portrait of Quidor as such, the Rip in this painting, much as Rimmer's *Dying Centaur*, also not a portrait as such, pretty much reveals how these two artists saw their place in the world in relation to their fellowmen.

I searched for any scrap of information I could find on the personalities, the habits, and the way of thinking of Fuller, Dewing, and Field—and found next to nothing. With Elihu Vedder (1836–1923), happily, there is a plethora of information contained in a meandering autobiography of 521 pages entitled the *Digressions of V. Written for His Own Fun and That of His Friends.*[56] Vedder was set apart from his fellowmen not only by an exotic childhood in Schenectady, Cuba, and Jamaica and an eventful life spent mainly abroad in France and Italy but by the droll people he seemed to attract and his bizarre imagination and wonderfully selective memory. The *Digressions of V.* is a selective compendium of impressions, snippets of events graphically described, that, taken together, would be hard to match in their strangeness in any other American biography.

During his childhood and boyhood certain events having to do with death and mutilation impressed themselves on Vedder. As a small boy, a pet kitten was found hanging by a cherry-colored ribbon that had attached itself to a nail in the fence, and he himself killed a pet dog by shooting it through the eye with an arrow in a game of cowboys and Indians. Dreams played a part in the fascination with death. In one, Vedder was in a tomb under a mountain of granite "which must have been at least five miles high" and he was convinced that only by forcing himself to awaken did he save himself from death. He remembered his father operating on wasps, trying to cut off their stingers so that their lives would be saved. In Cuba there was some sea creature, "a vigorous mass of vitality, of a rich velvet brown, and had large eyes," which a fisherman killed by biting its vitals: "at once over this rich brown live thing, spreading to the end of its arms, passed an

[56] Elihu Vedder, *The Digressions of V. Written for His Own Fun and That of His Friends* (Boston and New York: Houghton Mifflin, 1910). The title page bears this inscription: "Containing the quaint legends of his infancy, an account of his stay in Florence, the garden of lost opportunities, return home on the track of Columbus, his struggle in New York in War-time coinciding with that of the Nation, his prolonged stay in Rome, and likewise his prattling upon art, tamperings with literature, struggles with verse, and many other things, being a portrait of himself from youth to age. With many illustrations by the author."

ashy pallor." His grandfather once wound up his watch and said he would die at about three in the morning—and he did. Among the people he met were "the Hermit," Aunt Evvy's husband Caister, and "the little tramp." The strange-looking Hermit of Schenectady was rumored to have been married six times and would be seen in town buying fishhooks and fishline. Caister, a skilled mechanic predicted that one day carriages would run about the streets without horses and that people would fly through the air. He was judged incurable and sent off to an insane asylum. The tramp hit on a scheme to get his room and board: He played deaf and dumb and was maintained in an asylum for a month; he was discovered when his excitement in a game of tag betrayed him. There are accounts of gamecocks, which Vedder saw in the Caribbean, of his hunting for birds, which he began at the age of seven, of his amputating the leg of an injured chicken and fitting it with a splint.[57] Similar events and people have marked other childhoods. What is striking in the *Digressions* is their profusion, their vividness of detail, the matter-of-fact way with which they are set forth, and above all the dwelling on the gruesome.

Like some of the European Symbolists of his time (Redon, Moreau, etc.) and the Surrealists after him, Vedder sought to keep his imagination always at a high pitch, always procreative. He placed great importance on his dreams and relished describing them in detail. He loved what he called his legends of childhood, which, he wrote, had "just enough detail to convey the impression of their truth."[58] The rambling style of his *Digressions*, remarkably spontaneous and unstructured, is suggestive of free association. Among the artists of the past, William Blake, judging from the amount of space given him, occupied Vedder most. (This is the only instance when one of our American visionaries studied the art of a European visionary of the past.) Vedder first encountered Blake when a boy in school. He thought then: "Fancy the author of the illustrations of the Book of Job—mad! ! !"[59] Later in his life he concluded that Blake was not really mad after all. The passages on him are perhaps the most lyrical within the long *Digressions*:

> It was while at school, in Allan Cunningham's "Lives of Painters," I first met with the name of Blake. He is there called the "Mad painter,"

[57] Descriptions are taken from the first four chapters, *ibid.*, pp. 3–120.
[58] *Ibid.*, p. 312.
[59] *Ibid.*, p. 61.

and so he remains in the minds of most people to this day. But I never doubted his sanity. He was a man who had broken out of the prison of gentility, but not that of gentleness; thrown aside the shackles of Society, and lived a free life—a free man. By his own work he kept himself from actual want and thus was left to wander and dream in the world of his visions; this looks to me like sanity. Yet to me there is a lack of balance and proportion; I see it in his work and in his writings.[60]

Yet Vedder was no recluse. He might have said that his life had the balance and proportion that Blake's lacked. He cultivated and enjoyed his success—even acclaim—as an illustrator; in fact, the publication of his drawings for the *Rubáiyát of Omar Khayyám* (1884) opened up an era of art publication in America.[61] In the 1890s, when mural painting came into vogue, he turned to that area. Vedder concluded that he must master his imagination rather than be its slave. In his autobiography he stresses that he was not a mystic or learned in occult matters, that however free his imagination, however easy it was for him to conjure up visions, he needed to get his feet back to solid ground. In his words:

I am not a mystic, or very learned in occult matters. I have read much in a desultory manner and have thought much, and so it comes that I take short flights or wade out into the sea of mystery which surrounds us, but soon getting beyond my depth, return, I must confess with a sense of relief, to the solid ground of common sense; and yet it delights me to tamper and potter with the unknowable, and I have a strong tendency to see in things more than meets the eye. This tendency, which unduly cultivated might lead me into the extravagant, is held in check by sense of humour, and has enabled me at times to tread with safety that narrow path lying between the Sublime and the Ridiculous,—the path of common sense, which in its turn is dangerously near to the broad highway of the Commonplace. There is another thing —the ease with which I can conjure up visions. This faculty if cultivated would soon enable me to see as realities most delightful things, but my reaction would be beyond my control and would inevitably

[60] *Ibid.*, pp. 411–412.
[61] Vedder was concerned about being innovative as a book designer. He felt that "the effect of the page ought to be strong . . . in fact, I want to make the book a marked contrast with the namby-pamby style now current." Letter to M. Reich, June 28, 1883, Houghton Library, Harvard University. For reproductions of these and something of his achievements as an illustrator, see Marjorie Reich, "The Imagination of Elihu Vedder—as Revealed in His Book Illustrations, "*American Art Journal* 6, no. 1 (May 1974): 39–53.

follow and be sure to create images of horror indescribable. A few experiences have shown me that that way madness lies; and so, while I have rendered my Heaven somewhat tame, at least my Hell remains quite endurable. Thus it comes that Blake can wander with delight and retain his mental health in an atmosphere which would prove fatal to me.[62]

John La Farge (1835–1910), like Vedder, indeed more than Vedder, was a success, gaining fame as the leading American stained-glass designer and maker of his time.[63] Like Vedder, a mystic strain runs through his thinking and some of his art.

The son of Jean Frédéric de la Farge, a French immigrant who had known the perils of the French Revolution, fought naval battles in Santo Domingo in the ill-fated Napoleonic expedition there, and become wealthy through his real estate dealings in America, John La Farge was brought up surrounded at home by paintings of Claude-Joseph Vernet, Salvator Rosa, and Jacob van Ruisdael.[64] Throughout his life he projected an air of gentility and remoteness, and, it was written of him, "had a distaste for the promiscuous shaking of hands."[65] This is not to say that he was a recluse like Ryder, haunted by childhood legends like Rimmer, a devotee of Swedenborg's teachings like Page and Inness, a misanthrope like Quidor, and so on. Still, just as Vedder had sought wondrous realms within his own musings, La Farge sought them in real places within this world, strange places for the time not frequented by American artists. With his friend Henry Adams (1838–1918) he traveled to Japan in 1886 and to the South Seas in 1890, staying for more than a year in Tahiti (he arrived there about a year before Paul Gauguin, 1848–1903).

Tahiti became for him the fulfillment of his yearning for the legendary and elegiac. As he approached the island, he recorded in his *Reminiscences of the South Seas* (1912), he believed that "our feelings are intensified because they are directed toward a far-off island; a

[62] Vedder, *Digressions,* pp. 408–409.

[63] La Farge started experimenting with glass in 1877. Among his many commissions for stained-glass windows were those for Memorial Hall at Harvard University, executed in 1878, and those for Boston's Trinity Church, installed in 1887. From 1882 to 1884 he made stained glass and carved and inlaid panels for the Vanderbilt houses in New York.

[64] Royal Cortissoz, *John La Farge, A Memoir and Study* (Boston and New York: Houghton Mifflin, 1911), chap. 1.

[65] *Ibid.,* p. 1.

world, a thing of all time marked by men as something wherein to place the ideal, the supernatural."[66] La Farge did not go as far as Gauguin in living with the people and staying with their women, but he did observe them at length and mingled closely with them. He studied the Tahitian civilization. There are lengthy descriptions in the *Reminiscences* of their customs, rites, and ceremonies, such as this passage on Tahitian dances: "There were dances of the hammer and of gathering the cocoanuts by climbing, and then breaking them; and of the war canoes, with the urging of the steersman and the anxious paddling of the crew; and a dance of the Bath, in which the woman splashed water over her pursuer, as she moved with great stretching of arms as of swimming."[67]

Five years earlier, before boarding the boat at San Francisco for Japan, La Farge had told a newspaper reporter that he and Henry Adams were going to look for Nirvana.[68] Now, obviously, he did not come to Tahiti merely as a vacation spot. To him the Tahitians were a beautiful race, living in a kind of time gap—in "a life that recalled the silver if not the golden age."[69] Throughout the *Reminiscences* are passages in which La Farge compares the Tahitians to Greek statues, which was the artist's dream of man's perfection. If he could, he would have shaken off the hold that his own weary civilization had on him and become like them. Recalling that Queen Marau had made him by adoption a member of the royal family of Tahiti, he wrote, years later: "If only when I received my name [i.e., Teraaitua] and its associations I could have been given the memories of my long youth; the reminiscence of similar days spent in an exquisite climate, in the simplest evolution of society, in great nearness to Nature, that I might find comfort in those recollections against the weariness of that civilized life which is to surround me my few remaining years."[70]

I have worked backward, from the material fact of the visionary paintings themselves, to ask whether there existed in nineteenth-cen-

[66] John La Farge, *Reminiscences of the South Seas* (Garden City, N.Y.: Doubleday, Page & Co., 1912), p. 298.
[67] *Ibid.*, p. 165.
[68] Henry La Farge, *John La Farge, Oils and Watercolors*, catalogue (New York: Kennedy Galleries, 1968), pages unnumbered.
[69] La Farge, *Reminiscences.*, pp. 345–346. La Farge observed here that the Tahitians were a gentle people, "free from cruel and terrible superstitions of many savage tribes."
[70] *Ibid.*, p. 386.

tury American painting something that can be called the visionary personality. The answer, insofar as the evidence presents itself (and insofar as I selected it), is a very qualified yes. This "personality" does not comprise a single trait or habit, or point of origin, or even mode of living. Some of these twelve visionaries shunned their fellowmen while living among them (Quidor, Rimmer), while others (Ryder, Fuller on his farm, Newman) lived as solitaries and at times as isolates. One (La Farge) lived for over a year among Tahitians, and one (Blakelock) for twenty years in a sanitarium for the insane. Some (Inness, Page) were mystically inclined, and one (Vedder) worked like an athlete to keep his imagination always at high pitch. Some (Vedder, Page) lived in Europe for a large part of their creative life. Most preferred the city, but one (Fuller) lived on a farm for sixteen years, and one (Field) came from a small town and stayed in small towns for almost all his long life. In spite of these diversities, no other grouping of nineteenth-century American painters (genre painters, still-life painters, history painters, landscape painters, watercolor painters) were, in their various ways, as much outsiders. Hence, I call these twelve painters the visionary eccentrics. Also, to paint as a visionary in nineteenth-century America was to run against the grain, and this in itself would have reinforced the sense of inwardness that was, I suspect, part of these men to begin with.

3

The Visionary Eccentrics I:
The Subterranean Visionaries

In their paintings, the visionary eccentrics were as different—in their imagery and their choices of colors and ways of visualizing—as they were in the unfolding of their lives. Nineteenth-century American visionary painting is not a style but an approach, a predisposition, a set. On the broadest level this much is true: Ryder, Newman, Inness (in the last decade of his career), and Quidor (in the latter part of his career) achieve their results in large part through the resonance of their colors, which are sometimes deep and throbbing, sometimes softly elegiac (Quidor). Dewing, Page, and Fuller, especially, and to an extent Newman, Inness, and Blakelock present scenes that at first glance seem quite "normal." At first glance. Further perusal reveals that within the ordinary-seeming, there is something askew; there is something of the uncanny lurking.

Rimmer, Vedder, La Farge, and Field, on the other hand, present scenes that are obviously bizarre. I call them *subterranean visionaries.* They remind us a bit of the contemporary European Symbolists and may be seen, like them, to anticipate twentieth-century veristic Surrealism. Upon their canvases an entirely unfamiliar world is brought forth, a world of dreams, one divorced from wake-a-day reality. It is a world filled with hybrids (Vedder's *Questioner of the Sphinx* and *Sphinx of the Seashore*, Rimmer's *Evening, or the Fall of Day*), heads floating on the water (La Farge's *Strange Thing Little Kiosai Saw in the River*) and in the air (Vedder's *Memory*), Moorish-looking re-

splendent halls (Rimmer's *Flight and Pursuit*), phantasmagorical buildings (Field's *Historical Monument of the American Republic*), and fierce humanlike beasts (La Farge's *Uncanny Badger*). The distinctions among these groupings are not always maintained. One of Ryder's most bizarre paintings belong to this category. It is *The Race Track, or Death on a Pale Horse*, one of the last he did: In it the figure of Death holding a scythe rides alone around a deserted racetrack. And also Quidor's illustrations for Washington Irving's frightening tale "The Devil and Tom Walker."

Miraculous occurrences and many supernatural figures of course abound in paintings of the visionaries of the spectacular. But the auras projected in these paintings, dating before 1850, and in those of Rimmer, Vedder, La Farge, Field, and a few others of Ryder and Quidor of the period after 1850 are as different as can be. With the visionaries of the spectacular, as I've tried to point out in chapter 1, grandiloquent messages are contained in a catastrophist framework. Implied here is a world that, if not controllable, follows certain predictable courses plotted on gradients of ascent and descent. With the subterranean visionaries the subjects are privately obscure and esoterically remote, sometimes mysterious to this day.

One such painting, William Rimmer's *Flight and Pursuit* (1872), in the Boston Museum of Fine Arts, is extraordinarily intriguing. It has invited interpretations of which at least three have been put forth recently. It is a picture of a bearded, caped man, dressed in a tunic, racing through a Moorish hall. An endless, it seems, number of halls identical with the one in the foreground recede into the distance. In the second hall there is a curiously insubstantial hooded, heavily draped figure, spear in hand, whose running position nearly parallels that of the bearded man. The bearded man is preceded by his own shadow and followed by a sort of two-headed shadow, which could be cast by his two unseen pursuers. Jean Lipman and Helen M. Franc have suggested that Ralph Waldo Emerson's poem "Brahma" (1857) may have served as the point of departure for the painting.[1] Connoting the interchangeability of cause and effect, of actor and acted upon, Emerson wrote in "Brahma's" first stanza:

[1] Jean Lipman and Helen M. Franc, *Bright Stars: American Painting and Sculpture Since 1776* (New York: E. P. Dutton, 1976), p. 99.

If the red slayer think he slays,
Or if the slain think he is slain,
They know not well the subtle ways
I keep, and pass, and turn again.

Charles A. Sarnoff, a psychoanalyst, held that the key to Rimmer's painting lies in the variant title "On the Horns of the Altar."[2] Murderers who killed without premeditation were allowed, according to Exodus 21:12, to find refuge at the horns of the altar.[3] Sarnoff connected the idea of flight and refuge with Rimmer's own past, with the legend that he was the rightful heir to the French throne and was hunted by assassins sent by Louis XVIII, who had unjustly usurped that throne.[4] Finally, Marcia Goldberg, also seizing upon the variant title, has put forth an electrifying theory, in which the painting is tied to a specific flight—that of John Surratt, who had been sought throughout the world for his alleged complicity in Lincoln's assassination.[5] Before he was finally apprehended in Alexandria, Egypt, in November 1866, Surratt had been in Canada, Liverpool, and Rome, always, as Goldberg emphasizes, given protection by priests,[6] a fact that fits well within the concept of the altar as the source of refuge. Headlines announcing Surratt's imminent capture that appeared in New York newspapers on November 26, 1866, were probably seen by Rimmer, who was then heading Cooper Union's School of Design for Women.

These interpretations, however resourceful, are not ultimately satisfying to me. *Flight and Pursuit* remains for me as much a mystery

[2] Charles A. Sarnoff, "The Meaning of William Rimmer's *Flight and Pursuit*," *American Art Journal* 6, no. 1 (May 1973): 18–19. According to Flexner, Rimmer gave *Flight and Pursuit* a "variant title," which was "On the Horns of the Altar." James Thomas Flexner, *That Wilder Image* (New York: Dover, 1970), p. 173. According to Rimmer's biographer Truman H. Bartlett, however, Rimmer called a pencil sketch for the painting "Oh, For the Horns of the Altar!" Bartlett *The Art of William Rimmer: Sculptor, Painter, and Physician* (Boston, 1882), p. 127.

[3] The ancient Israelite altar had actual horns at the four corners. These were provided for in the instructions for its building in Exodus 27:2.

[4] "Hunter and the hunted, usurper and usurped, killer and he who may be about to die, Rimmer has portrayed them all in *Flight and Pursuit*." Sarnoff, "Meaning of *Flight and Pursuit*," p. 19.

[5] Marcia Goldberg, "William Rimmer's *Flight and Pursuit*: An Allegory of Assassination," *Art Bulletin* 58, no. 2 (June 1976): 234–240.

[6] *Ibid.*, p. 235.

as ever. Why, I ask myself, would Rimmer, in this single instance, have chosen as the basis of a painting the poem of a contemporary writer, and one who had been closer to his father than to him?[7] And is the painting really a visualization of Emerson's particular brand of pantheism offered in "Brahma"? That is, were Rimmer's two figures, who are running in a nearly identical manner and in the same direction (one clearly is not pursuing the other), meant as an illustration of the lines in the third stanza: "They reckon ill who leave me out;/When me they fly, I am the wings;/I am the doubter and the doubt"? Unlikely, I think. Sarnoff, who sees *Flight and Pursuit* as a reflection of Rimmer's childhood fear of pursuit and assassination and the shadows behind the foreground figure as cast by his pursuers (Louis XVIII's agents), does not get at the central issue of the relationship between the two figures. Lipman and Franc suggest that the painting is "an allegory of man and his conscience,"[8] and so try to get at the meaning of the two figures but do not expand on their idea. Goldberg, identifying the shadowy figure with Surratt while evading the question of the identity or meaning of the more palpable foreground figure,[9] might be hard put to defend her interpretation against some obvious questions. For instance, if the painting is tied to Surratt's flight, why did Rimmer wait until six years after the apprehension to undertake the subject? (In 1868 Surratt was discharged because of the statute of limitations—four years before the painting of *Flight and Pursuit*—and quickly slipped into anonymity.) In other subjects having to do with the Civil War, usually pencil drawings, Rimmer dealt with broad issues—a pencil drawing in the Boston Museum of Fine Arts called *Secessia and Columbia* (1862) portrays a clash between the symbolical figures of the North and the South—or groups of people—*A Border Family* (1862), another pencil drawing, is in the Fogg Museum in Cambridge. He did not deal with

[7] Besides, Rimmer was closest to Emerson from 1848 to 1850. Rimmer's father, Thomas, died in 1852. Lincoln Kirstein, *William Rimmer 1816–1879*, catalogue (New York: Whitney Museum, 1946), pages unnumbered. This was more than twenty years before *Flight and Pursuit* was painted.

[8] Lipman and Franc, *Bright Stars*, p. 99.

[9] Goldberg clearly suggests that the second, heavily draped figure is Surratt by writing that he "is covered with voluminous drapery as if his identity is to be hidden." Goldberg, "Rimmer's *Flight and Pursuit*," p. 235. Who, then, is the foreground figure?

single, identifiable figures.[10] Why are we to assume, with Goldberg, that he did so in the case of *Flight and Pursuit?*

But the alternate title, "On the Horns of the Altar," does establish, if not the ultimate meaning of the painting, its source in Israel's ancient proscription for those who murdered accidentally or on the spur of the moment. The two figures in the painting, the scraggly one in the foreground and the phantomlike one with his spear, could well be murderers running for the refuge offered by the altar. Thus, Rimmer, like several visionaries of the spectacular, used the Bible as a spring-board—but what a different sort of passage attracted him! The vision-aries of the spectacular, in keeping with their interest in catastrophism, went to well-known passages with a marked eschatological content: Hicks to Isaiah 11:6–9; West to Revelations 6:8 for his *Death on the Pale Horse;* Allston to Daniel, chapter 5, for his *Belshazzar's Feast,* and so forth. They were drawn to themes dealing with the end of days of the nation or of all mankind. Rimmer was drawn to a law deal-ing with the safety and punishment of the individual wrongdoer. Did he see himself as such? Sarnoff postulates a connection between the fleeing figure(s) and Rimmer himself. In any event, we find in Rim-mer, as a subterranean visionary, a predilection for an obscure per-sonal symbolism derived from a very rarely regarded biblical subject.

Nathaniel Hawthorne's (1804–1864) *Marble Faun* was published in 1860. It is an allegorical romance dealing with compulsion, the am-biguity of guilt, and the impossibility of escaping one's destiny. In this novel, Miriam, a mysterious artist living in Rome, is loved by Dona-tello, an innocent, sunny Italian, who physically resembles the statue of a faun by Praxiteles. One day Miriam and Donatello, accompanied by Hilda, an artist friend of Miriam, and Kenyon, an American sculptor, visit the catacombs and explore their shadowy recesses by torchlight (this in chapter 3, which is titled "Subterranean Reminiscences"). Mir-iam goes off by herself and returns with a strange man she has met in one of the tombs. This mysterious figure, her persecutor, follows her constantly. Days later, atop the Tarpeian rock, from which the ancient

[10] An exception of sorts is his pencil drawing of 1863 in the Boston Museum of Fine Arts *To the 54th Regiment of Massachusetts Volunteers.* This was dedicated to the first Negro regiment in a Northern state. The regiment was commanded by Robert Gould Shaw (1837–1863). In the drawing, the soldiers are represented as Greek hoplites and, significantly, none of them can be identified as Shaw.

Romans used to throw their criminals, Donatello attacks the persecutor and, heeding the look in Miriam's eyes, throws him over the cliff to his death. Donatello and Miriam, sharing in a crime, draw closer together, as Donatello becomes burdened by his conscience and, of course, less innocent. Hilda, who has witnessed the murder, confesses to a priest in Saint Peter's—and the secret is out. Donatello is sentenced to prison, but Miriam, who had commanded the murder by her look, escapes prosecution. At this point, Hawthorne reveals that her family had been involved in a crime and that she had come to Rome to evade her past (which reappeared in the form of her persecutor). She ends up isolated and miserable, haunted by her own guilt and dedicated to penitence. Various critics have remarked that Hawthorne intended to show that Donatello, at the beginning, was like innocent Adam before the Fall and that his encounter with evil, however disastrous, was elevating and humanizing. Miriam shows that sin is "original" and ever-renewed.[11]

In a book on nineteenth-century American art, I may have gone on here a bit too long on contemporary American literature. But I have done so to show, as I tried to do earlier in the chapter on the "Visionaries of the Spectacular," that the adumbrations of some of these paintings are not drawn in isolation. *Flight and Pursuit* does not specifically say all that *The Marble Faun* does; still, the eerie sense that one gets from both is somewhat the same. So, too, are the issues of flight and guilt. *Flight and Pursuit* is a "literary" kind of painting, and the two men fleeing their unseen pursuers, running presumably for the horns of the altar because of their guilt, may be linked to Miriam seeking to escape her destiny, or, by extension, as Sarnoff would say, to Rimmer himself, seeking to escape his assumed destiny, in the form of assassins or the throne of France.

Rimmer combined his own very careful studies of anatomy[12] with his insights into the paintings and drawings of Blake, which he saw in reproduction, and the sculpture of the ancient Greeks and of Michel-

[11] See, for example, Hyatt H. Waggoner, "The Marble Faun," in *Hawthorne: A Collection of Critical Essays*, ed. A. N. Kaul (Englewood Cliffs, N.J.: Prentice-Hall, 1966), pp. 164–176.

[12] Rimmer's *Art Anatomy*, originally published in 1877, was meant, with its plates, as a kind of textbook to present the figure in a number of poses and facial expressions, at rest and in motion, emotionally calm and in turmoil. In 1879 the plates and the unsold copies were destroyed by fire. *Art Anatomy* was republished in London in 1884, and in subsequent editions.

angelo, which he saw as casts at the Boston Athenaeum, to produce what were probably the most difficult and expressive figurative poses in nineteenth-century American art. There are drooping figures, figures floating or flying or hurtling through the air, figures expiring and falling in a variety of positions. In the bronze *Dying Centaur* (1871) the humanoid painfully sinks slowly to the ground, while the clay *Falling Gladiator* (1861), no longer in control of his limbs, is shown falling over backward. One of the most beautiful of the painted figures, called *Evening, or the Fall of Day* (c.1869), falls backward in a kind of cir-

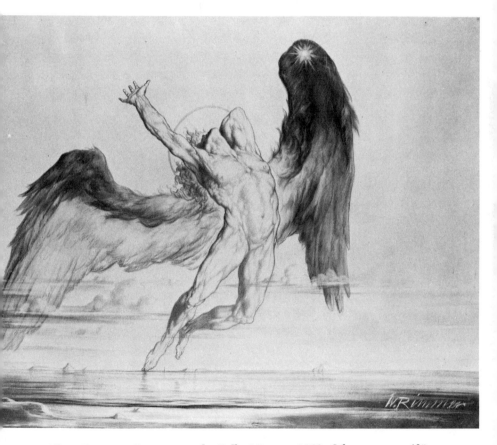

William Rimmer: *Evening, or the Fall of Day.* c. 1869. Oil on canvas. 40″ x 50″. Museum of Fine Arts, Boston.

cular motion even while sinking downward. The falling action is meant to suggest the gentle setting of the sun and the onset of evening. Probably Rimmer's idea of the human figure symbolizing a stage of the day came from Michelangelo's Medici Tombs. The figure and his wings are colored in the most delicate bistre tones. The edges of the wings dip in cloud banks. The waterscape below the airborne figure—Rimmer is never given credit for his seldom revealed abilities as a landscapist[13]— catches nuances of reflections and encompasses a vastness that cannot be duly assessed in photographic reproductions. Pencil and crayon sketches for the painting exist. In the Boston Museum of Fine Arts, I was shown a pencil drawing for what may have been Rimmer's conception for a companion painting to the *Evening*. I saw a baby cradled

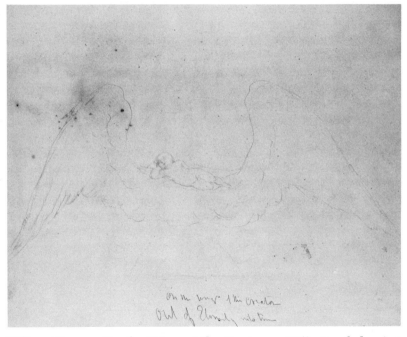

William Rimmer: *On the Wings of the Creator*. c. 1870. Pencil drawing. 11^{15}/$_{16}$" x 14⅜". Museum of Fine Arts, Boston; Bequest from the estate of Frank C. Doble.

[13] I discovered, in the stacks of the Boston Museum of Fine Arts, a lush landscape of Rimmer's, a hunting scene, with a ruined castle and figures in sixteenth-century costume.

upon great wings soaring through the air. The drawing is inscribed by Rimmer: "On the wings of the Creator/out of Eternity into Time." There is a bothersome sentimentalism about this rapidly executed sketch, and possibly Rimmer intended to work further on the idea. But, in America, it was a fresh concept for the time, a grandiose one, and even through this sketch the power of Rimmer's imagination is revealed.

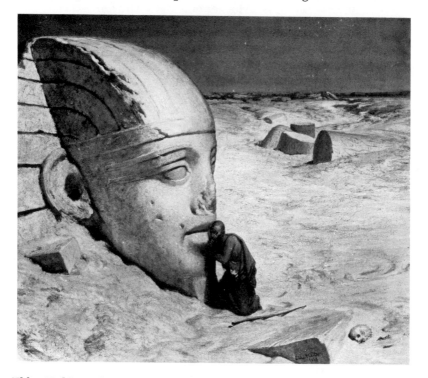

Elihu Vedder: *The Questioner of the Sphinx.* 1863. Oil on canvas. 35¾" x 42". Museum of Fine Arts, Boston; Bequest of Mrs. Martin Brimmer.

Elihu Vedder is best known for his mythical creatures in paintings like *The Lair of the Sea Serpent* (1864), *The Questioner of the Sphinx* (1863), *The Sphinx of the Seashore* (1890), and so forth. The most uncannily disturbing picture I've ever seen of Vedder's, though, is one of his least known. It is titled *Lazarus* (1899). I came upon it one day in early March 1977 in the basement stacks of the Boston Museum of Fine Arts while looking for some Rimmers that had been stored there. If

ever there was a painting that seemed to "leap out at me," this was one. In traditional versions of the subject, such as those by Giotto, in the Arena Chapel, and Rembrandt (which Van Gogh later copied in part), Lazarus, being brought to life by Christ, is shown in a ghostly pallor, still in his shroud. Vedder decided to show his Lazarus awhile after he had arisen, still wrapped in bandages but intensely alive. Christ is not in sight, and there is no evidence of a tomb. The somewhat elegant, moustached man could be virtually anyone of his apparent class and breeding. Although he is situated in a dry Near Eastern sort of terrain, there is nothing to indicate that something supernatural had taken place. The day is bright but calm and ordinary. What is striking is the closeness of this Lazarus, the way, cut off near the shoulders, he is thrust up at us, uncomfortably immediate. It is this that registers as this Lazarus's sudden aliveness. Vedder has limited his painting to three dull colors—blue for the sky, brown for the mountainous landscape, gray for the figure—to make the man's presence all the closer. So close to us does he seem, so without the "breathing room" that we normally give one another as amenities, that we feel him as belonging to a different order of reality. All this is accomplished without the props commonly associated with the portrayal of the supernatural. Vedder's use here of the extreme close-up, and of the bizarre effect he obtains through it, looks forward to that device in the photography of the last two decades to the work, for example, of such a portraitist as Diane Arbus (1923–1971), who makes the prosaic extraordinary through the fixity with which she presents it.[14]

Vedder's pictures of hybrids and other mythical creatures strike me as more contrived than his *Lazarus*. This is not to say that they are not engagingly fanciful. Perhaps it is the illustrative about them that keeps them from being genuinely terrifying for me—if, indeed, this had been Vedder's intention. The longer I know these pictures, the more I see some of them as a kind of spoof, like *The Sphinx of the Seashore*, in the Fleischman Collection. This could also be said of others to a lesser extent. If the *Lazarus* is vintage Alfred Hitchcock, then *The Sphinx of the Seashore* would be like the offspring of *The Exorcist*, imitations of which deluged American cinema from 1974 to 1976. Vedder himself, I believe, regarded some of his creations with a kind of tongue-in-cheek attitude, and it would be a mistake on our part to take them all

[14] See *Diane Arbus,* An Aperture Monograph (Millerton, N.Y.: Aperture, Inc., 1972).

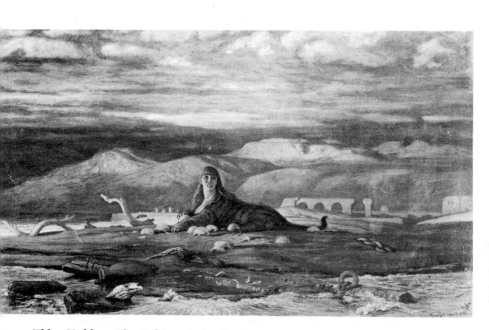

Elihu Vedder: *The Sphinx of the Seashore*. 1890. Oil on canvas. 16¼″ x 28¼″. Fleischman Collection, New York. Photograph: Kennedy Galleries, New York.

with a deadly seriousness just because they were so unusual for their time in America. Some of the most famous of the monster pictures, such as *The Lair of the Sea Serpent*, were being painted while the Civil War was raging and Vedder was taking his leisure at a Bohemian hangout in New York City, Pfaff's, on the corner of Broadway and Bond Street: "Pfaff's was situated in a basement, and the room under the sidewalk was the den where writers and artists—the latter mostly drawers on wood but not drinkers of water—met."[15] Vedder mentions in the *Digressions* that *The Lair of the Sea Serpent* was called by "the Boys" the "Big Eel," and *The Lost Mind*, "The Idiot and the Bath-Towel."[16]

Vedder came back to New York in 1861 after having studied in Florence for four years, where he had been associated with a group

[15] Elihu Vedder, *The Digressions of V. Written for His Own Fun and That of His Friends* (Boston and New York: Houghton Mifflin, 1910), p. 226.
[16] *Ibid.*, p. 241. Here Vedder dismissed the rumor that the model was a dead eel.

of Italian artists known as the Macchiaioli.[17] Why he was not drafted into the Union Army then when he was in his mid-twenties is a moot point. Vedder ventures that he "had already been shot once and could not have carried a gun a block in [his] left hand."[18] With his attraction to violence, he may well have been shot earlier, although whether this injury was serious enough to keep him out of the army is a little questionable, since he goes to some lengths to vindicate his evasion of the fighting for the days spent at Pfaff's.[19] He saw the New York draft riots at firsthand. At any rate, some of the hybrid and monster pictures should be seen against the backdrop of Pfaff's and the group that habitually congregated there. Regina Soria describes this society as one self-consciously trying to strike a pose of a cultivated weirdness. "As for the poets," she writes, "Poe's ghost presided over their tables at Pfaff's. 'Strange watchers watched beside my bed,' sang the young [Thomas Bailey] Aldrich [1836–1907], while Fritz Hugh Ludlow composed a 'weird' poem, 'The Hasheesh Eater.' "[20] One of the "boys" mentioned by Vedder was George Arnold (1839–1865), who used to sit by him while he was painting. This was when he was beginning *The Questioner of the Sphinx*. At Pfaff's, Arnold read for Vedder his poem "Here I Sit Drinking My Beer." Vedder adds: "He died young; I do not know of what he died, but he seemed to be worn out even when I first met him. . . . He thought his life a wasted life; it was with him a gorgeous romance [referring to the one woman who showed up at the funeral] of youthful despair."[21] There were droll and affected types

[17] The group, active around 1855–1865, was broadly antiacademic in sentiment. Its name had to do with the revelation of the individual touch or blob of paint. Some were influenced by Gustave Courbet and Jean Baptiste Camille Corot (Silvestro Lega, Fattori), some by Impressionism (de Nettis, Giovanni Boldini), while some turned out pseudoromantic history pieces.

[18] Vedder, *Digressions*, p. 233.

[19] *Ibid.* Vedder states that his name was down and that he took his chance with the others in the draft. Whether he was not taken because of his presumably injured left hand he does not make clear. He goes right into describing those friends who came back injured and mutilated (recalling his boyhood associations with mutilations). There was a friend named Coleman who was shot near the left corner of the mouth with the ball coming out of the neck under the ear; and another, George Butler, who lost his left arm at Gettysburg, "and ever afterwards made a fine martial figure with his empty sleeve"; etc. The wounded seem to serve as sufficient pretext for Vedder's not having served.

[20] Regina Soria, "Elihu Vedder's Mythical Creatures," *Art Quarterly* 26, no. 2 (Summer 1963): 182. The experiences at Pfaff's stayed with Vedder. Years later he illustrated a poem by Aldrich evoking the memory of those days.

[21] Vedder, *Digressions*, p. 228.

aplenty. Sometimes the drollness was mixed with tragedy; as with Ada Claire, termed "The Queen of Bohemia," who died of rabies contracted from her pet dog.[22] So, of the subterranean visionaries, where Rimmer is grand and mysterious; Field, playfully extravagant; La Farge, attuned to what is awesome and atavistic—Vedder, it's not surprising, is self-indulgently and at times grotesquely outlandish. This direction, laid down during his Civil War stay in New York, was continued throughout his long career abroad.

The landscape in *The Lair of the Sea Serpent* (1864), even more than that in the *Lazarus*, seems a representation of a specific spot, some bit of hilly beach. Friends of Vedder thought they knew the place near Boston. They were wrong; Vedder "drew it all out of [his] head." (But walking on that beach with them, he was astonished to find peering out of the sand what looked like a human eye. It turned out to be the glass eye of a doll.[23] Vedder was always turning up oddities of that kind.) What could be a garter snake is made to look like a menacing python; what could be a little hill of sand, like a gigantic dune. It's all done through the close-up and isolation of the subject, its placement on a kind of vantage point overlooking the sweep of the beach—and then letting our natural revulsion for all sorts of slithering creatures give play in our imagination. Then the deserted site and the calm brightness of the day lead us to suppose that this creature we are looking at is existing in primeval times, before the presence of man upon the earth, long before even the time of Cole's *Titan's Goblet*, when the earth was presumably inhabited by a race of giants. The sphinx is another mythic creature, but one, in its graven form, existing at the dawn of civilization. In his *Questioner of the Sphinx*, also painted during the Civil War, Vedder shows the gigantic monument, still partially buried in the desert's sand (before the archaeologists were to get at it), being questioned, as though it were alive and could solve problems, by a rather wizened Arab. (It is the reverse of the usual role the sphinx has played in literature, questioning rather than being questioned.) Compared with the later *Sphinx of the Seashore*, which can be characterized without any hesitation, I think, as kitsch, *The Questioner of the Sphinx* has the sense of some hidden, forgotten legend. *The Lost Mind* (1864–1865), of that period, in The Metropolitan Museum of Art, New York, called by "the boys" with a bit of justification "The

[22] Soria, "Vedder's Mythical Creatures."
[23] Vedder, *Digressions*, pp. 256–265.

Elihu Vedder: *The Lost Mind.* 1864–1865. Oil on canvas. 39⅛″ x
23¼″. The Metropolitan Museum of Art, New York; Bequest of
Helen L. Bullard in memory of Laura C. Bullard, 1921.

Idiot and the Bath-Towel," has the deranged wanderer placed, appropriately, Vedder must have thought, in an eerie lunar kind of landscape. But the painter's effectiveness with his mythic creatures is not carried over here. Vedder, at home with the bizarre, had a perverse attraction to, not an empathy with, misfortune and suffering. His *Lost Mind* is one to be stared at, even laughed at, at best pitied a little. Exploited is a tawdry sensationalism that lies on a lower level than the frightening empathy Jean Louis André Théodore Géricault (1791–1824) managed in his portrayals of the insane of forty-five years earlier.

Whatever can be mustered against Vedder, there is this, above all: Of all the visionary eccentrics he fostered best the taste for the ultimately bizarre, the recherché. His is the sensibility that is most distinctly alien. No one besides him could have or would have conceived of the image of the airborne head titled *Memory* (1870), which is in The Los Angeles County Museum. Nothing more strange can be found in Redon (who also liked airborne heads) or in the work of any other contemporary European Symbolist.

Elihu Vedder: *Memory.* 1870. Oil on mahogany panel. 21″ x 16″. Los Angeles County Museum of Art, California; Mr. and Mrs. William Preston Harrison Collection.

Vedder looked upon John La Farge as one of the great personalities and painters America produced: "If William Morris Hunt was comforting, La Farge was inspiring; I have never met anyone more so, and it was only my imperviousness that prevented my profiting more by his advice and example." He spent some time with La Farge in Boston in the 1890s, when he was back in America to execute murals that had been commissioned. He was much taken by La Farge's writings—"his words seem to hover about a thought as butterflies hover about the perfume of a flower"—and, among his paintings, the flower pieces— "This quality of subtlety is shown in those never-to-be-forgotten flowers . . . where the outside air faintly stirring the lace curtains seems to waft the odour towards you."[24] Some of the flower pieces can, indeed, be seen as visionary, but when the flowers are presented in great bunches of tropical flora in the South Sea Island pictures, the result is not too different from what might be offered by an artist of today in the employ of *National Geographic* magazine. La Farge sought his Nirvana, as he himself put it, in Japan and the South Sea Islands, and we should have expected that in his representations of those mythic places, reality would be metamorphosed into scenes of an especially subterranean visionary quality. The dry reportage in the pictures of South Sea Island civilizations is as different as can be from, for example, what we find in Gauguin's pictures derived from the same material at the same time. Frequently, the images evoked by La Farge's text in *An Artist's Letters from Japan*[25] and *Reminiscences of the South Seas*[26] surpass the images at hand in the accompanying illustrations.[27]

Nonetheless, out of this reportage can come, on occasion, documentation of an extraordinary quality—subjects seen by hardly any other American up to that point, and never recorded before by an

[24] *Ibid.*, pp. 259–260.
[25] John La Farge, *An Artist's Letters from Japan* (New York: Century Co., 1897).
[26] John La Farge, *Reminiscences of the South Seas* (Garden City, N.Y.: Doubleday, Page & Co., 1912).
[27] The captions of some of the illustrations (photographic reproductions of the watercolors) in the *Reminiscences of the South Seas* are suggestive of the documentary approach: "Swimming Dance, Samoa," "Edge of the Aorai Mountain Covered with Cloud, Midday. Papeete, Tahiti," "Edge of Village of Nasogo in Mountain of the Northeast, Viti Levu, Fiji," "Two Taupos Dancing a 'Game of Ball,' Samoa," "Chiefs in War Dress and Paint," "Samoan Courtship. Fasse, the Taupo or Official Virgin and Her Duenna Wait Modestly for the Approach of a Young Chief."

John La Farge: *The Great Bronze Statue of Amida Buddha at Kamakura, Known as the Daibutsu, from the Priest's Garden.* 1886. Watercolor. 15¼" x 18½". Kennedy Galleries, New York.

American artist, certain subjects in themselves of a mythic character. One of these subjects, painted in 1886 in Japan, was a statue, *The Great Bronze Statue of Amida Buddha at Kamakura, Known as the Daibutsu, from the Priest's Garden.* The Buddha, though of human form, is, in his utter imperturbability, as inhuman as any of Vedder's mythical hybrids. In his watercolor La Farge happily chose a commanding vantage point for the great head, catching it above the terrain, with its seeming changing aspects of buildings and mottled foliage. La Farge knew what the image of the Buddha meant and recognized that in

Kamakura, especially since the statue's chapellike enclosure had been swept away, the meaning was realized to perfection. In a particularly insightful passage from his *Artist's Letters from Japan,* originally written down at sea, off Izu, on September 3, 1886, he observed:

> An accident, the breaking of its prison temple by a great cataclysm of nature, a great wave of the sea coming far inland and destroying the great building, has given to the statue something that it could never have had to the physical eye—in the degree it has now. Now, freed from its shrine, the figure sits in contemplation of entire nature, the whole open world that we feel about us, or its symbols—the landscape, the hills, the trees and fields, the sky and its depths, the sunshine playing before the eyes of the seated figure, the air in which dance all things that live in air, from the birds that fly to the atoms of dust, and the drifting leaves and blossoms, the confusion or the peace of the elements, the snow in crystals, and the rain in drops. All this world of ours, which to the contemplative mind is but a gigantic fragment of the universe, lies before the mental gaze of the Buddha. Unwinking, with no change of direction, he looks forever; his will is forever subdued and held beneath him, as his fingers pressed together indicate his freedom from all the disturbances of that part of being which is subject to time and change, and his cognition, undisturbed, envelops and images the universe in final contemplation.[28]

John La Farge: *The Uncanny Badger.* 1897. Watercolor. 8″ x 8″. Kennedy Galleries, New York.

[28] La Farge, *Letters from Japan,* pp. 226–227.

The Uncanny Badger was painted in 1897, eleven years after the voyage to Japan, but the animal had been encountered then. La Farge noted: "With the Japanese the Badger is uncanny. He misleads and deceives by many tricks and takes wayfarers out of the way. Thus he calls at a distance by beating a tatoo on his swollen abdomen. The noise, as I have heard it, is not unlike the muffled roar of the waterfall near by."[29] So, he has placed the animal engaged in a characteristic activity in a habitat natural to it (by the waterfall). But once again, even through his documentary accuracy, La Farge has caught the presentiment of the preternatural. The animal he chose as his subject is at once cuddly like a baby and fierce, unwieldly, and clumsy; it is practically moored in its precarious perch and yet terrifyingly menacing, with its bared teeth and gleaming eyes. Both humanoid and bestial. Both seemingly helpless and seemingly very dangerous. Both frighteningly like us and remote (as the Buddha is also in his way). It is not too much to say that the badger suggests the baby that we all once were, suggests something of the atavistic for all mankind, and that La Farge has seen in that the loathesome and the repellent. Of the subterranean visionaries conjuring up an unfamiliar, dreamlike world, La Farge alone, then, recorded visual data quite accurately. This was because he found that the wide world could contain a reality, unhoned and untransformed, that was in itself as bizarre as our dreams and imaginings.

But another painting of 1897, *The Strange Thing Little Kiosai Saw in the River,* in The Metropolitan Museum of Art, New York, is presumably based on hearsay rather than on what La Farge saw for himself. It seems that one day Kiosai (a Japanese boy) saw a body, or a head, floating in the river, and this was reported to La Farge. The head seems peaceful enough, even asleep; the event it portends (murder? drowning? suicide?) is terrible. Again, the intimated reality beyond the surface appearance. It is an ordinary-enough head (although apparently Japanese) floating on the surface of the water. Without the eddies and the blossoms in the water it could almost be a woman leisurely submerged in her bath. The effect is achieved through the understatement of the strange image—no Moorish halls or mysterious caped figures, as in the *Flight and Pursuit*—as well as through its provocative title. As with Blakelock and his trip to the West, memories of the trip to Japan haunted La Farge years later, long after his return.

[29] Quoted in Henry La Farge, *John La Farge, Oils and Watercolors*, catalogue (New York: Kennedy Galleries, 1968), pages unnumbered.

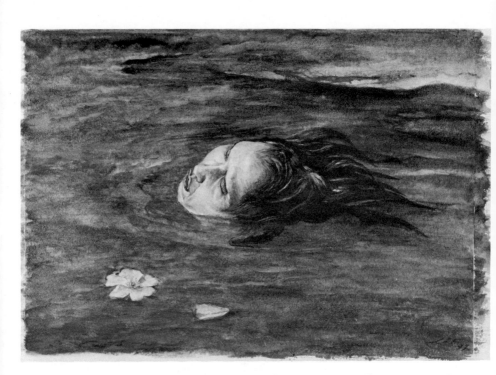

John La Farge: *The Strange Thing Little Kiosai Saw in the River.* 1897.
Watercolor. 12¾″ x 18″. The Metropolitan Museum of Art, New York; Rogers
Fund, 1917.

Neither Rimmer's *Flight and Pursuit* nor Cole's *Consummation of
Empire* is the most extravagantly fanciful architectural painting of the
century. It is Erastus Salisbury Field's largest painting, the *Historical
Monument of the American Republic* (c.1876), in the Springfield
(Mass.) Museum of Fine Arts. Probably the grouping of gigantic tow-
ers interconnected at the top by a network of steel bridges, which con-
vey the visitors by means of small steam-driven trains, was first
conceived of as an entry for a competition for the design of buildings
for the Centennial Exposition in Philadelphia.[30] Field intended, or
hoped, that these towers would indeed be built. He admitted that "a

[30] This proposition, Frederick B. Robinson, former director of the Springfield
Museum, admits, is conjectural. The painting was finished after the opening of
the Centennial, and none of the buildings on the Centennial grounds resembled
Field's buildings. Frederick B. Robinson, "The Eighth Wonder of Erastus Field,"
American Heritage 14, no. 3 (April 1963): 13.

professional architect, on looking at this picture, might have the impression that a structure built in this form would not stand." So he advised that the towers be filled with concrete "in one solid mass, all but the center and the entrance through each tower. . . . The center in each tower could be sufficiently large for circular stairs to reach to the top."[31]

The towers in the painting are adorned profusely with bas-reliefs and statuary commemorating and extolling the American past. That the basis of the Republic ought to be the teachings of the Bible is brought forth through the essay inscribed upon the base of tower 4. This begins with the words: "The Bible is a brief recital of all that is past and a certain prediction of all that is to come. It settles all matters of debate." The sculptures spread over the façades are so voluminous and multifarious that I would need pages to review them in detail. Towers 1 and 2 represent pre-Colonial history, and so on, through the span of American history. Some of the reliefs are modeled after famous paintings, such as West's *Penn's Treaty with the Indians* (1771) and Trumbull's *Declaration of Independence* (1786-1794). Tower 7 represents the Civil War. Tower 8, dedicated to the Constitution, actually celebrates Lincoln, whom Field admired, especially for his stand on slavery. Near the main entrance Lincoln is in the act of turning wheels, "which indicates that he kept the government machinery in regular operation during the terrible conflict."[32] At the top of this tower, Lincoln, being crowned by an angel, is about to ascend to heaven in a fiery chariot. Tower 8 is a smaller tower, which does not rise up to the network of train bridges. Its uniqueness is established by the great detailing given it and by its position in the forefront and in the center of the composition. On the extensive grounds before the veritable forest of towers—the painting is over thirteen feet in length—Field placed soldiers on parade and strollers taking in the spectacle. It is all meant as a paean to America at her Centennial, by a seventy-one-year-old man, who, for decades, as an itinerant painter, traveled her back roads safely in southern New England. And the scene, as it is presented, is a naïve re-creation of the actual Exposition in Philadelphia, which Field must have visited while involved with his painting.

[31] Erastus S. Field, *Descriptive Catalogue of the "Historical Monument of the American Republic"* (Amherst, Mass., 1876). Robinson points out that Field's concern with how his towers would stand indicates that he hoped they would be built. Robinson, "Eighth Wonder of Field."

[32] Field, *Descriptive Catalogue.*

Though there is nothing quite like the *Historical Monument* in Field's previous visionary painting based on the Old Testament, there, too, the love of panoply and large crowds is evident. These biblical pictures differ from those by such visionaries of the spectacular, before 1850, as West, Allston, and Hicks in this respect: The themes, even when catastrophist, are treated in so compelling a narrative manner that any eschatological innuendos they may have are lost on the viewer. In the cycle of paintings dealing with the plagues God visited upon the Egyptians and the resultant escape of the Israelites from bondage, we cannot but marvel at Field's ability, while working in his stiffish, primitive manner, to organize masses of people or to place groups engaged in a variety of activities within a great columned hall. In *The Death of the First Born* (c.1870), in the Garbisch Collection, Cambridge, Maryland, the sense of the overpowering massiveness of Egyptian temple architecture is effectively caught. At the foot of the stately row of mighty columns, the Pharaoh's courtiers are in consternation: A woman to the left clasps her hands in shock, the seated man to the right looks heavenward (as a Christian parishioner might). As though at a given signal, the eldest son of each family is stricken dead. This is the tenth and most terrible plague, as recounted in Exodus 12:29,[33] the one that compelled the Egyptians to let the Israelites go, after the nine previous plagues had proved ineffective. The Israelites' miraculous crossing on dry land through the midst of the Red Sea as the waters parted for them is the subject of a painting in the Collection of Mr. and Mrs. W. B. Carnochan, Woodside, California. The literary source is Exodus 14:19–23, which accounts for the orange-like form to the right center representing the source of light within the nocturnal scene: "Then the angel of God in front of the army of Israel moved to their rear (the column of cloud moved from before them to behind them), and went between the army of Egypt, and the army of Israel. When it was dark, the cloud lit up the night, so that the one army did not come near the other all night." Before the army of Israel, storming wildly toward the spectator, are herds of cattle and sheep. This is part of the "mixed multitude" mentioned in Exodus, and we can see that Field, who was maintaining a farm in Plumtrees, Massachusetts, through the 1860s, knew animals at firsthand.

[33] In the account in Exodus, the eldest son in all stations of Egyptian life died, from the son of Pharaoh to the son of the prisoner. Even the eldest offspring of the cattle perished. In his painting, Field shows only the deaths within the royal court.

With Field, originality does not mean total independence from all prototypes. A devout man, he used images from illustrated Bibles, such as a picture of the Tower of Babel in a New Hampshire Bible for the towers in his *Historical Monument*. For *The Garden of Eden* (c.1865), he incorporated details and compositional arrangements from a Bible illustration after Jan Brueghel the Elder and other sources.[34] But Field's visions are totally different from their sources. I had thought of the term *subterranean visionaries* as connoting, apocryphally of course, a kind of hidden recess in the brain where bizarre images are dredged up. Now, with this Exodus cycle of Field, this term has an added meaning. For the scenes in *The Death of the First Born* and *Israelites Crossing the Red Sea* (both, it is true, night scenes, following the Exodus text) seem, in their appearance, to be unfolding within some great dark underground enclosure. Field's visualizations of the Exodus stories, notwithstanding the influence of the prints after John Martin and other sources he came upon, bring with them the creation of an interior world familiar only to him.

John Quidor, like Field, used literature as the springboard for his lively imagination. With him, the writings of Washington Irving, an author who ranged in tone from the mawkishly ribald to the nightmarish, proved to be the catalyst. It is the latter quality, of course, that was best suited to the sensibility of the subterranean visionary, as Quidor on occasion showed himself to be. And few clearer examples of the nightmarish can be found in Irving's extensive writings than the tale "The Devil and Tom Walker" from the collection *Tales of a Traveler* (1834),[35] which Quidor chose to illustrate in 1856. By that time he had turned from the comical in Irving, both in the choice of incident and in its visual interpretation, as found in the Rip Van Winkle stories and *The Money Diggers* (1832; also from *Tales of a Traveler*), to what

[34] For his *Garden of Eden*, in the Shelburne Museum, Vermont, Field used, besides the Brueghel source, details from a *Temptation* by J. Jackson after John Martin. Originally printed in London in the 1830s, the illustration appeared later in a number of English and American Bibles. John Martin was a source for some of the architectural details in the paintings of the plagues. See Mary C. Black, "Erastus Salisbury Field and the Sources of His Inspiration," *Antiques* 83, no. 2 (February 1963): 201–206.

[35] It is noteworthy that Quidor should have been attracted by *Tales of a Traveler*, which, from its appearance in 1824, attracted universal adverse criticism. Irving was so dismayed that he did no writing for the next two years, which he spent partly in France and partly in England in pursuit of Mary Shelley.

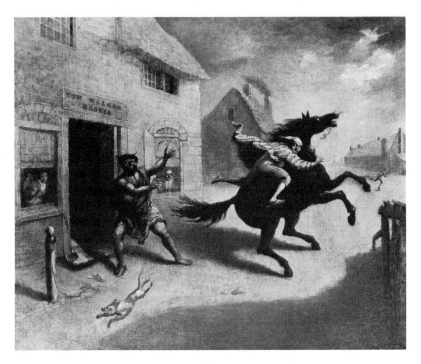

John Quidor: *The Flight of Tom Walker*. c. 1856. Oil on canvas. 27″ x 34″.
Kennedy Galleries, New York.

was genuinely fearsome. It is a change that makes some sense against
the unraveling of Quidor's life: As pointed out, in the previous decade,
the 1840s, he had been adrift, far from his roots in New York State,
struggling with his land speculation in Illinois.

"The Devil and Tom Walker" is a tale that has been repeated, with
variations, by other American writers.[36] It involves a man who sells his
soul to the devil. Irving's story takes place near Boston about the year
1727 and is about a certain Tom Walker, who "had a wife nearly as
miserly as himself: they were so miserly that they even conspired to
cheat each other." The pair "lived in a forlorn-looking house that stood
alone, and had an air of starvation." One day while taking a shortcut

[36] The most famous instance, of course, is Stephen Vincent Benét's "The Devil
and Daniel Webster" (1937).

home through a swamp, Tom encountered a stranger who had a curious swarthy, sooty appearance. This turned out to be patron of all that area from times immemorial, from the times of the Indians and much earlier, "the great patron and prompter of slave-dealers, and the grandmaster of the Salem witches." He told Tom he was known in some places as Old Scratch, whereupon they struck a bargain. When Tom's wife learned of this, she set out for the swamp to make her own bargain—and disappeared. Nothing was found but her apron, within which were tied a heart and a liver. Tom prospered by leaps and bounds as a usurer, lending money at four percent per month and squeezing his customers with relish. As he aged, he began to worry about the world to come. Then, just as he was exclaiming falsely to a man he had just broken, "The devil take me if I have made a farthing!" the devil came for him, placed him on his horse, and galloped off with him into a thunderstorm. Tom never returned. When the people looked about, they found that the mortgages in his coffers were reduced to cinders and that his chest was filled not with gold and silver but with chips and shavings. After his disappearance, his house mysteriously took fire and burned to the ground. Nothing remained of his wealth.[37]

I believe that had Quidor illustrated "The Devil and Tom Walker" in the 1830s, before he had been chastened by life's experiences, he would have preferred to draw the comic potential out of descriptions such as that the pair "lived in a forlorn house that stood alone, and had an air of starvation." Now in the 1850s, he has seized upon the sudden appearance of the stranger, who, bearing a seemingly human visage that has about it a hint of the supernatural, has been looming quietly in the shadows, a stranger with a swarthy, dingy face, who holds an ax and whose racial lineage cannot be clearly pinned down. In picturing this man whom Tom Walker sees just as he is stumbling upon a skull, Quidor conveys fully the understated sense of the macabre conveyed through Irving's text:

> Tom Walker, however, was not a man to be troubled with any fears . . . and delving with his walking-staff into a mound of black mould at his feet . . . his staff struck against something hard. He raked it out of the vegetable mould, and lo! a cloven skull, with an Indian tomahawk buried deep in it, lay before him. "Let that skull alone!" said a gruff

[37] Washington Irving, "The Devil and Tom Walker," in *The Complete Tales of Washington Irving*, ed. Charles Neider (Garden City, N.Y.: Doubleday & Co., 1975), p. 437.

voice. Tom lifted up his eyes, and beheld a great black man seated directly opposite him, on the stump of a tree. He was exceedingly surprised, having neither heard nor seen any one approach, and he was still more perplexed on observing, as well as the gathering gloom would permit, that the stranger was neither negro nor Indian. It is true he was dressed in a rude half Indian garb, and had a red belt or sash swathed around his body; but his face was neither black nor copper-color, but swarthy and dingy, and begrimed with soot, as if he had been accustomed to toil among fires and forges. He had a shock of coarse black hair, that stood out from his head in all directions, and bore an axe on his shoulder.[38]

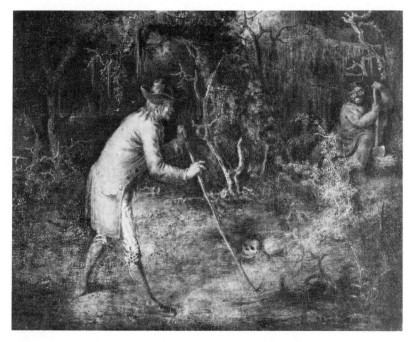

John Quidor: *The Devil and Tom Walker.* 1856. Oil on canvas. 27³⁄₁₆″ x 34⅜″. The Cleveland Museum of Art, Ohio; Purchase, Mr. and Mrs. William H. Marlatt Fund.

Albert Pinkham Ryder worked on his *Race Track* from about 1895 to 1910, and hated to let it go. The painting, now in the Cleveland Museum of Art, has come to be known also as "Death on a Pale Horse," and as a portrayal of the figure of Death, bears comparison with West's

[38] *Ibid.*, p. 439.

Death on the Pale Horse (1817), which contains personifications of the agents of Death, namely War, Pestilence, and Famine. The first is an exemplar of the subterranean visionary painting; the second, a painting consigned to the visionaries of the spectacular grouping. West's protagonists ride storming through the heavens above their cowering and afflicted victims, whereas Ryder's Death, thin, carrying a scythe, and sitting stiffly upon his modest horse, circles a small, deserted racetrack. Ryder's Death rides the race alone. There is no one to defeat,

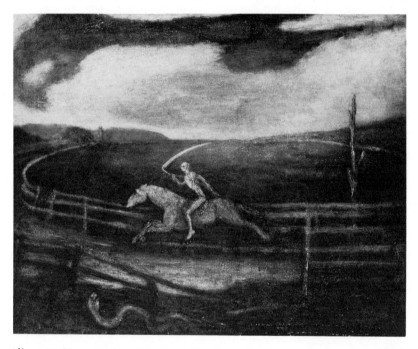

Albert Pinkham Ryder: *The Race Track, or Death on a Pale Horse.* 1895–1910. Oil on canvas. 28¼″ x 35¼″. The Cleveland Museum of Art, Ohio; Purchase from the J. H. Wade Fund.

for there are no other contestants. There is no one to terrify, for there are no onlookers. Thus, whereas West's *Death on the Pale Horse,* following Revelation, chapter 6, has to do, in operatic fashion, with the fate awaiting all mankind, there is the feeling, from the much narrower vista and lonely setting, that Ryder's painting has to do with some personal occurrence that was less portentous.

And so it had. Although after 1880 Ryder commonly based his paintings on the Bible, English literature, and operas, with *The Race Track* he was moved by a contemporary event. When Ryder stayed at his brother's hotel, the Albert, and even afterward, when he stayed at 308 West Fifteenth Street, he would eat his dinner at the hotel. He became friendly with a waiter, who seemed remarkably intelligent, a man who was interested in horse racing and who had made money by betting on races. One day Ryder heard that the man had just bet his life savings of five hundred dollars on a horse named Hanover entered in the Brooklyn Handicap. The morning after the race Ryder read that Hanover finished third and, concerned, he rushed to the Albert, to find that the waiter had shot himself to death the night before.[39] The subterranean visionary (as we shall see, not all of Ryder's work falls into this grouping) concerns himself with the private and the remote. The loneliness of the scene portends the waiter's lonely quest for wealth. And it is not too farfetched to suppose that the circular racetrack turning back upon itself was suggested by the tragic man's recurrent habit. Since the waiter killed himself at night, Ryder might have been moved to set his scene by night. But it is hard to tell from the painting whether the scene is set by night or by day. When someone remarked to Ryder that he could not determine when the scene was set, the visionary, absorbed completely in his own world and unable to articulate it to others, simply replied that he had never thought about the matter.[40]

[39] W. M. M. [William M. Milliken], "The Race Track or Death on a Pale Horse by Albert Pinkham Ryder," *Cleveland Museum of Art Bulletin* 15 (March 1928): 65–71.
[40] Lloyd Goodrich, *Albert P. Ryder* (New York: George Braziller, 1959), p. 20.

4

The Visionary Eccentrics II:
Visionaries of "the Normal"

The visionaries of "the normal" stand at an opposite pole from both the visionaries of the spectacular and the subterranean visionaries. The latter suspended the natural order of things: Cole conjured up legendary cities, from their beginnings to their ruined state, and a goblet the size of a mountain; Hicks painted into well-known Pennsylvania and Virginia locales wild animals whose habitats are Africa and Asia; Field invented a forest of towers covered by sculptures, towers between whose tops small railroad trains sped; Vedder and Rimmer populated their paintings with hybrids and other mythical creatures; and La Farge, if he did not invent what he never saw, tried to astound the viewer by painting the strange animals, a giant statue of the Buddha, and other arresting and unusual things he encountered on his trips to Japan and the South Seas. The *visionaries of "the normal,"* however, Page, the early Ryder, Dewing, Fuller, Newman, and the late Inness, show events and people that are commonplace and casually ordinary: a woman walking about a farm (Inness), a girl blowing bubbles (Newman), the portrait of a young woman (Fuller), a boy and a girl of about eighteen selling some merchandise on a street corner (Page), a group of women in a meadow (Dewing), a picture of a horse (Ryder).

At this point, the reader may ask: What makes the visionaries of "the normal" visionary at all? The question is understandable, because the paintings presented thus far have all had rather obvious earmarks

of the visionary. And the answer to the question is not an easy one; it cannot be offered in a sentence or two. Not only is this because the dreamlike qualities of these works are harder to get at in words, but because the visionaries of "the normal" comprise a less homogeneous group than the two groups I've presented so far. That is, the visionary in Page and the early Ryder is different from that in, say, Fuller and Dewing, just as all four of these artists differ together from the visionaries of the spectacular and the subterranean visionaries. On the broadest level, before we take a look at their paintings, this much can be offered about the visionaries of "the normal": Fuller, Dewing, the late Inness, and to an extent Newman need to be considered against the backdrop of the development of American Impressionism during the last two decades of the nineteenth century; while Page and the early Ryder cannot be considered within such a context.

Something of William Page's remarkable theories on art, which were built on the mysticism of Swedenborg, have been presented in chapter 2. Page held that art, rather than being a mere reflection of nature, should be a separate and functioning creation in its own right. The picture should be like nature, not an imitation of it, but something having the same principles, a kind of living object in itself. He dismissed the Apollo Belvedere, however successful it was as outward imitation, but responded strongly to the pedimental sculptures of the Parthenon because he sensed an aliveness to them, because he sensed that their outward forms seemed to have been built upon or to emanate from inner functionings: "When I look at the mutilated figures of the Theseus and the Illysis [sic] of the Elgin Marbles, I feel as though by placing my hands against the left side of the breast of the figures I could count the heart-beats beneath the surface through the ribs, for both these figures seem to possess heart and lungs and all other internals by reason of that wonderful rendering of all the forms of the surface of the man."[1]

In some of his paintings, Page seems to have entered into the flow of life, to have caught the movements of the figures as though from a looking glass. It is this uncanny sense of aliveness, of unpremeditatedness, that raises some of his paintings of the most ordinary events to the level of the visionary. It is as though the gap between art and life

[1] Quoted in Joshua C. Taylor, *William Page: The American Titian* (Chicago: University of Chicago Press, 1957), p. 231.

has been broken. This by an artist who, in like manner, found little gap between the living and the dead, whose voices he believed he heard and who, in turn, heard him. His *Young Merchants* (1842), in the

William Page: *The Young Merchants*. 1842. Oil on canvas. 42″ x 36″. The Pennsylvania Academy of the Fine Arts, Philadelphia; Bequest of Henry C. Carey.

Pennsylvania Academy of the Fine Arts, a picture of two young people selling papers and strawberries on a New York street corner, is unlike the contemporary genre scenes of William Sidney Mount (1807–1868), George Caleb Bingham (1811–1879), George Henry Durrie (1820–1863), Richard Caton Woodville (1825–1855), and others. Like those scenes, it, too, can be classified as genre. But there is neither compositional focus nor exploitation of the anecdotal possibilities nor stress of the picturesque nor choice of a particularly moving situation or gesture. In short, Page has not only taken a commonplace activity but has presented it in such a way as to suggest the randomness of which existence is really made. (For what is the heroic except what we choose to call heroic? What is picturesque or arresting about the everyday except what we designate as such or what genre artists such as Mount or Bingham designate as such?) The diffusion of light and

shadows over the surface and the softness and near-transparencies of the skin render a mobile quality to the painting, a kind of aliveness, that exists for its own sake rather than for the protraction of some meaning beyond itself. It must have been in mind of such qualities that Page proclaimed that "as every object in nature is inexhaustible to our contemplation, so in true art this inexhaustible quality is to be rendered," and that "the language of art is not thoroughly learned until the painter can bid you look into the painted space in vain to find a resting place for the eye."[2] Page's contemporaries insisted that art must be highly selective, must present something but not everything out of the flow of life; for art must be uplifting or instructive or sentimentalizing. Hence, when *The Young Merchants* was purchased, it was engraved, and the engraving was set to a story dealing with two children who are trying to find their home and have just seen a promising notice in the newspaper.[3]

The *Cupid and Psyche* (1843) in the Collection of John D. Rockefeller III, New York, is more startling still, and because of this, it may convince the reader that we are dealing with a kind of visionary approach different from those presented so far. The two lovers, purportedly representing ancient gods, are presented nude, but cut off at the waist, and are thrust up to the foreground. Painted nude figures of gods or allegorical figures, even more exposed, had been known in American art for some time: The most infamous was John Vanderlyn's outstretched sleeping Ariadne (1812).[4] In Page's painting, all that can be seen of the embracing couple is the back of one figure and the head and arms of the other. Still, the painting was rejected by the National Academy of Design, not because of the nudity but because Page had admittedly modeled the figures upon a cast in his studio of a marble in the Capitoline Museum, in Rome.[5] Such criticism could have been leveled at many other works. What the members of the academy's

[2] *Ibid.*, p. 233.

[3] Changes were introduced into the engraving to fit in with the story line. For instance, the girl was made more round-faced and sugary, and the boy was made to gaze pitifully to heaven. *Ibid.*, pp. 39–40.

[4] For a detailed treatment of the history of the nude in American art, see William H. Gerdts, *The Great American Nude* (new ed.; New York: Praeger Publishers, 1974).

[5] Page wrote to James Russell Lowell on March 21, 1843, that he had just finished the picture "from the cast you may remember to have seen in my room—kissing in a wood." Letter in the Houghton Library, Harvard University. *Ibid.*, p. 48.

William Page: *Cupid and Psyche*. 1843. Oil on canvas. 10⅞″ x 14¾″. Collection of Mr. and Mrs. John D. Rockefeller III, New York. Photograph: Otto E. Nelson.

committee may have felt, but either could not or would not articulate, was that Page's figures, caught off guard by the viewer, as it were, were more curiously erotic than any they had encountered before in American art. So completely engrossed are these figures with one another that they make no concession to the viewer. Yet, fully modeled, flesh-colored, seemingly pulsating (and different from the more flatly painted *Lazarus* of Vedder), these figures emerge from the dark, painted landscape to intrude into the viewer's space as real but miniature beings. They are part of a painted world that, in part, appears suddenly almost real. There seems to be a shifting back and forth between the artificial reality of the painted world and that world that is part of our own. Thus, there is a double alternation, or "jumping," within the *Cupid and Psyche*. The stiffness of the sculpture is carried over into the postures of the figures, which are rendered with unusual softness and the translucence characteristic of flesh. Then these painted figures, on the one level remarkably humanlike, on the other cut off at the waist and

partaking of the rigidity of marble, are projected so close to the viewer as to become part of his space-time.

Such "jumping" between levels of reality makes for a discontinuous sort of world quite unlike the one we experience normally. So the "normal" within Page's painting is only apparent, even though there are no hybrids, monsters, invented cities, or other obvious fantasies, even though everyone and everything is set within the usual context. It is nonetheless a world quite different from that of our wake-a-day existence. There is no exact equivalent to this state in American literature of the time, nothing as close as Hawthorne's *Marble Faun* is to Rimmer's *Flight and Pursuit*, with their twin themes of flight and guilt. Still, something like Page's "jumping" occurs in some poems of Emily Dickinson (1830–1886), where the uncanny, practically indescribable as well as invisible, dwells within the ordinary, indeed is inseparable from it. For Dickinson, the uncanny is encountered on occasion, without warning, by some people who seem to have nothing extraordinary about them. There is, for example, the "narrow fellow in the grass", who is given no special form, but who causes "a tighter breathing,/And zero at the bone":

> A narrow fellow in the grass
> Occasionally rides;
> You may have met him,—did you not?
> His notice sudden is.
>
> The grass divides as with a comb,
> A spotted shaft is seen;
> And then it closes at your feet
> And opens further on.
>
> He likes a boggy acre,
> A floor too cool for corn.
> Yet when a child, and barefoot,
> I more than once, at morn,
>
> Have passed, I thought, a whip-lash
> Unbraiding in the sun,—
> When, stooping to secure it,
> It wrinkled, and was gone.
>
> Several of nature's people
> I know, and they know me;
> I feel for them a transport
> Of cordiality;

But never met this fellow,
Attended or alone,
Without a tighter breathing,
And zero at the bone.

(986, 1872)

Page's portrait of his third wife, Sophie Candace Stevens Hitch-cock, was begun in Rome in 1860 and finished in New York the next year. Sophie had met Page in Rome in 1856, while he was still married, and cared for him and helped look after his daughters while he was ill, and her presence brought on a scandal. Page convinced her of the va-lidity of the teachings of Swedenborg. After the marriage she devoted herself to advancing her husband's fame, while her three brothers tried to advance his career financially. Her ambition for Page led her to write President Ulysses S. Grant in 1877 to get him to pose for a por-trait,[6] and it also led her to edit Page's notes and lectures for publica-tion.[7] In her portrait, Sophie Page makes a commanding presence as she stands before the Colosseum, a self-possessed, forceful, single-minded woman. Yet there is something more to this portrait. The sharply etched figure seems to stand apart from its setting. This is not just its isolation within its setting. Of an unusual distinctness that makes for a curious relation to the painted areas about it, the figure seems to occupy a time and space of its own different from that of the rocky ground near the Colosseum where it stands. The world about Sophie Page is like a ghostly echo; perhaps, I like to suppose, it somewhat resembles the way in which Swedenborg, who considered this existence a reflection of some higher, divine one, viewed the world. The technique in this por-trait whereby Page achieves his special sense of the uncanny is similar to effects attained in recent photography when a solarized or emulsi-fied figure is projected from the environment, which would otherwise unobtrusively contain it.[8]

[6] *Ibid.*, pp. 208–209.

[7] She got his illustrated article on human proportion, entitled "The Measure of a Man," published in *Scribner's Monthly*, in 1879, but did not succeed in getting his many lecture notes published. *Ibid.*, p. 211.

[8] Of the many photographers who could be cited in this respect, two who strike me as most important are Donald Blumberg (b. 1939) and Ralph Eugene Meatyard (1925–1972). For illustrations of Blumberg's work, see Nathan Lyons, ed., *The Persistence of Vision* (Rochester, N.Y.: Horizon Press in collaboration with George Eastman House, 1967), pls. 9–19. For those of Meatyard, see Max Kozloff, "Meatyard," *Artforum* 13 (November 1974): 68–72, and James Hall, ed., *Ralph Eugene Meatyard* (Millerton, N.Y.: Aperture, Inc., 1974).

Page's contemporary, the historian Henry T. Tuckerman (1813–1871) probably felt Page's strange power as a portraitist, for he made note of a portrait "where costume, attitude, and feature had such a relievo that the effect was like a reflection from a looking-glass—no modifying influence of light, shade, or perception subduing the palpable presence."[9] If other men of his time felt it, they seldom commented on it. In the nineteenth century, what was appreciated in the American portrait was the cliché, the idealization, the cleverly novel—not the profoundly unsettling, such as Page offered. His skill was frequently praised, but what he accomplished was blurred over.[10]

Albert Pinkham Ryder's (1847–1917) early work of the 1870s and the beginning of the 1880s is, like most of Page's work, deceptively innocuous. His subjects are quite bucolic: sheep in a meadow, a cow at pasture, a horse in a field, several cows on a hill, two horses in a stable, and so forth. These were the animals he saw on the small farms surrounding his native New Bedford, Massachusetts, and probably near New York City as well. The most commonplace scenes—yet Ryder made them oddly different from the hundreds of farmscapes then being produced in America. The difference lies in his ability to feel himself into the being of the animal, in his ability to make the viewer see in the animal a sensate soul. These animals are captured unusually closeup. I picture to myself the shy Ryder asking a farmer if he may go into the stable or climb a fence into the meadow. In practically the only testimony to come from those early days, the part-time painter William H. Hyde, who first met Ryder in 1873 at the age of twenty-six, recalled that he always came to his art classes at the National Academy of Design smelling of the stables. (The academy then was under the control of the old-line academicians. Ryder, rejected the first time he applied, was uncomfortable at the academy, which habitually refused to show his paintings in its exhibitions even after he had been accepted as a mem-

[9] Henry T. Tuckerman, *Book of the Artists, American Artist Life* (New York: G. P. Putnam's, 1965), p. 295.
[10] In one appraisal of a picture of Christ, Page was criticized because he showed too much of a naked shoulder and had too much red color in the robe. "There is nothing Godlike" the critic observed, "nothing of the divinity—nothing of the high mission on which he was sent, which ought to make his face sublime. . . . It is, however, such a picture as few artists but Page could paint." Taylor, *William Page*, p. 58. Observers, then, sensed an individuality in Page's work, but they could not put in words what was distinctive about it.

ber. As a result in 1877 Ryder became one of the twenty founders of a less stuffy rival organization in New York, the Society of American Artists.)

In his late teens, sometime before his arrival in New York in 1870 or 1871, Ryder had undergone as a fledgling artist what amounted to an ecstatic conversion. His appraisal and recollection of that event was transmitted with remarkable clarity in 1905 in a statement he gave as an interview:

> Nature is a teacher who never deceives. When I grew weary with the futile struggle to imitate the canvases of the past, I went out into the fields, determined to serve nature as faithfully as I had served art. In my desire to be accurate I became lost in a maze of detail. Try as I would, my colors were not those of nature. My leaves were infinitely below the standard of a leaf, my finest strokes were coarse and crude. The old scene presented itself one day. . . . It stood out like a painted canvas —the deep blue of a midday sky—a solitary tree, brilliant with the green of early summer, a foundation of brown earth and gnarled roots. There was no detail to vex the eye. Three solid masses of form and color— sky, foliage and earth—the whole bathed in an atmosphere of golden luminosity. I threw my brushes aside; they were too small for the work in hand. I squeezed out big chunks of pure, moist color and taking my palette knife, I laid on blue, green, white and brown in great sweeping strokes. As I worked I saw that it was good and clean and strong. I saw nature springing into life upon my dead canvas. It was better than nature, for it was vibrating with the thrill of a new creation. Exultantly I painted until the sun sank below the horizon, then I raced around the fields like a colt let loose, and literally bellowed for joy.[11]

Ryder confirmed the accuracy of this statement in 1907.[12] What seems probable to me, however, is that some of it refers to a later phase of his career, with the part about his racing around the fields like a colt let loose referring to the early formative episode before his coming to New York. (The statement works as a kind of encapsulation of Ryder's career.) The mention of squeezing out chunks of color and working with the palette knife might have to do with the more abstract work of the

[11] Quoted in Albert P. Ryder, "Paragraphs from the Studio of a Recluse," *Broadway Magazine* 14 (September 1905): 10–11.
[12] In a letter of November 3, 1907, Ryder wrote: "In the paragraphs from a studio you will find what is practically an interview by Miss Adelaide Samson, now Mrs. Maundy: it was done from memory: and gives a wrong impression in the instance of copying old masters: otherwise quite correct." Quoted in Allen Weller, "An Unpublished Letter by Albert P. Ryder," *Art in America* 27 (April 1939): 102.

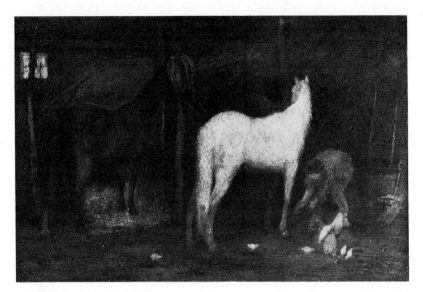

Albert Pinkham Ryder: *In the Stable.* 1870s. Oil on canvas. 21″ x 32″. National Collection of Fine Arts, Smithsonian Institution, Washington, D.C.; Gift of John Gellatly.

1880s and later. During the early episode, there was the stamping in of an attitude that served Ryder all of his creative life. This can be ferreted out of the statement. The attitude involves a seeming contradiction. Ryder found that he could neither imitate the canvases of the past nor be faithful to nature ("In my desire to be accurate [to nature] I became lost in a maze of detail"). Then, working freely in his way, nature sprang to life upon his canvas, he achieved something "better than nature, for it was vibrating with the thrill of a new creation." What were these two "natures"? One was the nature we all see; the other, which Ryder with sudden clarity realized was a legitimate concern of art, was something parallel to nature's life's force (something Page was concerned with), which can be conveyed by the painter without the imitation of nature's outward forms.

There are two horses facing one another in *In the Stable* (1870s), a white mare with a glistening, almost phosphorescent body, in the foreground, and a black horse in the rear stall. The central gesture about which the painting is organized, the central event, is the turning of the mare toward the black horse, turning to him in love, in desire, in kin-

ship, in recognition, or whatever it is that these two animals feel for each other. The hypothetical constructs of our language are meager attempts to explain, and by no means offer equivalents for this feeling. It is the visible evidence of this mysterious "whatever" that Ryder so ably catches. The stable is the world of the horses, and it is redolent with their presence. The stableboy, stooping awkwardly at his chores beside the mare, is oblivious to the animals' inner life; he is interested in the horses only in terms of his scheduled rounds. In *The White Horse* (before 1909) in The Art Museum, Princeton University, a white horse stands alone on a stable floor; there is no other animal in the picture this time with which it might communicate. Yet, uncannily, we are made to feel in the expression in the eye, in the tilt of the head of this not entirely noble-looking (but neither pathetically emaciated) horse, and in its tenuous position beside the sturdy row of wooden posts that

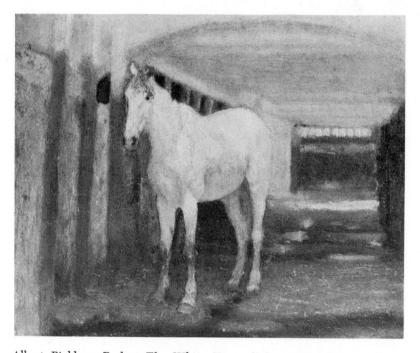

Albert Pinkham Ryder: *The White Horse*. before 1909. Oil on canvas. 8⅟₁₆" x 10". The Art Museum, Princeton University, Princeton, New Jersey; Gift of Alastair B. Martin, Class of 1938.

hold it within its long, narrow space, a kind of consciousness that cannot be conveniently reduced to an identifiable emotion or condition.

For Ryder all the world is charged, reeks with energy, "will [in the words of the English poet Gerard Manley Hopkins, 1844–1889] flame out, like shining from shook foil." Not just man, but all about him, and perhaps even more than he, is sensate—the trees, the clouds, the water of the oceans, and of course the animals. This awareness persists through all of Ryder's paintings, from the early farmscapes with which I deal here to the later ones, which are of broader scope and more abstract configurations—the marines and the scenes drawn from literature and operas. In spite of stylistic differences, his work is of a piece. Nowhere can this be seen to greater advantage than in the Ryder Room in the Smithsonian Institution's National Collection, Washington, D.C., where all phases of the artist can be seen at once, from the seemingly regular *In the Stable* to the turbulently active *Jonah* (c. 1885) and *The Flying Dutchman* (1887).

Seventeen of the eighteen Ryder paintings in the National Collection (the largest single collection of his work) were donated in 1929 by John Gellatly (1853–1931), who had been one of Ryder's staunchest patrons during the 1880s as well as the greatest support of Robert Loftin Newman, Ryder's friend or acquaintance and neighbor when he stayed at the Benedick.[13] As I have already mentioned, the two knew a lot of the same people. Also, the French painter Thomas Couture was, in a sense, common to them: Newman studied with him in Paris in 1850, and Ryder's teacher, William E. Marshall (1837–1906), with whom he worked informally during his first years in New York, had once been a student of Couture. Ryder's painted world, though, is energized, and the figures in it partake of that energy; Newman's is inert and inchoate, at times vaguely threatening, out of which his people, unprotected, tenuously offer themselves forth as protagonists. There are a lot of other differences. Ryder is the more strikingly imaginative—Newman could not have conceived of his strange horses. Newman based his scenes more directly on his observations; Ryder looked in a more total way into himself. Newman seems the more clumsy draftsman, although this in no way detracts from his power (he could, if he

13 At one point Gellatly owned thirty of Ryder's canvases. He lent fourteen of them to Newman's show, in 1894, at Knoedler's, which he helped organize. Albert Boime, "Newman, Ryder, Couture, and Hero-Worship in Art History," *Art in America* 3 (Fall 1971): 12. This was the only showing of Newman's work held during his lifetime.

wished, draw with great accuracy and fastidiousness—but those are his worst paintings[14]), and the more strikingly original colorist. Newman knew how to apply his paint with facility, adding his color. economically, whereas Ryder kept repainting many of his canvases for years, often painting over still-wet surfaces.

Newman painted genre pictures and religious scenes that have the look of genre. In his religious scenes he was drawn, in a turnabout from the visionaries of the spectacular West and Allston, to people in the Scriptures who were homeless and destitute rather than to stories of miraculous occurrences. Newman himself was a wanderer for much of his life, and he lived the last thirty-five years of his life outside his native South, which he loved.[15] At least two versions exist of *Hagar and Ishmael,* showing Abraham's unfavored wife and her son wandering homeless in the desert; and there are at least four of *The Good Samaritan;* and at least four of *The Flight into Egypt.* His favorite religious subject was the Madonna and Child, of which at least ten versions exist. The frequency of this theme in Newman's religious work becomes more meaningful when it is recalled that he was under his mother's protection until his forty-sixth year and lived most of that time in their home in Clarksville, Tennessee. And though he was to live alone for the rest of his long life, he had, it was reported, a great fondness for children.[16]

Newman's typical pictures, whether religious or genre (it doesn't really matter which), consist of one to four small figures cast in some unbounded, shadowy place in the outdoors, the backdrop of which is

[14] Stylistically, Newman's early works, hard, linear, a little reminiscent of the early Gilbert Stuart (1755–1828), are astonishingly unlike his later more painterly ones. But even in these statically posed stiff figures there is the trace of something haunted. His *Portrait of Adelia Boisseau Warfield and Daughter Huldah Belle Warfield* and his *Portrait of Wallace Warfield and Son* (with a slightly sinister dog kneeling at the foot of the master), both from about 1857, are illustrated in Marshal E. Landgren, *Robert Loftin Newman, 1827–1912* (Washington, D.C.: Smithsonian Institution Press, 1974), pp. 32–33.

[15] In a letter to William W. Ferguson sent from Nashville on November 8, 1872, Newman referred to the North as "the foe." He urged that the South dispense with the use of Northern products and consume its own manufactures, and that all possible impetus be given to fostering Southern industries. Thomas B. Brumbaugh, "Letters of Robert Loftin Newman, a Tennessee Artist," *Tennessee Historical Quarterly* 32 (Summer 1973): 117–118. In 1872–1873 Newman was in Nashville trying to establish a regional academy of fine arts.

[16] He reportedly told his friend Nestor Sanborn that he "loved children, dogs seen in the *Girl Blowing Soap Bubbles* [c. 1880], and above all trees." Quoted in Landgren, *Newman,* p. 72.

usually ominously stormy and windswept and sometimes uniformly dark. These figures are made to seem somehow fragile and beset by unknown, unseen terrors. They manage to elicit our concern, even our pity, although they are not wounded or afflicted and there is no discernible danger. It is this sense of the perilous that distinguishes these pictures, and it is this that Newman succeeds in imparting to scenes, which, when taken on the face value of what is actually going on, constitute the soul of innocence. The sketchiness and ill-definition of the figures do not impart mere carelessness: In their broken forms these figures are being curiously eaten away, reduced, as it were, by the very atmosphere of their vast surroundings. These surroundings exist not as a container for the figures so much as a kind of elemental protagonist that besets them. Newman's people, real enough on their own, are placed in a kind of no-space or no-place. The vague disquietude or ominous emptiness of this no-place is out of keeping with the literal pleasantness of the actual situation. Thus it is that the whole scene takes on the character of a strange dream.

Among Newman's varied genre subjects are children playing; girls playing with a doll; girls reading; lovers; a mother and child, of which at least thirteen versions exist; a mother and child in which the child presumably sees a nightingale off in the distance; and two, sometimes three figures, one of whom (we learn from the title) is a fortune-teller. In versions of *The Lovers, The Nightingale, The Fortune-Teller*, and in other paintings, a figure points out of or into the painting. As we do not see and usually do not even know (an exception is *The Nightingale*) at what the figure is pointing, a sense of mystery is generated by the introduction of something or someone not in the painting holding the interest of someone within it. This sense of mystery may be built into the theme in still more obvious ways, as in *The Letter* (1880s), in the Phillips Collection, Washington, D.C., where two women avidly read the letter whose contents we naturally wonder about. This in itself of course, is insufficient to raise the picture to the realm of the visionary. The two women seem to float in air—although the strokes marking the space about them read, at the same time, as a shadowy backdrop. The bare upper part of the painting is suggestive of a dark night, out of which the two women emerge, insubstantially, with a fitful light playing unaccountably over them. In the *Children Playing* (c. 1890), in The Brooklyn Museum, the landscape in which the figures move is charged, fraught, we sense, with danger. The distant trees are shadowy and

Robert Loftin Newman: *The Letter*. 1880s. Oil on canvas. 17½″ x 13¼″.
The Phillips Collection, Washington, D.C.

looming, like threatening personages; the deep slope of the hill behind the children seems almost capable of moving about them and enfolding them; the dense clouds in the sky are like some specter, capable of suddenly materializing into something monstrous. One is reminded of such stories of Henry James (1843–1916) as "The Turn of the Screw" (1898), where the presentiment of evil lies couched within the commonplace and the distinction between dream and reality is never clearly marked. That is a story, too, in which children are threatened

Robert Loftin Newman: *Children Playing*. c. 1890. Oil on canvas. 10⅜″ x 14¼″. The Brooklyn Museum, New York.

and threaten others through means that on the surface are quite innocent; and it is not clear, both to the reader and to characters within the story, what is the real essence behind the appearance.[17] So, too, in Newman's *Children Playing*. The figures are made up of dabs of color hastily applied, so that they and the whole scene appear ghostly and

[17] See Jane P. Tomkins, ed., *Twentieth-Century Interpretations of the Turn of the Screw and Other Tales* (Englewood Cliffs, N.J.: Prentice-Hall, 1970).

evanescent, in the process of corroding or dematerializing before our eyes.

The *Girl Blowing Soap Bubbles* (c. 1880) in the Corcoran Gallery of Art, Washington, D.C., strikes for me another note: It is mysterious, even haunted, but in a less frightening, more lyrical way. The backdrop here is dense and brown and syrupy, like molasses, and yet catches the feel of a heavy Southern night, a night that is impenetrable and devoid of lights and life. Why do I say "Southern" night? Knowing Newman lived the first part of his life in the South, I may be shamelessly reading what I wish to into the painting. The girl's purple pink dress is light and flimsy, standing out from the heavy molasses color of the inert night, a pathetic touch of gaiety that cannot really affect the enveloping heaviness. It is also an act in itself, this blowing of bubbles, symbolical of the flight of the imagination: We see the bubbles wafting upward (the uppermost one might almost represent the moon). The girl's face is turned upward, looking beyond the darkness; the posture of her body hints at a straining upward as well. Again, as with the pointing gesture in other paintings, Newman sets forth, as a logical extension of the image, the sense of the figure's reaching; here the reaching involves the entire body and connotes, poetically, a yearning, an attempt to go beyond or project oneself beyond a terrestrial confinement.

From the late 1860s, largely as a result of influences from the French Barbizon school, a softening effect invaded much American painting, and from the 1880s on, this became combined with the broken color effects favored by the American Impressionists. Prominent among the Impressionists were Theodore Robinson (1852–1896), who studied with Claude Monet (1840–1926), and members of the "Ten American Painters" group, such as John Henry Twachtman (1853–1902), Childe Hassam (1859–1935), and J. Alden Weir (1852–1919). Softened contours appear as well in the paintings of the early Ryder and in Fuller, and softened contours as well as patches of broken color and facile brushwork characterize the paintings of Newman, Dewing, and the late Inness. Technically most of the visionaries of "the normal" resemble the Impressionists. But they used impressionist devices and techniques for ends that went beyond Impressionism, that is that went beyond the simple desire for the vividness and emotionalism that could be derived from the high-keyed broken color.

Even when, at their most lyrical, the Impressionists partially veiled their forms in a silvery mist, they still seem to be attempting to capture certain fugitive atmospheric conditions, they still seem much closer to the observed event than the visionaries, more dependent on the shifting visual data as perceived by the senses.

It had become current among American art historians of the 1960s to assert that what was intrinsic to or "American" in American painting was a fidelity to fact, an empirical approach, a respect for "the thing-ness of the thing." And so American Impressionism was slurred over in a lot of books of that period, treated as though it never really mattered, as though it were a hand-me-down of European Impressionism and not a bona fide expression of the American experience. Thus John McCoubrey noted, in a parenthetical fashion, that "finally, Weir, Twachtman, Robinson, and Hassam brought to America a pale, belated impressionism which gave their pictures—despite a supposed devotion to particularity—only a vague unlocalized prettiness."[18] Barbara Novak, in her book on nineteenth-century American painting, dismissed Twachtman and Hassam as having produced a hybrid, imported style.[19] However, the works that accumulated through a number of key exhibitions in the 1970s, as well as the books of Donelson F. Hoopes and Richard Boyle, revealed that American Impressionism was remarkably wide in scope[20] and included paintings of a high caliber. (What was American about American painting now needed to be seriously reconsidered.) But with the new importance given American Impressionism, there is the tendency to group under that heading some visionary painters who resemble the Impressionists superficially, without showing what was distinctive about them, and to ignore others completely who might have been grouped with them. Among the sixty-four plates in his book, Hoopes includes one Inness, the *Gray Day, Goochland, Virginia* (1884), in the Phillips Collection, Washington, D.C., and two Dewings

[18] John W. McCoubrey, *American Tradition in Painting* (New York: George Braziller, 1963), p. 31.

[19] Barbara Novak, *American Painting of the Nineteenth Century* (New York: Praeger Publishers, 1969), pp. 59, 89.

[20] Here are some of the little-known and lesser-known Impressionists discussed and illustrated by Hoopes: Joseph R. De Camp (1858–1923), Frank Weston Benson (1862–1951), Robert Reid (1862–1929), Abbott Handerson Thayer (1849–1921), Henry Ward Ranger (1858–1916), Theodore Earl Butler (1860–1936), Edward Henry Potthast (1857–1927), Sören Emil Carlsen (1853–1932), Edmund Charles Tarbell (1862–1938). Donelson F. Hoopes, *The American Impressionists* (New York: Watson-Guptil, 1972).

(which are not among his most visionary), the *Lady in Gold* (c. 1900), in The Brooklyn Museum, and *The Spinet* (1902), in the National Collection, Washington, D.C. The Inness is the first plate in the book, as though he constitutes a kind of preamble to American Impressionism; but there is no concerted attempt to show how he differs from the other painters. As to Fuller and Newman, their names are not once mentioned by Hoopes. Boyle does not mention them either. Inness flits through his book, never getting two pages in succession, and is never discussed in terms of his painting. It is as though he was present among the Impressionist coterie without ever really becoming part of them. This is never explained but is to be inferred from his treatment—or lack of it.[21] Inness, in fact, was quite aware of Impressionism, and his apartness from it; he called the impressionist approach "the original pancake of visual imbecility."[22] Happily, Boyle gives Dewing more space, whom he aptly characterizes as "quietly original and poetic."[23]

The issue is this. The objects in the pictures of the bona fide Impressionists seem dissolved by a physical light or rendered somewhat impalpable by an overlaid color grid. With those visionaries who ostensibly use impressionist means, the light is more than physical—*metaphysical,* to use an overused designation—and the dissolving of the object makes for a strange union of it with the world about it (or, with Newman, antagonism to that world). The object becomes dreamlike, "the embodiment of those elusive thoughts that only people the soul by continually flitting through it." These last words are taken from Herman Melville's (1819–1891) *Moby Dick* (1851), from a passage in which a harpooner complains about the lack of whales when a certain man is up at the watch, and the narrator observes that perhaps the whales were always there but, blending into the ocean, were not really discernible from the masthead for what they were:

"Why, thou monkey," said a harpooneer to one of these lads, "we've been cruising now hard upon three years, and thou hast not raised a whale

[21] He is mentioned briefly on seven pages, mainly in terms of which artists he admired and which he knew. The only one of his paintings that is shown, *The Lackawanna Valley* (1855), is an early one, and its connections with Luminism are rightfully mentioned. Richard J. Boyle, *American Impressionism* (Boston: New York Graphics Society, 1974), p. 47.
[22] Quoted in George Inness, Jr., *The Life, Art, and Letters of George Inness* (New York: Century Co., 1917), p. 169.
[23] Boyle, *American Impressionism,* p. 172.

yet. Whales are scarce as hen's teeth whenever thou art up here."
Perhaps they were; or perhaps there might have been shoals of them
in the far horizon; but lulled into such an opiumlike listlessness of
vacant, unconscious reverie is this absentminded youth by the blend-
ing cadence of waves with thoughts, that at last he loses his identity;
takes the mystic ocean at his feet for the visible image of that deep,
blue bottomless soul, pervading mankind and nature; and every
strange, half-seen, gliding, beautiful thing that eludes him; every dimly-
discovered, uprising fin of some undiscernible form, seems to him the
embodiment of those elusive thoughts that only people the soul by
continually flitting through it.[24]

In the last ten years of George Inness's (1825–1894) life, the ob-
jects making up his landscapes became like ghostly immanences, taking
on something of the spirit of those whales that, for Melville's narrator,

George Inness: *Harvest Moon.* 1891. Oil on canvas. 30" x 44½". The Cor-
coran Gallery of Art, Washington, D.C.; Bequest of Mabel Stevens Smithers,
1952, The Francis Sydney Smithers Memorial.

perhaps were there. They then came to serve as the expression of the

[24] Herman Melville, *Moby Dick* (New York: Random House, 1930), chap. 35,
pp. 227–229.

objects of some inner landscape, some inner mystery. It is likely that his growing immersion in Swedenborgian mysticism, which he had first encountered in 1866 through Page, led to this change in his art. Swedenborg urged that what we see as a solid, palpable world is really a reproduction of some phantom, invisible world; and Inness's late landscapes look as though they could be snippets of that world. It is of interest that Inness stated that "the true use of art is first to cultivate the artist's own spiritual nature" and that "the true purpose of a painter is to reproduce in other minds the impression which the scene made on him." We cannot know for ourselves what sorts of impressions scenes made on Inness's mind during those last ten years to have led him to paint those strangely flickering landscapes. Did Inness really begin to see phantom landscapes where others saw more solidly constructed ones? All we know is that he advised his son that the painted landscape should be full of light and air and animated by transparent colors: "There you see, George, the value of the gray color underneath glazing. The transparency of it comes out in tone. The shadows are full of color. Not pigment; all light and air. Wipe out a little more of it. Never was anything as nice as transparent color."[25]

Unlike Asher B. Durand, who used broadly open areas with picturesque vistas to contain the allegorical figures and buildings in his landscapes the *Morning* and *Evening of Life* (1840), Inness, for his late landscapes, preferred sites that did not lend themselves to the dramatic: There are no high mountains, steep inclines, vast distances, wide lakes, majestic groupings of trees, such as abound in the Hudson River paintings. Rather, we find a bit of marshland (*Home of the Heron*, 1893), a small area of a rather run-down farm (*The Clouded Sun* and the *Harvest Moon*, both of 1891), a small expanse of meadowland with a couple of modest buildings on it (*Gray Day, Goochland, Virginia*, 1884), and a small section of a forest interior (*The Trout Brook*, 1891). When there are figures, they neither go about their activities nor, as in some Hudson River landscapes (Durand's *Kindred Spirits*, 1849, in The New York Public Library), stand gazing in worshipful awe at nature's grandeur, which, of course, is not found in these paintings anyway. As solitary, brooding sorts of figures, they pass fitfully through the landscape, immersed in themselves. These solitary strollers are in more than half of the late paintings and can be seen in *The Clouded Sun*, the *Harvest Moon*, and *The Trout Brook*. At the same time, details of trees,

[25] Quoted in George Inness, Jr., *George Inness*, p. 129.

George Inness: *The Trout Brook*. 1891. Oil on canvas. 30″ x 45″. The Newark Museum, New Jersey; Purchase 1965 Members Fund. Photograph: Armen.

George Inness: *Gray Day, Goochland, Virginia*. 1884. Oil on wood panel. 18″ x 24″. The Phillips Collection, Washington, D.C.

buildings, and figures have been obliterated; everything is enveloped in a dense mist or fog, which emanates from no discernible condition of nature. It is a mist saturated with a grayish hue—rose gray in the *Gray Day, Goochland,* almost purplish gray in the *Home of the Heron*—and this prevailing tonality does not derive from any natural conditions of light. The objects in the scene appear perfectly "normal," except that they are bathed in an unnatural color. The lack of dramatic emphasis within the scene and the self-immersion of the figures contribute to a mood of quietness; the gray-hued tonality and the all-enveloping mist endow the quietness with a strange remoteness.

Not only does what we see in these late landscapes seem like the reflections, the spectral afterimages of another, more sharply etched landscape—and that is, because of the mist and the ensuing softening of forms—but the strange remoteness is produced by something else, which is a bit harder to get at when we try to put our finger on it. And that is the sense of measured cadence; even more than that, it is as though this painted world operates through some slowed-down pace, through some frame of reference that is alien to ours (or, presumably, to the Americans of the last decade of Inness's life—some of whom are still alive). It is tempting for me to say, although I cannot be sure that this is true, that Inness determined these landscapes after certain passages in Swedenborg's writings, such as the following descriptions of the spiritual world:

> We need space and time that we may recognize ourselves and others, and make use of the things about us; or, in one word, live. But we no longer need *such* space and time as we had in this world: we no longer need their restraint and compulsion, and these pass away; but we do need as much as before their assistance, and that we have. We may express the difference in a few words, thus: In this world, space and time control thought and will; in that world, thought and will control space and time.[26]

As in the paintings, the spiritual world resembles the natural one, although the things in it are not hard and unyielding and the spaces between them are not fixed (and here that idea of a slowed-down cadence can apply):

> Since angels and spirits see with eyes, just as men in the world do, and

[26] Theophilus Parsons, *Outlines of the Religion and Philosophy of Swedenborg* (New York, 1903), p. 87.

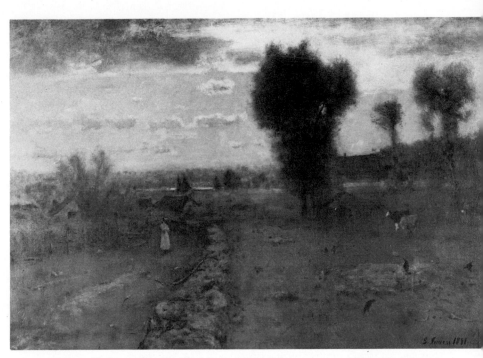

George Inness: *The Clouded Sun.* 1891. Oil on canvas. 30″ x 45″. Museum of Art, Carnegie Institute, Pittsburgh.

> since objects cannot be seen in space, therefore in the spiritual world where angels and spirits are, there appear to be spaces like the spaces on earth; yet they are not spaces, but appearances; since they are not fixed and constant, as spaces are on earth; for they can be lengthened or shortened; they can be changed or varied.[27]

I say "thoroughly true" because I do not believe that Inness purposefully set out to make his landscapes resemble the imagined landscapes of Swedenborg's spiritual world. But without his consulting Swedenborg's writings, they would not have come out as they did. From the material I have already presented, it should be evident that Inness was steeped in those writings. Other evidence could be presented as well. The artist D. Maitland Armstrong (1836–1918) published this reminiscence:

[27] Emanuel Swedenborg, *Divine Love and Wisdom* (London: Dent, n.d.), para. 7.

I once met him in the White Mountains and we spent several hours talking together, or rather he talked and I listened, about a theory he had of color intertwined in a most ingenious way with Swedenborgianism, in which he was a devout believer. Toward the latter part of the evening I became quite dizzy, and which was color and which religion I could hardly tell.[28]

That the visionary paintings produced by Inness from around 1884 were not due *solely* to his absorption with Swedenborg's thinking becomes more evident when we see that around the same time other painters were becoming visionaries in much the same way. That way was through a blurring of contours and a general softening of figures and objects, which are set within a misty landscape, all calculated to provide a mood of dreaminess and detachment. George Fuller, after leaving his Deerfield farm in 1876, worked in this manner until his death in 1884. Exactly how much Inness owed to Swedenborg and how much to the temper of the times, that is, to these mystical departures from an Impressionist vein, is, of course, impossible to say. But both played a role in molding the style of his last decade.

Whereas Inness continued to paint landscapes in his last period, from 1884 to 1894, George Fuller painted mostly figures from 1876 onward. These are typically of a young woman, shown nearly full length, staring vacantly toward the viewer. She is typically set in a gauzy, indefinite landscape. Fuller was closely paraphrased as saying that he "preferred to remove the object of interest in his picture a degree into its atmosphere, believing that this gave a greater chance for expression."[29] This does not at all mean, as we can obviously see from the *Winifred Dysart* (1881) and the *Nydia* (1882), setting the figure back into the space of the picture: It means, as Fuller allegedly said, suffusing the figure with the surrounding atmosphere. The delicate modeling and shading of these young women are calculated to enhance their sense of mystery. Fuller said that "color in its highest sense is a delicate sense of gradation."[30] It doesn't always come off completely well, for some of the young women are too vacantly pretty to be other-

[28] D. Maitland Armstrong, *Day Before Yesterday; Reminiscences of a Varied Life* (New York: Charles Scribner's Sons, 1920), p. 288.
[29] Frederick F. Sherman, "Four Pictures by George Fuller," *Art in America* 7 (1919): 85.
[30] *Ibid.*

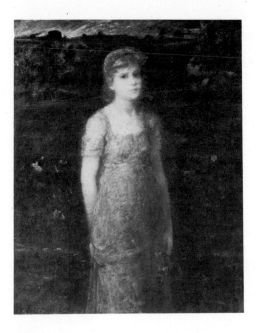

George Fuller: *Winifred Dysart*. 1881. Oil on canvas. 50⁷⁄₁₆″ x 40½″. Worcester Art Museum, Worcester, Massachusetts.

worldly types trying to pierce the veil (such is the case with *Winifred Dysart*). In his portrait titled *Nydia,* however, modeled after the blind heroine in Edward Bulwer-Lytton's *Last Days of Pompeii* (1834), Fuller achieved something memorable in conveying both the woman's urgent, terror-stricken haste and her groping helplessness. *And She Was a Witch* (c. 1883) is one of Fuller's more ambitious attempts. The several figures in the landscape play out a drama having to do with the witch-hunting times of early New England, a subject Fuller portrayed in *The Trial of the Salem Witches* (c. 1883; The Art Institute of Chicago) showing the courtroom trial of a suspected witch. Here a woman is cast off into the countryside, derided by others of her community. The vaporous trees surrounding the figures are redolent with mystery, thus underscoring the unknown and occult aspects of the subject.

Fuller, in 1859, the year before he settled at the Deerfield farm, went to London, then to Paris, then to the museums of Belgium, Holland, Germany, and Italy, where he admired the old masters, especially

Rembrandt.[31] In 1860 he was dissatisfied with his own painting.[32] The prolonged isolation on the farm then released his mystical proclivities, which he realized beginning in 1876, at the age of fifty-four. It served him somewhat in the way that Swedenborgianism served Inness. But, again, the direction those proclivities took was determined by the wider artistic currents of the time. And by that is meant tonalism, a manner of expression that would be appealing to an artist as withdrawn as Fuller. A relatively new addition to the terminology of art history, *tonalism* refers to that colored vaporousness, that veiling of images prevalent in

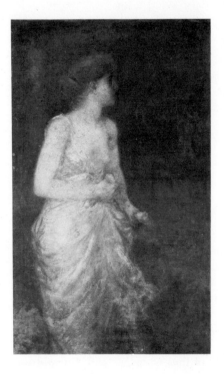

George Fuller: *Nydia.* 1882. Oil on canvas. 50" x 32¼". The Metropolitan Museum of Art, New York; Gift of George I. Seney, 1887.

[31] Charles H. Caffin, *The Story of American Painting; The Evolution of Painting in America from Colonial Times to the Present* (New York: Frederick A. Stokes, 1907), pp. 222, 225.
[32] Charles De Kay, "George Fuller, Painter," *Magazine of Art* 12 (1889): 350.

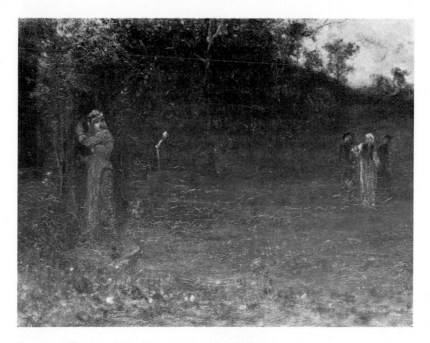

George Fuller: *And She Was a Witch.* c. 1883. Oil on canvas. 30" x 40". The Metropolitan Museum of Art, New York; Gift of George I. Seney, 1887.

much American painting from the 1880s to the early 1900s.[33] The tremulousness, the vibrations of mood provided by an overall color tonality can be found in a number of artists besides Inness and Fuller, who relate to, but stand apart from, Impressionism. These include Elliott Daingerfield (1859–1932); William Keith (1837–1911), who was interested in Swedenborgianism like Inness, whom he hosted in San Francisco in 1890; Willard L. Metcalf (1858–1925); John Francis Murphy (1853–1921); Dwight W. Tryon (1849–1925); and Thomas W. Dewing.

Dewing is the most disquieting of these tonalists and, I would say,

[33] See especially Wanda M. Corn, *The Color of Mood: American Tonalism 1880–1910* (San Francisco: M. H. De Young Memorial Museum, 1972). This is the catalogue of and essay for the exhibition held in 1972 at the M. H. De Young Memorial Museum and the California Palace of the Legion of Honor. Of the ninety-five pieces in the show, about half are photographs by A. W. Brigman (1869–1950), Alvin Langdon Coburn (1882–1966), Frederick Holland Day (1864–1933), Gertrude Käsebier (1852–1934), Joseph T. Keiley (1869–1914), Edward Steichen (1879–1973), Alfred Stieglitz (1864–1946), and Clarence H. White (1871–1925).

the most visionary. He studied first in Paris, under Jules Lefebvre (1836–1912), then in Munich with Gustave Rodolphe Clarence Boulanger (1824–1888). When he returned to America in 1879, he was an accomplished Salon painter. He became that—and something more. He began to draw inspiration from James Abbott McNeill Whistler (1834–1903) and from Japanese prints. The influence of those prints can be detected in the asymmetrical arrangements and in the cutting of objects by the painting's frame, such as in *The Piano* (1891), in the Freer Gallery of Art, Washington, D.C.[34] From the 1880s on, his two favorite

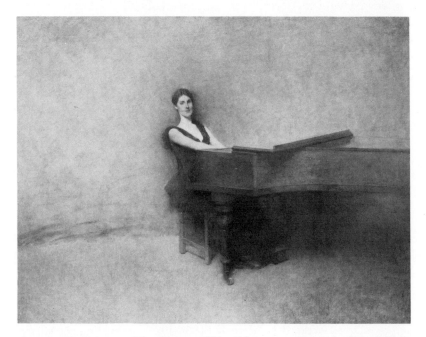

Thomas W. Dewing: *The Piano*. 1891. Oil on wood panel. 20″ x 26⅝″. Freer Gallery of Art, Washington, D.C.

[34] Charles Lang Freer (1856–1919), who made his money in the manufacture of railroad cars, specialized in the collecting of Oriental art, Whistlers, and the paintings of Tryon, Thayer, and Dewing, who were part of his inner circle. They advised him on the selection and design of wallpaper for his home, and he advised them on musical instruments (Aline Saarinen, *The Proud Possessors*, New York: Random House, 1958, pp. 126–127), which come up often in Dewing's paintings. At the time of his death, Freer had accumulated twenty-seven Dewings. His gallery, in Washington, D.C., opened in 1923. John Gellatly, who collected Ryder and Newman, also collected Dewing.

artists were Whistler and Vermeer, the latter of whom he must have admired for the fastidious fashionableness of his interiors and the aplomb with which his seventeenth-century bourgeois women carried themselves.

No other painter—not even Abbott Henderson Thayer (1849–1921) or George de Forest Brush (1855–1941)—was better than Dewing at portraying the American woman of the 1890s with a sense of chic and aloof independence. The well-bred woman, or she who aspired to appear as such, was his chief interest. He shows her at her leisure, reading or playing a musical instrument, imperially slim, adorned in rich silks, her shoulders bared, her hair set with pearl combs. Dewing's appreciation of elegance and the masterful draftsmanship with which he expressed that elegance would have satisfied even his French contemporary Edgar Degas (1834–1917).

In the interior scenes, the Freer *Piano,* for example, there is an

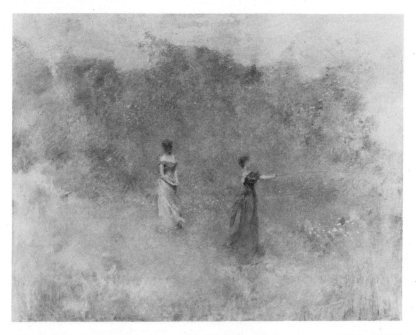

Thomas W. Dewing: *Summer.* 1889–1890. Oil on canvas. 42⅛" x 54¼". National Collection of Fine Arts, Smithsonian Institution, Washington, D.C.; Gift of William T. Evans.

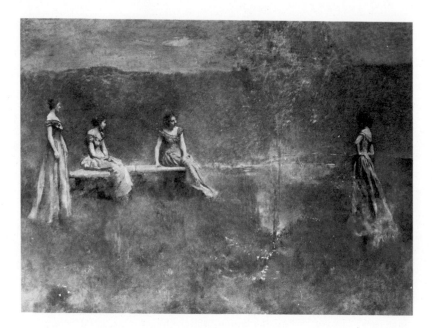

Thomas W. Dewing: *La Pêche*. c. 1890. Oil on canvas. 35″ x 48″. Kennedy Galleries, New York.

emptiness of space, a curious isolation of the figure. But it is in the out-door pictures, *The Recitation* (1891), *Summer* (1889–1890), *La Pêche* (c. 1890; so named after that one woman of the four who is holding a fishing rod), that the sense of the dream thoroughly comes to the fore. These languid, beautiful women, whose lives are ostensibly with-out care and who are set on a spacious lawn or in the country, seem to float in a sea of green. The continuous filmy background is broken only by a few chairs (*The Recitation*), a bench (*La Pêche*), a scroll of furniture. *The Recitation* is the oddest of the outdoor pictures. Where are these two solitary women located? In a yard before a house? Then, where is this house? where is a street? Are they in a park? Then, where are other people, and whence have the chairs come? These women, embodiments of the fashion of a certain time and place, carry the accouterments of that fashion with them, even while all other evi-dence of that time and place is missing. They are a world unto them-selves, cool and impervious, a nonexistent, mysterious, sealed-off world

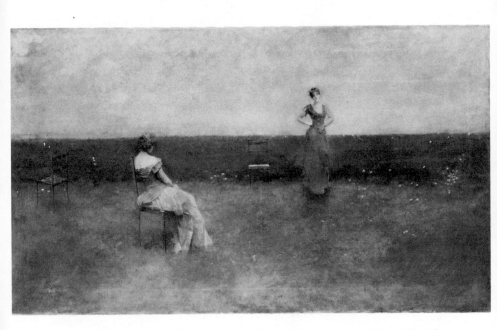

Thomas W. Dewing: *The Recitation*. 1891. Oil on canvas. 30″ x 55″. The Detroit Institute of Arts, Michigan; Purchase, The Picture Fund.

where there are no guideposts, boundary lines, or cues to the measurement of space.

Swedenborgianism forms a bridge between the late work of Inness, an artist associated with the tonalists, and the work of Page, a visionary of "the normal" who preceded him. Nonetheless, the visionaries of the "normal" were hardly cognizant, as a group, that there was anything "spooky," uncanny, or disturbing about their work, which contains no imaginative extravaganzas, no obvious earmarks of the bizarre. The visionaries of the spectacular—West, Allston, Cole—and probably even the primitive Hicks would have been aware that the theme of catastrophism ran through most of their visionary work. Neither they nor the subterranean visionaries congregated as a group. Still, if Rimmer, Vedder, La Farge, Field, and Quidor had ever gotten together to look at those of their paintings that I have presented in this book, I feel certain they would have appreciated the kinship among them. There is not the least hint that either the early Ryder or Newman thought of

himself as separate from other American animal and genre painters, that Dewing and Fuller (who had next to nothing to say about their own art) saw their paintings as more otherworldly than those of the tonalists, to whom they are related. The visionaries of "the normal" were the least aggressively visionary, the least obviously so, the least aware of the resonances of their paintings (except for Page), and it is for this that they are the more compelling for me.

5

The Visionary Eccentrics III:
The Cosmic Visionaries

The categories of visionary painters that I have presented so far—visionaries of the spectacular, subterranean visionaries, and visionaries of the "normal"—were each defined in terms of the content of the paintings' scenes, their themes, and also in terms of the degree to which people or beings (hybrids) who appear are commonplace or not. Cosmic visionary painting usually consists of landscapes, seascapes, and literary scenes, but it is not these general types in themselves that matter so much as the conception behind them. But the definition of the category *cosmic visionary* is more elusive than the definitions of the other three.

By *cosmos* is meant a vast system of interdependent parts. Most commonly, *cosmos* brings to mind the universe. But the term can apply also to nature (which embraces, as well, the people within it) as being one vast order, a kind of energized macrocosm, where everything partakes of the same rhythm, of the same moving forces. The world of nature is not merely a container or backdrop for what goes on within it; it is an extension of this activity; and, conversely, human activity is an extension of the life within nature. Nature embraces mankind, and all nature, all the visible cosmos, as it were, is alive, and alive in the same way. An analogy between the extension of that life or energy and the outward radiation of ripples in a pool would be only partially correct. The concept is not one merely of life or energy extending but, more to the point, one of the whole as being alive in the same way as the smallest particle within it.

So far, my discussions have been centered on the subjects of the paintings and on the strange worlds that the visionaries conjured up. With the cosmic visionaries, however, namely Blakelock, and Ryder and Quidor in areas of their work not yet examined, other considerations come into play. Certain forms become modified; there are exaggerations and distortions. These are not the major distortions that we find in twentieth-century Expressionism and in twentieth-century visionaries linked with Expressionism, the most notable of whom in America was probably Charles Burchfield. Labels can be irksome, however, and comparisons can be forced. Suffice it to say that we have with the cosmic visionaries something akin to the devices that the Expressionists were several decades away from inventing.

After Albert Pinkham Ryder's first decade of his farmscapes, his technique coarsened considerably. Now in many of the seascapes, such as The Metropolitan Museum of Art's *Moonlight Marine* (1880s), he produced powerful horizontal wedges of clouds and water thrusting across the picture space and, it would seem, on and on, with the horizon beyond the picture's frame. In *The Flying Dutchman,* the air and the materializing spirit within it, and the water below—all are made up of the same system of violent, heaving torrents. In *Jonah* (c.1885), which is almost entirely a picture of the ocean's water, Ryder virtually sought to enter into the swell and foam of the waves, into nature's elemental violence. *Jonah* is an attempt not at the mere representing of this violence but, as much as was possible within the pictorial limitations of his time, an attempt at its re-creation. "I am in ecstasies over my Jonah," Ryder wrote to his patron, Thomas B. Clarke (1843–1911), "such a lovely turmoil of water and everything."[1]

Some of John Quidor's paintings, the *Battle Scene from Knickerbocker's History of New York* (1838) and the *Embarkation from Communipaw* (1861), for example, which show, respectively, a furious battle and a rollicking departure to sea, are made up of designs of sweeping lines and restless curls. Not only the participants but also the trees and branches and clouds are engaged together in a kind of quivering, all-encompassing dance, a cosmic dance, as it were.

Ralph Albert Blakelock uncovered in nature a motion that, although less immediately dramatic or perceptible, is more relentless and

[1] Written in April 1885. Quoted in Lloyd Goodrich, *Albert P. Ryder Centenary Exhibition, October 18–November 30, 1947,* catalogue (New York: Whitney Museum of American Art, 1947), p. 18.

inexorable. This is a growth of vegetation, more exactly the expansion of the forest, which is dense and foreboding. In the forest moonscapes, Blakelock exaggerated the spread of the latticework of the branches, branches reaching and growing toward the light as though by a mysterious tropism. It is the affinity of one part of nature for another. Everything interacts, nothing stands in isolation.

In the writings of Poe and in Shelley's "Ozymandias" are viewpoints parallel to the catastrophist approaches commonly adopted by the visionaries of the spectacular. I have also tried to show that there are correspondences between the visionaries of the "normal" and the poems of Emily Dickinson, Henry James's "Turn of the Screw" and other stories, and certain passages in Melville's *Moby Dick*. When we think of the cosmic visionaries, it is Walt Whitman (1819–1892), of nineteenth-century American poets, who best exemplifies their approach. He desired personally to experience all, to feel as broadly as possible, and thus to identify himself with mankind's vitality. He wrote of himself:

> *Walt Whitman, a kosmos, of Manhattan the son,*
> *Turbulent, fleshy, sensual, eating, drinking and breeding,*
> *No sentimentalist, no stander above men and women or apart from them*
> *No more modest than immodest.*

From this, Whitman came to believe that what seems to be diversity is really unity, that all existence, not only over the extent of the earth but throughout all past and future generations, is permeated by a kind of all-engulfing energy. This credo he put forth in a poem of 1860 from his vast collection *Leaves of Grass*, which he called, appropriately enough, "Kosmos":

> *Who includes diversity and is Nature,*
> *Who is the amplitude of the earth, and the coarseness and sexuality of the*
> * earth, and the great charity of the earth, and the equilibrium also,*
> *. .*
> *Who, out of the theory of the earth and of his or her body understands by*
> * subtle analogies all other theories,*
> *The theory of a city, a poem, and of the large politics of these States;*
> *Who believes not only in our globe with its sun and moon, but in other*
> * globes with their suns and moons,*
> *Who, constructing the house of himself or herself, not for a day but for all*
> * time, sees races, eras, dates, generations,*
> *The past, the future, dwelling there, like space, inseparable together.*

What permeates most of Whitman's poetry is the sense of expansiveness, the thrusting outward from the poet himself, the "I" who stands at the center of the poems, to encompass wider and wider areas, from the life of the city to that of the whole country, and even to the life out in space beyond the globe.[2] It is this expansiveness and reverberating energy that for me links Whitman to the cosmic visionary painters.

As did the cosmic visionaries in their painting, Whitman in his poetry developed new modes of expressionism, new forms. For instance, the very language of "Out of the Cradle Endlessly Rocking," (1871)[3] whether read aloud or silently, conveys fully to the reader, I'm sure kinesthetically in some cases, the sense of a movement's force. The poem becomes like music or like the ebbing and flowing of the sea; with the sea analogy, it becomes a verbal equivalent to Ryder's *Jonah* and other seascapes. The first part of this long poem goes:

Out of the cradle endlessly rocking,
Out of the mocking-bird's throat, the musical shuttle,
Out of the Ninth-month midnight,
Over the sterile sands and the fields beyond, where the child leaving his
* bed wander'd alone, bareheaded, barefoot,*
Down from the shower'd halo,
Up from the mystic play of shadows twining and twisting as if they were
* alive,*
Out from the patches of briers and blackberries,
From the memories of the bird that chanted to me,
From your memories sad brother, from the fitful risings and fallings I heard,
From under that yellow half-moon late-risen and swollen as if with tears,
From those beginning notes of yearning and love there in the mist,
From the thousand responses of my heart never to cease,
From the myriad thence-arous'd words,
From the word stronger and more delicious than any,
From such as now they start the scene revisiting,
As a flock, twittering, rising, or overhead passing,
Borne hither, ere all eludes me, hurriedly,

[2] The fusion of the celebration of the self and an unbounded democratic faith and idealism keeps recurring in Whitman's poetry. A good example is "Song of Myself" (1855). The idea of the self reaching out into measureless space is beautifully unfolded in "A Noiseless Patient Spider" (1862–1863), one of Whitman's best-known poems.

[3] Though dated in the anthologies as 1859, the poem did not know its final form until 1871, or a little more than a decade before those works of Ryder that I designate as cosmic visionary. When the poem was first published in 1860, it was called "A Word Out of the Sea."

A man, yet by these tears a little boy again,
Throwing myself on the sand, confronting the waves,
I, chanter of pains and joys, uniter of here and hereafter,
Taking all hints to use them, but swiftly leaping beyond them,
A reminiscence sing.

In this poem the three persistent images of boy (who is the poet when young), bird, and sea become interwoven in meaning and sound. So the heavy moon "swollen as if with tears" and the sea pushing upon the land express the feelings of love and frustration that the boy when grown, or the maturing poet, experiences. By the end of the poem, the poet comes to recognize in the bird who lost his female companion both the foreshadowing of his own losses and outpourings of love and the basic motion for his poetic expressions. Whitman identifies with the bird, who is his "sad brother." The process of interweaving has been effected, Walter Sutton has pointed out, both by syntactical and sound devices, and also, in the first part (just quoted), by the repeated introductory prepositions *out of, over, down from,* and *up from*—all indicating the thrusting out from a center (the boy in the cradle) and the returning to it.[4]

Let us return now to the matter of the definition of *cosmic visionary,* which, as I've said from the outset of the chapter, is more elusive than the other three categories of nineteenth-century American visionary painting set up in this book. In chapter 4 I tried to show that William Page, for instance, endowed some of his figures with a special quality of aliveness so that they seemed almost to quiver and to protrude into our space. This can be seen in his *Cupid and Psyche* (1843) and the portrait of his third wife, Sophie (1860–1861). The early Ryder knew how to infuse his farm animals with an uncanny aliveness and expressiveness, so that we the spectators are made to feel as though we can enter into their feelings, as though we are their kin (as Whitman said of the bird—a "sad brother"). Newman endowed his landscapes with a force that seems to reside in the trees and shadows, which loom and threaten the figures beneath them and among them as if they were sinister protagonists themselves. The difference between that aspect of the visionaries of "the normal" and the overall definition of the cosmic

[4] Walter Sutton, "Whitman's Poetic Ensembles," in *Whitman: A Collection of Critical Essays,* ed. Roy Harvey Pearce (Englewood Cliffs, N.J.: Prentice-Hall, 1962), p. 125.

visionaries can be seen as one of degree. The cosmic visionaries shake off restraints. That "normality" that clouded issues (and that made for the wonderful quality of spookiness in many of the canvases of the visionaries of "the normal") would have been seen by them as incomplete, a halfway measure, and would have been dismissed or disregarded by them—or even overlooked by them. Page's figures emerge out of their backdrop with an extraordinary aliveness; but now there is nothing to emerge out of, because *everything* is charged with an aliveness, everything—to let "Out of the Cradle Endlessly Rocking" serve as a comparison—is inextricably interwoven. And at times, too, the boundaries between these two categories become uncertain. (The art historian's beloved categories: If formulated with imagination, they can help elucidate the mechanisms within a movement or an approach in art, as I hope mine have done; but even at best, they impose an artificial rigidity upon a naturally fluid situation.) When does that point come in which "everything is charged with an aliveness," or, to put it another way, when do the visionaries of "the normal" change into the cosmic visionaries? With Robert Loftin Newman, I was uncertain and believe, even up to this point, that (with the omnipotence that the art historian consigns to himself) he might just as easily have been placed with the cosmic visionaries. With Ryder the case is more clear-cut: After his farmscapes, sometime in the early 1880s, he became a cosmic visionary. It was not a new outlook, a new direction, but a deepening of his earlier one, a pursuing of it to its ultimate conclusions.

Goodrich places Ryder's marines, those pictures of solitary boats cast upon the sea, in the 1880s.[5] In *The Lovers' Boat, or Moonlight on the Waters*, which he dates no later than 1881,[6] the boat is gliding out of a little cove, between some rocks and a shadowy hill upon whose crest some buildings sit. In the marines, which he places later in the 1880s, all trace of land has vanished, and we presumably see the little craft somewhere deep at sea. Now the relationship between boat and sea becomes something entirely natural, natural in the sense of eternal and relentless. Boat and sea become wedded in a common destiny. No figures of sailors can be made out, no act or task (rigging the sails, fish-

[5] Lloyd Goodrich, *Albert P. Ryder* (New York: George Braziller, 1959), pp. 113–114.
[6] The painting was exhibited in 1881. *Ibid.*, p. 114. It is in the Guennol Collection, New York.

Albert Pinkham Ryder: *Moonlight Marine*. 1880s. Oil on wood panel. 11⅜″ x 12″. The Metropolitan Museum of Art, New York; Samuel D. Lee Fund, 1934.

ing, harpooning) is shown that would make for a particularization of the moment in time. Nothing but the dark silhouette of the boat, heavily encrusted, set against the expanse of ocean and sky, as in The Metropolitan Museum of Art's small paintings on wood, the *Moonlight Marine* (1880s) and the *Toilers of the Sea* (before 1884). There is an overall consistent surface treatment, a hallmark of the cosmic visionary.

Ryder's visualizing of the sea as something pristine and compelling, as uncontrolled, as the arbiter of man's lot, came not from books or the accounts of others but from his own firsthand knowledge. Too much emphasis cannot be laid on the fact that Ryder was born in New Bed-

ford, Massachusetts, in 1847 and stayed there until 1870 or 1871, or the time when that southeastern Massachusetts seaport was still near the height of its prosperity derived from the whaling industry. And it is this background that helps to explain the persistent seascapes of the 1880s. In 1838 the town of New Bedford owned 170 whaling vessels manned by four thousand sailors, and had seventeen candle and oil factories; by 1850 the number of vessels had jumped dramatically to 450 (though that number dropped a bit thereafter until the partial recovery after the Civil War). Into New Bedford in 1837 were brought 75,675 barrels of sperm whale oil and 85,668 barrels of right whale oil, figures that rose in the following years; and by 1845, two years before Ryder's birth, the town was third in the country in the total tonnage of vessels handled.[7]

Ryder himself probably visited nearby whaling towns, such as Fairhaven, and the great whaling center on the Island of Nantucket, which was linked to New Bedford by the vessels of the New Bedford, Vineyard and Nantucket Steamboat Company, incorporated in 1854.[8] In 1791 there sailed from Nantucket and New Bedford, respectively, the *Beaver* and the *Rebecca,* the first two American ships to hunt whales off Cape Horn. As the demands of the populace increased and larger boats were built, voyages lasted up to a year, a year and a half, and longer; and many times—Ryder undoubtedly knew this—New Bedford whalers never returned home. Ryder must have stood in the Beth-el Chapel in New Bedford and taken cognizance of the nameplates on the walls inscribed with the names of those lost, the years of their lives, and the briefest details of their deaths—killed in a storm off this or that coast, killed by a whale in such and such a place. Ryder must have known that the same sea that provided livelihood killed men in the prime of their lives: And this, for him, must have been the prime feature of the cosmic interrelatedness of things. The nameplates are a poignant reminder of that fact. I read most of them as I stood in Beth-el in the summer of 1976. The chapel has hardly changed from the days of Ryder and Melville, who definitely visited it before sailing from New Bedford in 1841 on a whaling voyage to the Pacific. Melville based

[7] Rev. Frederic Denison, *Illustrated New Bedford, Nantucket, Martha's Vineyard* (Providence, R.I., 1880), p. 21.

[8] The yearly expenditure of $70,000 is a good indication of the close ties maintained through the company between New Bedford and the Islands. *Ibid.,* p. 25. By 1854 Nantucket had pretty much recovered from the disastrous fire of 1846.

"The Pulpit," chapter 8 of *Moby Dick*, on it, paying close attention to the pulpit (the same one that stands there today) shaped like the beak of a boat with its paneled front fashioned like a boat's bluff bows. He apparently saw in this unusual pulpit a dual symbol, for both a ship and the world, which is like a ship that God guides on some unknowable voyage. "The Pulpit" ends with this paragraph:

> What could be more full of meaning?—for the pulpit is ever the earth's foremost part; all the rest come in its rear; the pulpit leads the world. From thence it is the storm of God's quick wrath is first descried, and the bow must bear the earliest brunt. From thence it is the God of breezes fair or foul is first invoked for favorable winds. Yes, the world's a ship on its passage out, and not a voyage complete; and the pulpit is its prow.[9]

The sea and New Bedford were in Ryder's blood. His forebears had been among the earliest settlers of old Yarmouthport, on the north shore of Cape Cod. A Samuel Ryder had come there in 1638,[10] and the family, which included shopkeepers and seafarers, stayed there until moving to New Bedford about 1840. Two of Ryder's brothers were whalers, and when he was in New York City, he kept as one of his closest friends the sea captain John Robinson, with whom he crossed the Atlantic in 1887 and 1896. Cape Cod, moreover, is a region with a special "feel" to it. Frank Jewett Mather, Jr., wrote that the soft humid air there entrapped the most moonlight of anywhere he knew.[11] I do not know everywhere Mather traveled, but the moon does hang heavy about Cape Cod and its surrounding areas. The young Ryder might himself have become a whaler had his eyes not been weakened and had he not been prone to ulcers;[12] so, at an early age, he kept to himself and wandered about by night to protect his eyes from glare. The marines, then, mostly painted eleven to sixteen years after Ryder had left New Bedford for New York, were evocations of the sea dramas and sea scenes he had known and were distilled by his nocturnal reveries set within an unusually redolent setting.

[9] Herman Melville, *Moby Dick; or, the Whale* (New York: Random House, 1930), chap. 8, p. 57.
[10] Richard Braddock, "The Literary World of Albert Pinkham Ryder," *Gazette des Beaux-Arts* 33 (January 1948): 49.
[11] Frank Jewett Mather, Jr., "Albert Pinkham Ryder's Beginnings," *Art in America* 9 (April 1921): 120.
[12] *Ibid.*, p. 121.

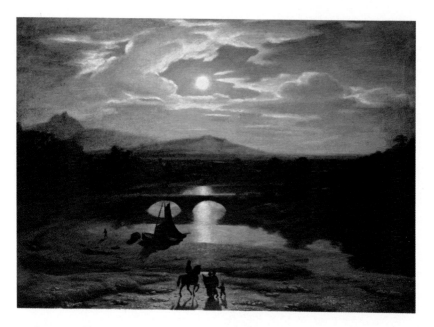

Washington Allston: *Moonlit Landscape*. 1819. Oil on canvas. 24″ x 35″. Museum of Fine Arts, Boston; Gift of Dr. W. S. Bigelow.

Thomas Cole: *Desolation* from "The Course of Empire" series. 1836. Oil on canvas. 39¼″ x 63½″. The New-York Historical Society, New York.

Thomas Cole: *The Architect's Dream.* 1840. Oil on canvas. 54" x 84". The Toledo Museum of Art, Ohio; Gift of Florence Scott Libby.

Edward Hicks: *The Peaceable Kingdom.* 1844. Oil on canvas. 24" x 31¼". Abby Aldrich Rockefeller Folk Art Center, Williamsburg, Virginia.

William Rimmer: *Flight and Pursuit.* 1872. Oil on canvas. 18" x 26¼". Museum of Fine Arts, Boston; Bequest of Miss Edith Nichols.

Elihu Vedder: *Lazarus.* 1899. Oil on canvas. 20″ x 31½″. Museum of Fine Arts, Boston; Gift of Edwin Atkins Grozier.

Elihu Vedder: *Lair of the Sea Serpent.* 1864. Oil on canvas. 21″ x 36″. Museum of Fine Arts, Boston; Bequest of Thomas G. Appleton.

Erastus Salisbury Field: *Historical Monument of the American Republic*. c. 1876. Oil on canvas. 9'3" x 13'1". Museum of Fine Arts, Springfield, Massachusetts; Morgan Wesson Memorial Collection.

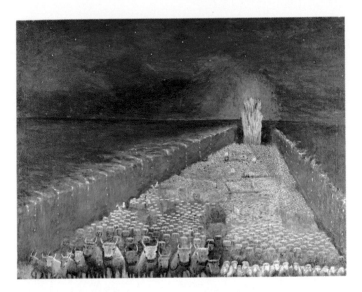

Erastus Salisbury Field: *Israelites Crossing the Red Sea*. 1865–1880.
Oil on canvas. 34¾″ x 46″. Collection of Mr. and Mrs. W. B.
Carnochan.

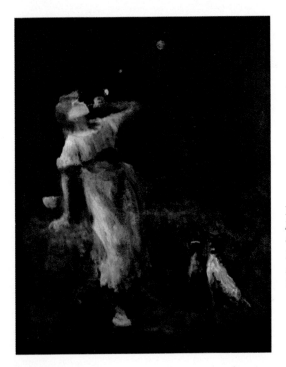

Robert Loftin Newman:
Blowing Soap Bubbles.
c. 1880. Oil on canvas.
16⅛″. The Corcoran Ga
Art, Washington, D.C.;
Purchase Gallery Fund,

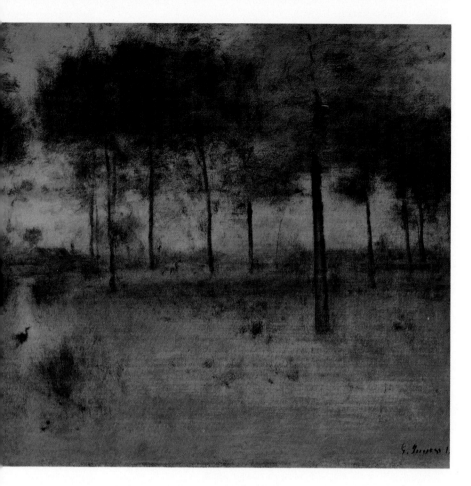

George Inness: *The Home of the Heron*. 1893. Oil on canvas. 30″ x 45″. The Art Institute of Chicago, Illinois; Edward B. Butler Collection.

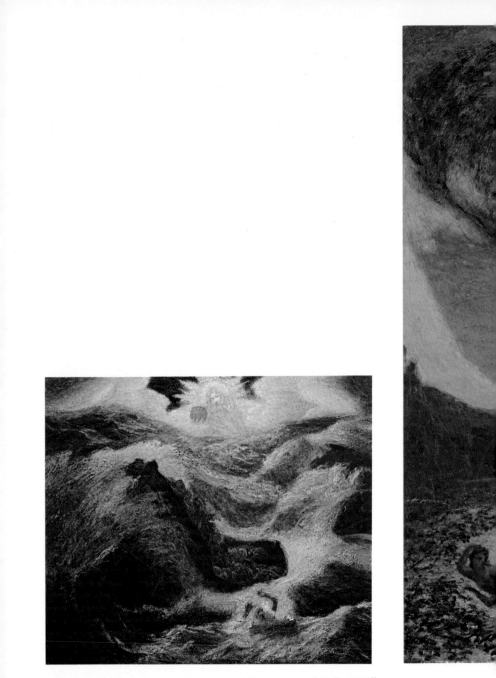

Albert Pinkham Ryder: *Jonah*. c. 1890. Oil on canvas. 26½″ x 23½″
National Collection of Fine Arts, Smithsonian Institution,
Washington, D.C.; Gift of John Gellatly.

Albert Pinkham Ryder: *Siegfried and the Rhine Maidens*. 1888–1891. Oil on canvas. 19″ x 22½″. National Gallery of Art, Washington, D.C.; Andrew Mellon Collection.

Ralph Blakelock: *Indian Encampment.* c. 1871. Oil on canvas. 16½″ x 24½″. The
M. P. Potamkin Collection.

Ralph Blakelock: *Moonlight.* c. 1890. Oil on canvas. 27⅛″ x 37⅛″. The Corcoran
Gallery of Art, Washington, D.C.; Bequest of William A. Clark.

John Quidor: *Embarkation from Communipaw*. 1861. Oil on canvas. 27″ x 34¼″. The Detroit Institute of Arts, Michigan.

Louis Michel Eilshemius: *Jealousy*. 1915. Oil on academy board. 19½″ x 25″. Philadelphia Museum of Art, Pennsylvania; Gift of Mr. and Mrs. Henry Clifford.

Arshile Gorky: *Agony.* 1947. Oil on canvas. 40″ x 50½″. The Museum of Modern Art, New York; A. Conger Goodyear Fund.

No diagnosis of Ryder's problems with his sight has been passed on. We can be sure, though, that those problems did not keep him from dipping widely into the Bible and English and American literature, since so many of his paintings have literary sources. Among other examples that could be cited are these: From the Old Testament came the picture of Jonah foundering in the ocean as the big fish approaches; and from the New Testament, pictures of Christ appearing to Mary, and of the Crucifixion and Resurrection. In Shakespeare, Ryder went to act I, scene 2, of *The Tempest*, where Prospero, Miranda, and Caliban appear together, and to act I, scene 3, of *Macbeth*, where Macbeth confronts the witches on the heath; and in Chaucer's *Canterbury Tales* to "The Man of Law's Tale," in which Constance, daughter of the emperor of Rome, was cast adrift and miraculously preserved. *The Temple of the Mind* (mid-1880s), in the Albright Gallery, Buffalo, derives from Poe's "Fall of the House of Usher." A devotee of the opera, Ryder also used Wagnerian themes. Other paintings came from the writings of Byron (1788–1824), Thomas Moore (1779–1852), Thomas Campbell (1777–1844), and Tennyson (1809–1892).[13] And so Ryder's slovenliness, inwardness, and strange naïveté must not lead one to believe that he was illiterate or nearly so. Although his name is omitted, unjustly, from anthologies of American poetry, the fifteen or so of Ryder's poems that have survived establish him as a minor but noteworthy literary figure of his time.[14]

> In splendor rare, the moon,
> In full-orbed splendor,
> On sea and darkness making light,
> While windy spaces and night,
> In all vastness, did make,
> With cattled hill and lake,
> A scene grand and lovely.
> Then, gliding above the
> Dark water, a lover's boat,
> In quiet beauty, did float
> Upon the scene, mingling shadows
> Into deeper shadows
> Of sky and land reflected.

The story of Wagner's *Fliegende Holländer (The Flying Dutch-*

[13] For Ryder's literary sources, see Goodrich, *Ryder*, and Braddock, "Literary World of Ryder."

[14] The following poem, for example, accompanied *The Lovers' Boat*, exhibited in 1881:

Albert Pinkham Ryder: *The Flying Dutchman.* c. 1887. Oil on canvas. 14¼″ x 17¼″. National Collection of Fine Arts, Smithsonian Institution, Washington, D.C.; Gift of John Gellatly.

man) centers on a Dutch sea captain by the name of Vanderdecken, who, sailing against a gale, is unable to double the Cape of Good Hope and vows he will sail forever until he succeeds. The devil, hearing the oath, condemns him to sail the sea until he finds a woman who will love him faithfully; and to find her he is allowed to go ashore once every seven years. In Ryder's conception, a small boat with three sailors buffeted by the churning waves occupies the foreground; and one of those three sailors, an old man presumably who has heard and seen much, points out to his companions the spectral ship of the Dutch-

man in the middle ground. Above that ship and the brightly shining moon (or sun) there materializes out of the mist a shrouded, perhaps lunging, distorted figure, the personification of the fate besetting the hero. The fate of Vanderdecken has determined the appearance of the sea and sky at this moment. The clouds parting from this yellowish gray figment are a hard yet unearthly slaty gray, the heavy sea is a malachite green. Ryder searched for and found stories in Richard Wagner (1813–1883) and elsewhere in which he could frame his conception of man as part of the wider rhythms of nature, a nature that could be for him sometimes turbulent and menacing, sometimes calm and benign. For him, nature was not merely a neutral setting for man's actions. Rather, nature and man were one; or, better, as in the case of his Wagnerian paintings, for instance, nature reflected the storminess and the ecstasy that lay within man. This is obvious, too, in *Siegfried and the Rhine Maidens* (1888–1891), in the National Collection, Washington, D.C., which Ryder, according to his own account, painted frenziedly after hearing Wagner's *Götterdämmerung* (1874). The painter and writer Elliott Daingerfield wrote in 1918 that Ryder once told him that he got home about midnight from the opera and worked on the painting for forty-eight hours without sleep or food.[15] Siegfried is shown wearing the Tarnhelm and the ring made of the Rheingold, as he is encountering the Rhine Daughters, who urge him on with shouts of triumph while watching him ride to the castles of the Gibichungs. The abnormally writhing branches (like fingers of some giant claw) of the large central tree portend his impending death at the hands of Hagen, half brother of the Gibichung Gunther.

Of Ryder's works, his *Jonah* (c.1885) was the most singled out by early writers on the artist from 1890 on, or before the painting knew its final form, through the first quarter of this century. And I can think of nothing in nineteenth-century American painting that can be called visionary, in the mystical, dreamlike sense, that contains at the same time as much awesome grandeur. Jonah was the least compliant, the most rebellious of the Old Testament prophets. He fled by sea to escape God's command that he warn Nineveh of its doom. So God, as the biblical account goes, caused a storm to rise at sea, and the sailors of the ship, realizing that Jonah was at fault, threw him overboard. Then God

[15] Elliott Daingerfield, "Albert Pinkham Ryder, Artist and Dreamer," *Scribner's Magazine* 63 (March 1918): 380.

summoned a great fish to swallow Jonah whole. From within the fish Jonah repented his disobedience, and God had this fish spew Jonah out upon dry land. The prophet foretold Nineveh's destruction, but the city repented its evil ways and saved itself. Ryder probably seized eagerly upon this biblical story or its version in the form of a sermon put by Melville in the mouth of Father Mapple in chapter 9 of *Moby Dick*[16] (Melville as a source for Ryder has never been suggested, as far as I know, but it is possible in this case): Here is God as nature's prime mover who makes the ocean storm and a fish swallow a man because of that man's intransigence. Nature is the offshoot of a man's deeds. Man's deeds are raised to a cosmic level. (This is the essence of *Moby Dick*.) So the ocean's maelstrom in the painting is meant by Ryder as the mirroring of Jonah's own inner turmoil. Jonah is shown in dire peril: He is struggling to keep afloat as the great fish (shaped curiously like the ship with its terrified occupants) bears down upon him. In the narrow band of sky above the churning water is the figure of God, depicted as an old man with a blond flowing beard, who holds the globe of the world in his right hand and gestures toward the fish with his left. Ryder brings us as close as possible to the ocean's elemental force; the swirling water occupies most of the canvas, now more than at other times. Though in 1885 Ryder wrote of the "lovely turmoil of water," in 1890, we know from an engraving, that the unity of the painting was broken up then by a prominent flying sail above the ship.[17] Ryder was at work on the painting, intermittently, for some ten years.[18]

[16] Father Mapple casts the Jonah story in modern terms and invents the character of the ship captain, who is a wily thief out to charge Jonah dearly to take him aboard his ship of smugglers. The Bible speaks of a big fish, which in the sermon is a whale, prefiguring the great white whale that Ahab is to hunt in the later chapters. Indeed, the character of Jonah, who repents and accepts God without question, was meant by Melville to contrast with Ahab, who continually defies and struggles against the great white whale, which personifies what he sees as the prevailing evil and irrationality of the universe.

[17] We know that besides the sail, Jonah's arms were extended in front of him rather than above his head, as they are now. Elbridge Kingsley's (1842–1918) engraving was printed as part of Eckford's article of 1890. See Henry Eckford [Charles de Kay], "A Modern Colorist, Albert Pinkham Ryder," *Century Magazine* 40 (June 1890): 256.

[18] Ryder worked for years on many of his paintings and built up layer upon layer of pigments and glazes. There are stories of his refusing to let canvases go at the appointed time to those who had paid for them or commissioned them. He is supposed to have said: "The canvas I began ten years ago I shall perhaps complete today or to-morrow. It has been ripening under the sunlight of the years that come and go." Quoted in Goodrich, *Ryder*, p. 22.

More than any of the other eccentrics, Ryder's name has been, from the first decade of this century, practically synonymous with visionary painting. Some visionaries were well known in their time, only to be forgotten in ours. Others were hardly known in their time, then fell into utter oblivion, and were resurrected recently; while others of this ilk remain unknown today except to the most careful students of American painting. It cannot be said that Ryder saw the dreams of his inner eye more clearly than the others or painted more profoundly or movingly; but it can be said that his range was the broadest, and the quality of his work consistently high. In his *Forest of Arden,* from Shakespeare's *As You Like It,* finished in 1897 and patterned after Fort Tryon Park, in the Bronx, the flufflike foliage and lawns like congealed lava suggest a world smoldering with a cool greenish flame. It is an unreal world but wholly consistent on its own terms, all parts intertwined in a cosmic visionary sense. *The Temple of the Mind* (mid-1880s) has a jewel-encrusted stillness to it, with its stately portico and softly hanging trees. I have not given Ryder the space he deserves, but this is not to deny his unique importance, even his deserved preeminence. So immediately strange, so compellingly dreamlike, is *The*

Albert Pinkham Ryder: *The Temple of the Mind.* mid-1880s. Oil on wood. 17¾″ x 16″. Albright-Knox Art Gallery, Buffalo, New York; Gift of R. B. Angus, Esq.

Temple of the Mind and other of Ryder's cosmic visionary paintings that he alone of the American painters of the dream was singled out in his own time, by the public and critics alike, and to this day has remained the best known of all of these painters.

Comparable to Ryder's rushing home to paint *Siegfried and the Rhine Maidens* after hearing the *Götterdämmerung* was Blakelock's use of music as an impetus to his painting. The latter painter's appeal to music was even more direct, and apparently more regular (this was, of course, before he was institutionalized). Blakelock, a fine pianist, believed that by improvising on the piano he could work out ideas for his painting;[19] and his friend Henry W. Watrous, who sometimes visited him during these musical excursions, would urge him on by saying: "Now play me a moonlight at sea."[20] Daingerfield reported that, according to Watrous, Blakelock used to rush from piano to easel and back again, working on a painting as he played.[21] Aside from this similarity, Blakelock and Ryder, as cosmic visionaries who intuited an activated and integrated universe and in their paintings modified the appearances of objects to reveal this, differed considerably. For Ryder, nature possessed many moods—from the most turbulent, as in *Jonah,* to the tranquil and expansive, as in *Constance,* which was based on a character in the "Man of Law's Tale" from Chaucer's *Canterbury Tales* and which was finished in 1896, to the held, concentrated stillness of *The Temple of the Mind*—and in her moods reflected the manner of actions or psychological makeup of the human actors in the paintings. In the paintings of Blakelock, who, in direct contrast to Ryder, seldom painted the sea, nature is more limited both in moods and in varieties of terrain. The human actors are reduced in scale and significance, and when they are characterized, as in *The Chase,* in the Worcester Museum in Massachusetts, it is they who take on the coloration of nature's moods, not they who determine them. Only two seascapes are known, *The Sun, Serene, Sinks in the Slumbrous Sea* (1880s) in the Springfield

[19] Lloyd Goodrich, *Ralph Albert Blakelock Centenary Exhibition,* catalogue (New York: Whitney Museum of American Art, 1947), p. 20. Goodrich, in his notes, cites as his source (p. 42) an "unidentified newspaper of April, 1891."

[20] Gustav Kobbe, "Belated Honors Come to Ralph Blakelock," *New York Herald,* magazine section, May 4, 1913, p. 2.

[21] Elliott Daingerfield, *Ralph Albert Blakelock* (New York: F. F. Sherman, 1914), p. 32.

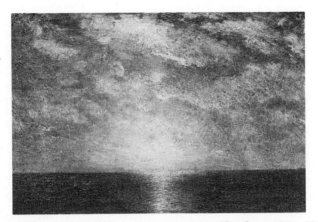

Ralph Blakelock: *The Sun, Serene, Sinks in the Slumbrous Sea.* 1880s. Oil on canvas. 16″ x 24″. Museum of Fine Arts, Springfield, Massachusetts; Bequest of Horace P. Wright.

Museum of Fine Arts in Massachusetts and the privately owned untitled seascape, considered by Blakelock's family to be the artist's last painting.[22] In them there are no boats, no human actors, no sign of marine life. There is only the windswept ocean and the stormy sky and, in one of these paintings, the orb of the sun. Here is nature as it was at the beginning of the world, before the coming of man, moved by secret, living forces.

Blakelock loved best to show the forest. From sometime in the mid- or late 1870s, when the details of branches and the smaller clusters of leaves ceased to interest him,[23] he would show it by night with the

[22] That untitled seascape is illustrated in *The Enigma of Ralph A. Blakelock 1847–1919,* by David Gebhard and Phyllis Stuurman, catalogue (Santa Barbara, Calif.: University of California Art Galleries, 1969), fig. 85. There is also, in the Boston Museum of Fine Arts, the early *Rockaway Beach, Long Island, New York* (1870), where, to the right of the canvas, a few waves are shown rolling up to the beach, with its strollers and bathers. *Ibid.,* fig. 41.

[23] Among the early landscapes, which have little of the visionary to them, are the *Autumn Landscape, Catskills,* in the Collection of Dr. and Mrs. F. Lifshutz (*ibid.,* fig. 32); *Woodland Scene,* in the Collection of Mr. and Mrs. William P. Wood (*ibid.,* fig. 30); and the large, majestic *Boulder in the Flume,* recently acquired by The Metropolitan Museum of Art. I am grateful to Mr. Lewis Sharp, associate curator of American art, who showed me, in April 1977, this last-named painting in The Metropolitan Museum of Art's basement stacks. It is a painting that is unlike Blakelock's later forestscapes, a large daytime forest scene that has no touch of the visionary.

Ralph Blakelock: *The Chase.* 1879. Oil on canvas. 20⅛" x 36³/₁₆". Worcester Art Museum, Worcester, Massachusetts; Theodore T. and Mary G. Ellis Collection.

moon shining brightly, or toward evening as the day's light was waning. From this time, too, when the trees would be rendered in large, dark, lacy silhouettes, rising over lakes shimmering in the moonlight, the forest took on the character of a pristine realm, making no concessions to the little figures sometimes grouped within it. It was a realm of inchoate and unbounded growth, a growth permeating every nook and cranny, and of fearsome beauty and forbidding dangers. Of *The Chase*, we feel that the Indian bowman about to disappear upon his rushing horse (an unusually prominent figural group for Blakelock) into the dense clump of trees draws his unbridled fierceness out of this ethos to which he so naturally belongs.

Like Blakelock, most painters of the Rocky Mountain regions, Thomas Moran (1837–1926), Frederick E. Church (1826–1900), Albert Bierstadt (1830–1902), and others, unveiled an untrammeled wilderness, but they preferred the broadest vistas and the highest mountains. This was not the case with Blakelock, who focused on the narrow forest clearing, located probably somewhere on the slopes of the Rockies. With him it was not the site in itself that mattered so much as the eli-

sion and obscuring of details, the glow of the moonlight, and the mood created through an ineffable tone that prevailed throughout the whole canvas and the deep, suggestive resonance of layer upon layer of glazes. Sources and precedents have been suggested for Blakelock's forest-scapes, which would seem to have been based on the terrain he saw during his trip or trips to the West from 1869 to 1872. Elliott Dainger-field vaguely hints that he may have used photographic reproduc-tions[24] but does not venture to say who took the photographs or what they were of and when they were taken. Lloyd Goodrich argues from the richness of Blakelock's pigment that he was influenced by the Bar-bizon school, specifically by Théodore Rousseau (1812–1867), Jules Dupré (1811–1889), and Narcisse Virgile Diaz de La Peña (1807?–1876), whose formulas for drawing trees are close to his.[25] David Geb-hard thinks that the Barbizon influence was indirect, coming by way of such American landscapists as Alexander H. Wyant (1836–1892).[26] The Barbizon influence, whether it existed, directly or indirectly, cannot ex-plain the strange aura in the forestscapes; this came from some deep chord within Blakelock. Daingerfield has offered no hard evidence whether he used photographs. The other alternative, unlikely although not impossible, is that Blakelock for more than ten years preserved within himself his memories of the West. Although the paintings are of generalized locales, he may have used as a jumping-off point his fairly accurate topographical sketches, which often included Indians within their habitats, made during his journey.

Both Ryder and Blakelock grasped the stylistic implications of their cosmic visionary approach; that is, both knew how to convey, through a variety of formal devices, a nature that is one, the parts of which are inextricably interwoven. And interwoven, too, in form and content (as Whitman's "Out of the Cradle Endlessly Rocking" is inter-woven in sound and meaning). There are in Ryder, the overall twisting and agitated forms in *Siegfried and the Rhine Maidens;* the overall tex-ture of the blue gray and straw gray churning water in most of the *Jonah* and the distorted shape of the boat to echo that of the big fish; the interrelating wedge shapes in the *Moonlight Marine;* and, in those and in other paintings, the integration of the sensuous color surface

[24] Daingerfield, *Blakelock,* p. 11.
[25] Goodrich, *Blakelock,* p. 22.
[26] Gebhard, *Blakelock,* pp. 16–17.

Ralph Blakelock: *Moonlight Sonata.* c. 1892. Oil on canvas. 30″ x 22″. Museum of Fine Arts, Boston.

built up through layer upon layer of pigments and glazes. (Unfortunately, the once resonant surfaces can seldom be seen in their original glory. Many of Ryder's paintings have cracked because he painted over surfaces that were still wet, which resulted in different rates of drying, and he used dangerous media such as wax and candle grease.)

Blakelock introduced his own modifications of visible reality. His moon, commonly placed at or near the center of the forestscapes, is made, in a supernatural way, to radiate its light and energy throughout much of the scene. There are color tonalities to this light and in the parts of the painting not lit by the moon that go beyond our ordinary experience. In the Boston Museum of Fine Arts' *Moonlight Sonata* (c. 1892), the air varies from a yellowish green to a light blue, with the lower areas just above the horizon becoming a strange green-blue gray; the color changes seem to come about through pulsations or transmissions of the moon's energy. The *Moonlight* (c.1890) in the Corcoran, has gray blues for much of the sky that pass into silvery grays, darker green grays for the shadowy trees, and brownish silvery grays toward the bottom of the painting. The moon, in dead center, is a pure silver and is the most heavily built-up area. But the color of other areas is physically built up through curious encrustations or, more accurately, through tiny globules of paint forming little stringlike formations. These encrustations help unify the surface, even as Blakelock endowed all nature with an all-enveloping energy. Also, there is for me an extraordinary suggestiveness brought about by these encrustations, as though, metaphorically, I were looking through layers of films of time. It must have been of paintings of Blakelock's like this in the Corcoran that Daingerfield wrote (while the artist was still alive):

> When the silvery ground of his picture was hard and dry, he floated upon it more forms, using thin paints much richer in quality of color; when partly dry these were flattened with a palette knife, the forms brought into relief by subtle wipings, and once more allowed to dry. This process was repeated frequently, and when the surface became gummy or over-glazed, he reduced it by grinding with pumice stone. The effect of this would bring the under silver of his first impasto into view, and with this for his key of grey he developed his theme, drawing with the darker and relieving with the under paint.[27]

In some of the forestscapes tepees of the Indians and mounted riders are to be seen in the clearings. As in The Brooklyn Museum's

[27] Daingerfield, *Blakelock*, p. 19.

Ralph Blakelock: *Out of the Deepening Shadows.* 1880s. Oil on wood panel. 8¾16″ x 12⅛″. The Art Museum, Princeton University, Princeton, New Jersey.

Moonlight (1889–1892) these function as incidental genre passages within the larger landscape. But in the *Indian Encampment* (c. 1871), in the Potamkin Collection, there are no trees, and the tepee and the small figures moving about and seated around the fire are situated on open ground. This is one of the unusual Blakelocks I know. The sky occupies perhaps three-quarters of the painted area and is a golden yellow, something like the rich gold color symbolizing heaven that can be seen in early Christian mosaics. It is this expanse of gleaming yellow that one first notices from across the room, before a single detail can be made out. The texture of the very earth and of a low-lying rock is rendered in coarse detail (I can't help being reminded of Jean Dubuffet's [b. 1901] early paintings of soil). Blakelock here endows the material of the earth with a kind of sanctity and sets it beneath a golden sky of rare preciousness.

When the cosmic visionary character of the paintings of Ryder and Blakelock is fully grasped, we will be inclined, I think, to use such words as *pantheism* in connection with them. This is difficult, however, with Quidor, whose ribald illustrations of Washington Irving's stories tend to move us to near-laughter rather than anything like religious awe. There is in Quidor the genuinely fearsome, as we've seen in the "Tom Walker" paintings, but there still persists with him, even after 1850, the genial and the humorous; and there is something of this in that framework I refer to as cosmic visionary.

The comic and the cosmic are wedded in Quidor's *Embarkation from Communipaw* (1861), in The Detroit Institute of Arts. The scene is derived from that passage in book 2, chapter 4, of Irving's *Diedrich Knickerbocker's A History of New York* (1809)[28] where the bumptious burghers of Communipaw, located somewhere in that area of the New Jersey shore from Hoboken to the Amboys, are leaving their swampy terrain to search for a more suitable site for a new settlement. The leader of these Dutch settlers was Oloffe Van Kortlandt, who, Irving wrote, was one of those prophetic dreamers who predicted events after they came to pass and kept his high head in the community because of his sugarloaf hat. It was he who urged the move from Communipaw after the advice of Saint Nicholas, who had appeared to him in a dream. Following Irving's description, Quidor has Van Kortlandt, upon whose head is the sugarloaf hat, blowing a blast on a conch shell as the villagers, escorted by their friends and relatives, trudge to the boats. The awkward energy of these villagers is transferred to the lunging branches, the rolling waves, the windswept clouds, the lurching boats; it is as though the whole world is partaking of this rollicking adventure. Here, in a different key, is another approach within the mode of the cosmic visionary, as Quidor attempts to find a stylistic metaphor for Irving's scope and sweep.

[28] The *History of New York* was begun as a collaboration between Washington Irving and his older brother, Peter, and was concluded by Washington himself. The original title was "A History of New York from the Beginning of the World to the End of the Dutch Dynasty." "Diedrich Knickerbocker" was a pseudonym adopted by Washington Irving, who created the character through an elaborately contrived hoax: He had printed in a newspaper a notice on the disappearance of a man by that name and then later advertised that a curious book (the *History*) had been left with the landlord of the vanished Dutchman to cover arrears in rent. During the writing, Matilda Hoffman, Washington's fiancé died of tuberculosis; and so, the humorous tone of the *History* and the hoax of the invention of Diedrich Knickerbocker became useful in dispelling the author's grief.

The *History of New York* is a vast, humorous pseudohistory beginning with the creation of the world and winding down with the surrender of New Amsterdam to the English on August 27, 1664. It is full
of asides, all sorts of chatter, meandering digressions that contain curious researches based on obscure sources in classical antiquity, but from
book 2 on, it does manage to trace the story of the settlements of the
Dutch in the eastern part of America through a mixture of fact, legend,
and sly invention. There are such recognizable figures as Henry Hudson, who, we are told, always jerked up his breeches when giving
orders, and Peter Stuyvesant, who gets three volumes dedicated to him,
even though he is always bumbling his way through things. Irving loves
poking fun at his Dutch forebears, who are set forth as likable blowhards, generally lacking in industry and not very competent at anything anyway. There is, for example, Mynheer Wouter Van Twiller,
who was appointed governor of the province of Nieuw Nederlandts in
1629; he was descended from a long line of Dutch burgomasters who
had dozed away their lives. Van Twiller was exactly five feet six inches
in height and six feet five inches in circumference. His habits were regular: He limited his four daily meals to one hour each, he smoked and
doubted (his name was a corruption of the original *Twijfler,* meaning
"Doubter") eight hours, and he slept the remaining twelve. When troubled by deliberations in the council, he would shut his eyes for two
hours at a time. Once, when two contending parties came for judgment, he weighed the books of account, and finding them equally
heavy, had the contested amount divided equally. But along with its
humor, the *History of New York* is a book of tremendous sweep. In
chapter 3 of book 1 there is speculation about whether Noah discovered
America, and hope is held out that someday his logbook will be revealed. Saints and classical gods are always mixing in the affairs of the
Dutch. In their war against the Swedes, there rallied to them the oxeyed Juno, who was brandishing a pair of black eyes from a recent
tiff with Jupiter; Minerva, who tucked up her skirts and swore in bad
Dutch (having only lately studied the language); and Vulcan, who had
just been promoted to be a captain of the militia. And it seems that
Quidor must have felt this sweep, for it presumably inspired his cosmic
visionary (or comic visionary) approach in his painted illustrations of
this history of Irving.
 If anything, the *Battle Scene* (1838), in the Boston Museum of
Fine Arts, is even more riotous and rollicking than the *Embarkation
from Communipaw,* which, as a late work of Quidor, after 1850, has a

John Quidor: *A Battle Scene from Knickerbocker's History of New York.*
1838. Oil on canvas. 27" x 34½". Museum of Fine Arts, Boston; M. and M.
Karolik Collection.

touch of the elegiac to it because of its muted, golden tonality.[29] The
painting was taken from the account in book 6 of the battle (even
though the only casualty was a flock of geese) between the Dutch,
under Peter Stuyvesant, and the Colony of New Sweden across the
Delaware, under Jan Claudius Risingh, who, Irving tells us, could have
been a model for a Samson or a Hercules had he not been somewhat
knock-kneed and splayfooted. During the furious battle, "the earth," we
read, "shook as if struck with a paralytic stroke; trees shrunk aghast,
and withered at the sight; rocks burrowed in the ground like rabbits;
and even Christina creek turned from its course, and ran up a hill in

[29] As I've maintained earlier, Quidor's work changes after the 1830s, when it
was exclusively funny and nearly caricaturish. In the 1850s he produced his fear-
some paintings based on "The Devil and Tom Walker." Both the *Battle Scene*
(1838) and the *Embarkation from Communipaw* (1861) are funny and droll, and
cosmic visionary; but with the latter there is a touch almost of sadness, of elegiac
resignation. It may seem unlikely that something can be sad and droll all at once;
still, the *Embarkation from Communipaw* is just that.

breathless terror!"[30] The battle was decided by the defeat of Risingh in face-to-face combat with Peter Stuyvesant. Quidor showed the two combatants in the midst of the fray at the instant before Peter, lying on the ground at the feet of Risingh whose sword had broken harmlessly on his hard skull, was about to "deal[t] him a thwack over the sconce with his wooden leg" and shoot him with a pocket pistol that "was not a murderous weapon loaded with powder and ball, but a little sturdy stone pottle charged to the muzzle with a double dram of true Dutch courage."[31] The empty foreground of the picture is full of gnarled roots, drawing the attention of the viewer; there is a well-placed withered tree (from Irving's text) in the middle ground among the furious fighters, and the sky is filled with wildly veering geese.

The legacy of the cosmics continued into the visionary painting of the twentieth century, although there is nothing that can be called a line of stylistic development, and no debt, of course, was ever acknowledged. I am thinking especially of paintings of Charles Burchfield, such as the *Night Wind* (1918), with its fingerlike patternings connoting the blasts and thrusts of a wind emerging everywhere in the land and sky, and of Arshile Gorky (1904–1948), where, out of all those intertwined forms vaguely suggestive of flowers or bits of flesh, emerges a psychosexual universe. In them, as in the cosmics, there are distortions, even more extreme in their case, enforcing the vision of a flow and aliveness that permeates the entire painted world.

Except for Louis Eilshemius, the visionary eccentrics (of whom the cosmics are but one grouping) disappeared by the second decade of the twentieth century. Visionary painting went on, but it was not produced by the same sort of men. The eccentrics, in steering their individual course, lived lonely and, in some cases, we may be sure, bitter lives. They stood alone. In most cases, only small numbers of their countrymen knew of their works. In most cases, they were not bolstered by what others of their number had accomplished. In some cases, they did not even think of themselves as visionaries. But in the end they drew out of their imaginings a wealth of pictorial invention that has enriched American painting far beyond their grasp.

[30] Washington Irving, *Knickerbocker's History of New York* (New York: G. P. Putnam's Sons, 1900), p. 237.
[31] *Ibid.*, pp. 239–240.

6

Visionaries, 1900–1950

Louis Michel Eilshemius (1864–1941) was the last of the visionary eccentrics. But there is a twist. Like them, he was at variance with the public, kept largely to himself, indulged in egocentric, antisocial behavior, and was markedly unusual in the paintings he turned out. Yet, while they were driven by certain single-minded concerns that had a centrality and rootedness to them (Rimmer's delusions of a royal birth, Page's and Inness's Swedenborgianism, Blakelock's overriding concern with money, etc.), his was an eccentricity gone amok, torn apart at the center. His life came to represent what is for me the denouement of the visionary eccentric.

At first Eilshemius courted success passionately, frantically, desperately: He took to signing his name "Elshemus" because he felt Eilshemius sounded too foreign, and he kept badgering gallery owners with demands for exhibitions. After he was answered with rejection after rejection,[1] in frustration he gave up painting in 1921 at the age of fifty-seven, and his already erratic behavior increased to a stance of blustery egomania. He declared himself Mahatma, Mightiest of the Mighty, and attacked all art magazines, all critics (except the few who became favorable, like Henry McBride, 1867–1962), and practically all artists, writing that "Van Gogh tried his best to paint, but ah! He never

[1] After two of his paintings were exhibited by the National Academy of Design, New York, in 1888, Eilshemius was not given a show until after he retired from painting in 1921. He was given his first one-man show in 1926, when he was sixty-two (Robert Loftin Newman was given his when he was sixty-seven).

studied technic—we'll call him 'Bah!'" He claimed to have anticipated the ideas for the multigraph, propellers in airplanes, and electrical waves of communication.[2] He handed out leaflets proclaiming his accomplishments:

> Amateur All round Doctor, Mesmerist-Prophet and Mystic, Reader of Hands and Faces, Linguist of 5 Languages, Dramatist (7 works), Short Story Writer and Novelettes, Humorist, Galore, Ex-Mimic, Ex All Round Athletic Sportsman (to 1889), . . . Best Marksman to 1881, Ex chess and Billiard Player to 1909, Scientist Supreme: all ologies, Ex Fancy amateur Dancer, the most rapid master creator in the 3 Arts . . . travelling salesman in 30 cities in 30 nights, Philanthropist, saved 20 lives—3 from suicide, Greatest Religionist, Globe Trotter, Half the Globe, Western.[3]

Eilshemius's claim to being "the most rapid master creator in the 3 Arts" is reminiscent of Ryder's charming visit to him back in 1908. Eilshemius, ever concerned with speed (between 1882 and 1920 he finished three thousand paintings), asked Ryder how long it took him to execute a single painting. The answer that came back was ten years. Eilshemius was chagrined, for he thought that Ryder meant that he was continuously at work on a piece rather than that he periodically returned to it; and so, he concluded that the man was unsure of himself, or worse, a bungler. Eilshemius countered that he could turn out a painting in a couple of hours and did so, choosing to make his own versions of Ryder's *Macbeth and the Witches* (1890–1908) and *The Flying Dutchman,* the latter of which is now in the Whitney Museum of American Art, New York.[4] Later he would boast of writing sonnets in fifteen minutes and a ballad of 423 lines in six hours.[5]

Marcel Duchamp (1887–1968) singled out Eilshemius in 1917, claiming that his was one of the only two worthwhile works in the Independents Exhibition at the Grand Central Galleries, New York, of that year. That meant discovery. Then he was given a show in 1926 at

[2] William Schack, *Biography of Louis M. Eilshemius: and He Sat Among the Ashes* (New York: Ryerson Press, 1939), p. 270. Schack takes the title of his book from the Book of Job, implying a comparison between the sufferings of Job and those of Eilshemius.

[3] *Ibid.,* p. 266.

[4] *Ibid.,* pp. 151–152.

[5] James R. Mellow, "The Case of Eilshemius," *Arts* 33, no. 7 (April 1959): 38.

New York's Valentiner Gallery, and gained a measure of critical success in the 1930s. But it was too late to enjoy that success: In the 1930s he was broken and hopelessly embittered, and from 1932 confined to a wheelchair as the result of an automobile accident. He lived the last decade of his life, in part with his older brother, as a virtual recluse and died penniless in Bellevue Hospital, New York, in December 1941. Two years before the painter's death Duncan Phillips ventured that Eilshemius, unable to keep up with his ambitions, was progressively pushed into mental illness by the rejections that overtook him, that he was treated most unkindly, that the best of his work had merit, and that he deserved a better fate.[6]

In the two decades after Eilshemius's death, his reputation rose and fell along peaks and valleys. Today, with the leveling off, we can see that he was neither as remarkable nor as ignominious as was claimed now by his defenders, now by his detractors. Much of what he painted is handled in a slapdash, pasty sort of way. The early work, however, has a Salon approach, meticulously handled, with a flavor of kitsch. There is an appeal in the utter bad taste, the pretentiousness of the *Afternoon Wind* (1899), in The Museum of Modern Art, New York, with its airborne nudes, perhaps a meaningful motif for someone who would claim to have anticipated the use of propellers in airplanes. In 1899 Eilshemius was still feeling the effects of his classical training: Late in 1886 he had sailed for Paris, where he studied under Adolphe William Bouguereau (1825–1905) at the Académie Julian. In the first decade his work became more childlike in appearance; his subjects were rolling country meadowlands with comfortable houses and crudely rendered nudes splashing about idyllically in a stream or at the edge of the sea (he had been to Samoa in 1901). Toward the middle of the second decade the mood darkened considerably as scenes of violent death and imagined murders became commonplace. In a coded way this was evidence of the slings and arrows Eilshemius himself had suffered and provoked. In *Found Drowned* (1916), in the Wadsworth Atheneum, Hartford, Connecticut, the corpse lies upon a rocky promontory protruding from the sea. In *Jealousy* (1915), in the Philadelphia Museum of Art, three women, nude or scantily dressed, taunt and entice their male victim, as one of them stabs him with a dagger. The vehemence of the handling and the bloodred tones is apt for the vio-

[6] Duncan Phillips, "The Duality of Eilshemius," *Magazine of Art* 32 (December 1939): 694–697, 724–727.

Louis Michel Eilshemius: *The Haunted House.* c. 1917. Oil on pressed
board. 30″ x 39¾″. The Metropolitan Museum of Art, New York; George A.
Hearn Fund, 1937.

lence depicted. In its lurid sexuality the scene would delight today's
purveyor of pornographic films and magazines. The device of the
painted curved frame used in *Jealousy* and in other paintings, such as
The Haunted House (c. 1917), in The Metropolitan Museum of Art,
New York, reinforces the meaning of the foreboding subject; for we are
made to feel as though, through an opening in a wall, we are looking
upon something dark and secret.

 After 1900 the state of American visionary painting changes dras-
tically. It changes, first, in the sheer volume of paintings produced and
in the numbers of artists involved. Between 1850 and 1900, visionary
painting had been carried on by the twelve eccentrics, men we can
say in retrospect were resolute, solitary adventurers. After 1900 this

painting expands on many fronts: Sometimes it builds upon the foundations set down by Ryder and other of the eccentrics; sometimes it stems out of the developments of early Modernism (as with Arthur G. Dove and Georgia O'Keeffe), Expressionism, Surrealism, and Abstract Expressionism (as with Arshile Gorky); and sometimes, as with Morris Graves, it steers an independent course. So, the situation from 1900 to 1950 is comparable to that from 1800 to 1850, when the visionaries of the spectacular were a part of international romanticism; in both cases American visionaries were associated with other traditions. And it changes, second, in the attitudes and personalities of the artists. The eccentrics, as the term connotes, were isolates in action or thought, the oddest of men, bizarre either in the way they dressed and lived or in their beliefs and philosophical attachments, or in both. The visionaries who came after them, and Eilshemius was a blatant exception, were no more odd or eccentric than the other American painters of their time.

A group of artists calling themselves the Introspectives formed in 1917 in reaction to World War I and the worsening international situation, as well as to what they called "the rapid vortex of our modern life." This group, which included, among others, the now forgotten Benjamin D. Kopman (1887–1965), Abraham Harriton (b. 1893), Claude Buck (1890), and Jennings Tofel (1891–1959), developed an art of personal symbolism often derived out of Ryder and the Tonalists.[7] In the catalogue for their show held at the Knoedler Galleries, New York, from April 2 to April 16, 1917, a number of the contributors commented on the significance of their work. Agnes Pelton wrote: "Though aiming at obvious visible beauty, the art of painting should convey through its language of colour—the without seen from within." As though he needed to confirm the efficacy of his visions, James W. Parry proclaimed exultantly: "It will be questioned when the sun rises, do you not see a round disk of fire somewhat like a guinea? Oh, no, no! I see an innumerable company of the heavenly host crying, 'Holy, holy, holy, Lord god Almighty!' "[8] And from Olin Rush on her portrait of a girl: "I desired to convey something of the emotion I have when I see at evening a white flower lifting from the earth. The quiet look from a child's face often arrests me in the same way." So where the visionary eccentric dreamt on by himself, here are visionaries gathering together

[7] Edith W. Powel, "The Introspectives," *The International Studio* 61 (May 1917): xc–xciv.
[8] *Ibid.*, xcii.

for mutual sustenance and encouragement. And where the visionary eccentric spoke in a heartfelt way, here there is a groping for effect, a note of hyperbole.[9] As to the impact of Ryder, it was felt in American visionary painting after Eilshemius and the Introspectives into the mid-1940s. The Swedish-born Henry Elis Mattson (1887–1971) offered versions of the raging sea, sometimes at night, that were somewhat inspired by Ryder's "moonlight marines" but caught little of Ryder's sense of mystery. The Scotch-born, self-taught Matthew Barnes (1880–1951), who settled in San Francisco, tried to catch Ryder's and sometimes Marsden Hartley's (who himself was influenced by Ryder) brooding loneliness; an example is his *High Peak* (1936).

Arthur Bowen Davies (1862–1928) was one of the most adroit as well as eclectic of these new visionaries who built upon the past and the achievements of the visionary eccentrics. Before he turned to a modified cubist manner, around 1913, Davies's art was rooted in American Tonalism and was close in spirit to the subterranean visionaries, as well as such European Symbolists as Pierre Puvis de Chavannes (1824–1898) and Hans von Marées (1837–1887), and the English Pre-Raphaelites by way of Botticelli, whose linear rhythms he appropriated. His subjects then were languorous nudes, unicorns (which look back to the hybrids of Rimmer and Vedder), and wide-eyed innocent children who sometimes have the uncanny about them (thus looking back to Newman), as in his *Foot Log on Jonathan Creek*, in The Newark Museum, New Jersey. Some of the paintings before 1913 have a murallike quality to them; and it is noteworthy in this respect that Davies admired Pompeiian frescoes.

Davies combined, in an extraordinary way, an abiding appreciation of the past and the purely aesthetic and skill as a manipulator within the world of the practical and the immediate. No American visionary painter was ever more instrumental than he, as an administrator, in shaping the course of art history. Because of his reputation as a fund raiser, he was chosen in January 1911 to fill the post of president of the Association of American Painters and Sculptors, New York. Using

[9] Jennings Tofel even issued an Introspective manifesto, which read in part: "There are no rules laid down for the constituents of this group to obey. They agree, however, on the principles of beauty, order—the faculties of imagination and fancy. A work of art shall be abstracted from nature. Life shall enter it—indeed it must, but through the crucible of the artist's mind. It shall suggest more than relate, for suggestion is the depth beyond the depth—the gauntlet to the imagination of the observer, that disturbs and quickens his susceptibilities." *Ibid.*, p. xcii.

Matthew Barnes: *High Peak*. 1936. Oil on canvas. 36¼″ x 42⅛″. The Museum of Modern Art, New York; Lillie P. Bliss Bequest.

the power of his position and his influence with the wealthy, he, with the aid of Walt Kuhn (1880–1949), arranged for the mammoth exhibition of some sixteen hundred pieces of paintings, drawings, prints, and sculpture (none predating Goya) that opened on February 17, 1913, in the Armory of the New York National Guard's Sixty-ninth Regiment.[10] The show was subsequently seen also in Chicago and Boston. Thus, at a single stroke, the country was exposed to the latest currents in international art, Impressionism, Post-Impressionism, Fauvism, and Cubism. This duality of interest in the immediate and the remote was reflected also in Davies's interests and tastes. He loved music and the dancing of

[10] For the extensive part that Davies played in realizing the show, see Milton W. Brown, *The Story of the Armory Show* (Greenwich, Conn.: New York Graphics Society, 1963).

Arthur B. Davies: *Measure of Dreams*. 1909. Oil on canvas. 18" x 30". The Metropolitan Museum of Art, New York; Gift of George A. Hearn.

Isadora Duncan (1878–1927), and read legends and fairy tales, translations from the Greek poets, Elizabethan poetry and drama, and the poetry of Blake, Coleridge, and Poe. At the same time he was a baseball enthusiast to the extent of knowing the players' batting averages.[11]

This duality is reflected as well in his visionary art. His *Measure of Dreams* (1909), in The Metropolitan Museum of Art, New York, has been described as "a woman lost in sleep . . . seen passing from one dream to another."[12] The sleeping woman moves unconsciously, involuntarily through a misty, shadowy landscape (derived from Tonalism), which is shaded effectively to serve as a visualization of our concept of dream. William Rimmer himself might have been drawn to this poetic conveyance of an abstract idea in his vision of the airborne

[11] Forbes Watson, "Arthur Bowen Davies," *Magazine of Art* 45 (December 1952): 363.

[12] Duncan Phillips, "The American Painter, Arthur B. Davies," *Art and Archaeology* 4 (September 1916): 175.

nude. In the *Crescendo* (1910), in the Whitney Museum of American Art, New York, however, the movements of the nudes are mechanical, overly contrived. We are looking at a series of dance steps or calisthenics, where each pose is exactly recorded (like the baseball averages).

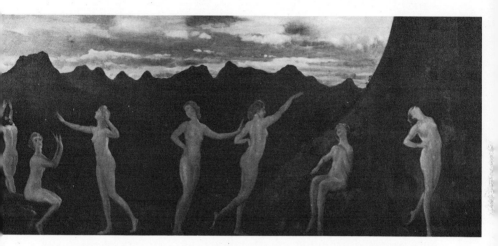

Arthur B. Davies: *Crescendo*. 1910. Oil on canvas. 18″ x 40″. Whitney Museum of American Art, New York. Photograph: Geoffrey Clements.

There was that in Davies that had to systematize, to codify. This quality is discernible in some of the friezes of dancing nudes, as well as in his manner, sometimes, of approaching problems. Where William Page held that there was a lifelike force apparently contained by the Parthenon pedimental figures—and let it go at that—Davies, with the cooperation of Gustavus A. Eisen (1847–1940), came up, around 1922, with the theory of inhalation. Here was a kind of rigidity of approach rarely found among the eccentrics. According to the theory, the Greek sculptor, to catch the lifelike quality, always had the figure frozen at the moment when breath was drawn in.[13]

As the result of seeing modern European works in Europe, at the Armory Show, and at Stieglitz's "291," New York, many American artists formulated new pictorial solutions. Following the examples of

[13] G. A. Eisen, "Davies Recovers the Inhalation of the Greeks," in *Arthur B. Davies: Essays on the Man and His Art*, by Duncan Phillips *et al.* (Cambridge, Mass.: Harvard University Press, 1924), p. 70.

the Cubists, some fragmented their forms and painted diaphanous areas, while others undertook startling simplifications or distortions of form. Still others became completely nonobjective. Within early American Modernism elements of fantasy appeared. Artists of a visionary bent learned to accommodate themselves to these new approaches. As Hicks and Field had used primitivism as their vehicle, Inness and Dewing, a modified tonalism as theirs; so, in the twentieth century, there were American visionaries who adopted the styles they felt were appropriate to the times.

One of these, Arthur Garfield Dove (1880–1946), invented visual metaphors for processes of organic growth and movement. Significantly, he lived close to nature most of his life: From the ages of five to nine he was taken hunting and fishing; when he was in his thirties, he supported his painting by illustrating and farming, even winning a prize for the raising of chickens; for seven years from 1920 he lived upon a houseboat and cruised the waters about Long Island Sound; and in 1934 he settled upon a farm in Geneva, New York, close to Hobart College, which he had attended thirty-five years earlier.[14] His stylizations have to do with the animals in the fields, the rising of the moon, the long, rolling hills, the beating of the waves. Like Ryder, he could feel himself into the coursing of nature. Unlike his visionary predecessor, he could on occasion link an image with a correlating sound, just as in his writings he could link music and painting. In the catalogue for his exhibition of December–January 1927–1928 at the Intimate Gallery, New York, of Alfred Stieglitz, he observed: "I should like to take wind and water and sand as a motif and work with them, but it has to be simplified in most cases to color and force lines and substances, just as music has done with sound."[15] On many nights aboard his houseboat Dove must have heard the warning blasts of foghorns disturbing the

[14] Barbara Haskell, *Arthur Dove,* San Francisco Museum of Art, November 21, 1974–January 5, 1975, catalogue (Boston: New York Graphics Society, 1975). Frederick S. Wight, *Arthur G. Dove* (Los Angeles: University of California Press, 1958).

[15] In this regard, it is especially noteworthy that Dove painted nonobjective pictures purportedly derived from the sounds of musical compositions. Examples of 1927 were titled *I'll Build a Stairway to Paradise* and *George Gershwin's "Rhapsody in Blue" Part 1.* He wrote that "the music things were done to speed the line up to the pace at which we live today. . . . The line was a moving point reducing the moving volume to one dimension. From then on it is expressed in terms of color as music is in terms of sound." Quoted in Wight, *ibid.,* p. 55.

Arthur G. Dove: *Fog Horns*. 1929. Oil on canvas. 18″ x 26″. Colorado Springs Fine Arts Center, Colorado; Gift of Oliver B. James.

empty silence of the dark waters. And in his *Fog Horns* (1929), now in the Colorado Springs Fine Arts Center, he conveyed his remembrance of these experiences through three circular forms set upon a waterscape. These forms suggest not only the rims or funnels of the horns themselves but the emanation of the living waves of sound spreading over the waters, pulsating outward like the ripples in a still pool.

I have pointed out what by now must be for the reader too obvious to need mention, that visionary painting is not delimited by subject. But at least one image has recurred regularly, from the early nineteenth century (through the visionaries of the spectacular and the visionary eccentrics), and into the visionary painting of this century. It is an image ideally suited for the visionary, for perhaps more than

any other it has symbolized for man the unknowable, the eternal, and the unreachable (though, in his musings, he kept trying to reach it,[16] and recently has succeeded). This is the moon. Its rays shine on water in Allston's *Moonlit Landscape* (1819), it glimmers tiny and cold in Cole's *Desolation* (1836); it is in Vedder's *Lost Mind* (1864–1865) and in most of Ryder's seascapes and many of his literary scenes; it is in the center of Inness's *Harvest Moon* (1891); and it peeks out from behind the latticework of branches in Blakelock's forestscapes. In the twentieth century, it is found in many paintings of Dove and in William Zorach's (1887–1966) cubist reconstructions of 1915–1920, and with some of Morris Graves's birds.

While Dove used broad curvilinear patternings, Zorach within three or four years after exhibiting two paintings in the Armory Show, was working in a cubist manner, dislocating and fragmenting some forms, laying others out side by side in flat shapes, as in Synthetic Cubism. He did not regard Cubism's ambiguities, though, as an end in themselves, as the French classical Cubists generally did, but as the means whereby he could charge nature with mystery. His *Mirage— Ships at Night* (1919), set in or near Stonington, Maine, where the Zorachs renewed their friendship with John Marin (1870–1953), is a jeweled evocation of the mood cast by a small fishing village on a moonlit night. Zorach wished, as he put it in the catalogue of the Forum Exhibition (1916), to express "the inner spirit of things" and get at "that inner feeling which something in nature or life has given me."[17] If Zorach did not use his moonscape as a setting for the enigma of human purposiveness, as Washington Allston used his exactly one hundred years earlier, he did, like Allston, reveal a mysterious tranquillity of nature that lies beyond surface appearance.

By the mid-1920s a more conservative style, which came to be

[16] Some pictorial fantasies of man's reaching the moon were exhibited with other paintings and prints having to do with aviation at the Philadelphia Museum of Art in 1964. See Kneeland McNulty, *Lunar Madness*, catalogue (Philadelphia: Philadelphia Museum of Art, 1964). Included was a colored etching of the Man in the Moon welcoming passengers of an airship to his domain, made by the English artist George Humphries in 1828 and an illustration of another English artist, B. Edward Lear (1812–1888), titled *The Lunar Animals and Other Objects Discovered by John Locke* (1835).

[17] *Forum Exhibition of Modern Painters . . . on View at the Anderson Galleries,* catalogue. Foreword by Alfred Stieglitz. (New York: The Forum, 1916), pages unnumbered.

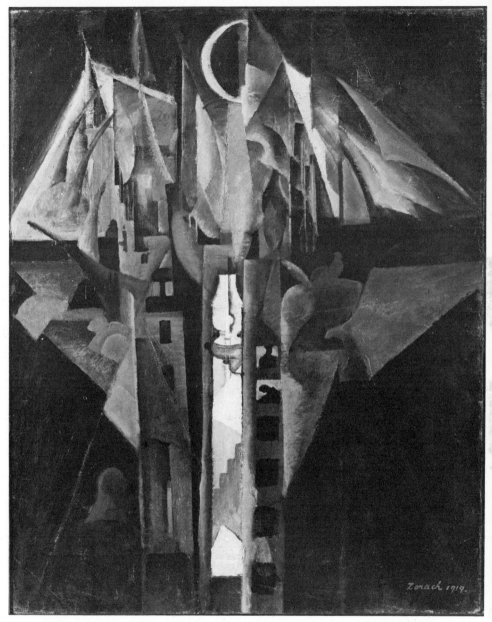

William Zorach: *Mirage—Ships at Night*. 1919. Oil on canvas. 32⅛" x 26¼".
National Collection of Fine Arts, Smithsonian Institution, Washington, D.C.;
Gift of Tessim Zorach.

known as Precisionism or Immaculatism, widely superseded cubist and nonobjective approaches in early American Modernism. Precisionism featured not the breaking up of objects, as Zorach had done in his *Mirage—Ships at Night,* but their geometric simplification (and objects that had a geometrical character were often chosen) with some elimination of surface texture. These objects were placed in an airless environment, rendered in a dry, linear, impersonal manner, and pushed up starkly to the frontal plane. Even among artists using such an austerely impersonal approach, a visionary appeared. This was Georgia O'Keeffe (b.1887), who differs most obviously from others in the group —Charles Sheeler (b.1883) and Charles Demuth (1883–1935), for example—in her devotion of many of her paintings to organic subject matter, mostly hills, flowers, and skulls, rather than to such severely rectilinear objects as buildings.

O'Keeffe was born in remote farming country in Wisconsin. Her subsequent desire for seclusion and closeness to nature led her to settle for four years into teaching jobs near Amarillo, in the vast, dry, seemingly boundless region of the Texas Panhandle ("that was my country—terrible winds and a wonderful emptiness"[18]), and thereafter she visited the desert of the Southwest often. In 1949, three years after the death of her husband, Alfred Stieglitz (1864–1946), she established her permanent residence in Abiquiu, New Mexico. In her paintings of desert skulls, the quality of the visionary arises from a contradiction: The strength of the image and the hard-edge precision of its rendering are at odds with the ideas we normally associate with a skull. O'Keeffe's skull seems incapable of decay or disintegration; this object, so deeply fraught with intimations of death, is altogether divested of them. Standing inviolably for itself, it becomes something other than itself, something other than a thing of death. O'Keeffe wrote: "The bones seem to cut sharply to the center of something that is keenly alive on the desert even tho' it is vast and empty and untouchable—and knows no kindness with all its beauty."[19] The coupling of the skull and the Latin cross seen in the *Cow's Skull: Red, White, and Blue* (1931), fre-

[18] Quoted in Lloyd Goodrich and Doris Bry, *Georgia O'Keeffe* (New York: Whitney Museum of American Art, 1970), p. 9.

[19] From Calvin Tomkins, "The Rose in the Eye Looked Pretty Fine," *The New Yorker* (March 4, 1974): 50; a valuable recent interview with O'Keeffe combining direct quotations with biographical sections. She insists that the coupling of the skull and the Latin cross had, in her mind, nothing to do with the Crucifixion.

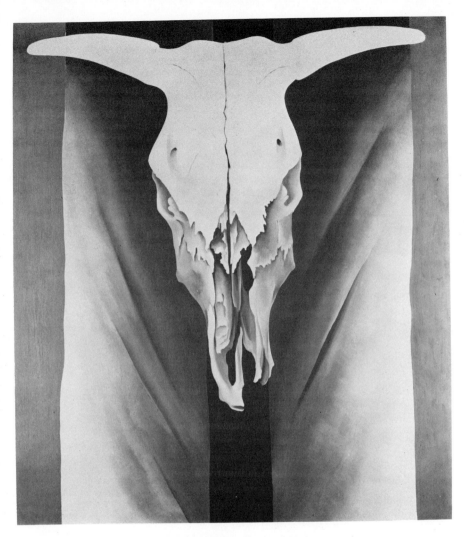

Georgia O'Keeffe: *Cow's Skull: Red, White, and Blue.* 1931. Oil on canvas. 39⅞" x 35⅞". The Metropolitan Museum of Art, New York; The Alfred Stieglitz Collection, 1949.

quently found in O'Keeffe's work around 1930, suggests parallels with contemporary European surrealist painting, in which objects are pulled out of their accustomed contexts and recombined illogically. O'Keeffe herself, however, has staunchly denied the existence of such a link. She

has said that she used the cow's skull merely as a parody on those who would make a big thing of the American scene.[20]

It is Peter Blume's (b.1906) extravagantly detailed, bizarre work of the 1930s, especially *The Eternal City* (1937), that bears the closest resemblance to the contemporary European veristic Surrealism of Dali and others. Except for Cole's *Titan's Goblet* (1833) and some of his "Course of Empire" pictures (1836), nothing in nineteenth-century visionary painting prepares us for this piling up of images normally disconnected in time and place. Also, unless we accept Marcia Goldberg's unlikely proposition that Rimmer's *Flight and Pursuit* (1872) alludes to the assassination of Lincoln, this is our first encounter with a visionary painting that has to do directly with a current political situation. That situation, of course, is the rise of Italian fascism, as we can see from the dominating poison green jack-in-the-box leering head of Benito Mussolini (1883–1945). With the aid of a Guggenheim Fellowship, Blume had gone to Italy to paint in 1932–1934, which happened to coincide with the tenth anniversary of the Fascist March on Rome, and there were many celebrations to see. While Blume was in Italy, Mussolini invaded Ethiopia, became closely allied to Hitler, and announced a national mobilization of twenty million soldiers.

The Eternal City was begun in October 1934, after the return from Italy, and was finished in mid-July 1937; so, as with Allston's *Moonlit Landscape,* a visionary scene is reconstructed through the remembrance of a far-off place. Actually, Blume placed in *The Eternal City* both

[20] Her explanation is rather humorous, and I would venture to say that no one looking at one of her paintings of cows' skulls would dream of why she chanced on the subject. O'Keeffe told Tomkins: "I'll tell you what went on in my so-called mind when I did my paintings of animal skulls. There was a lot of talk in New York then—during the late twenties and early thirties—about the Great American Painting. It was like the Great American Novel. People wanted to 'do' the American scene. I had gone back and forth across the country several times by then, and some of the current ideas about the American scene struck me as pretty ridiculous. To them, the American scene was a dilapidated house with a broken-down buckboard out front and a horse that looked like a skeleton. I knew America was very rich, very lush. Well, I started painting my skulls about this time. First, I put a horse's skull against a blue-cloth background, and then I used a cow's skull. I had lived in the cattle country—Amarillo was the crossroads of cattle shipping, and you could see the cattle coming in across the range for days at a time. For goodness' sake, I thought, the people who talk about the American scene don't know anything about it. So, in a way, that cow's skull was my joke on the American scene, and it gave me pleasure to make it red, white, and blue" (*ibid.,* p. 48).

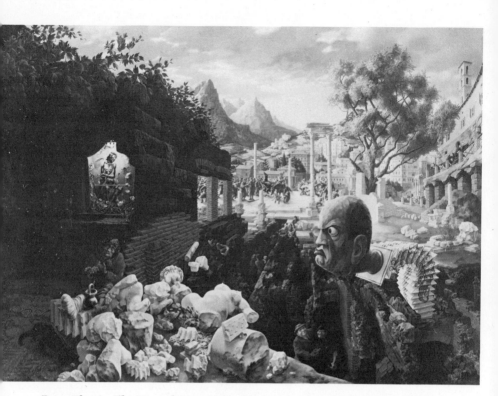

Peter Blume: *The Eternal City.* 1937. Oil on composition board. 34" x 47⅞".
The Museum of Modern Art, New York; Mrs. Simon Guggenheim Fund.

things that he had found in Italy and things from America. Of the for-
mer, there are the popping Mussolini head, based on a papier-mâché
image from the exhibition hall in the Decennial Exposition in Rome;
the subterranean corridors, beneath the head, like those of the Colos-
seum; a Christ shrine, to the left, decked with jewels and epaulets,
based on a shrine in the Florentine Church of San Marco; and ruins
of the Roman Forum in the background. Of the latter, there are, be-
hind the Forum ruins, a view of the Rocky Mountains, which Blume
visited; and the tall tree to the right, a willow from Connecticut. These
details were communicated to James Thrall Soby (b.1906). The
painter also revealed to him the exact moment when he was struck
with the idea for the painting: It was one afternoon in January 1933,

when he noticed a strange light illuminating the ruins as he stood in the Roman Forum near the Arch of Septimus Severus.[21]

During the nineteenth century, the category of *visionary*, even when it came to the visionaries of "the normal," was clear-cut. Now there can be a confluence with other approaches. *The Eternal City*, because of its antifascist statement, shares in the Social Realist approach of Ben Shahn (1898–1969) and Jack Levine (b.1915); but those painters never used a surreal manner in getting their message across. The painting is like an elaborate tableau, with separate events staged next to one another to reveal Blume's revulsion with the state of affairs in Italy. The broken sculptures, if reassembled, would form two lovers; the allusion is to an Italy full of discord, turned in upon itself. The shrine to the left is repellently gaudy (this is not a literal copy of the Florentine shrine), meant to show that organized religion does not offer a way out. The common people of Italy move through the Colosseum-like corridors, away from the head, while women crawl under the soldiers' horses in the Forum; this must indicate the deep dissatisfaction with fascism, which is a harsh regime.

If Blume can be linked to the Surrealists, then Charles Burchfield (1893–1967) is to be grouped with the Expressionists. (Thus in the twentieth century, those within the visionary tradition are acknowledged to have made use of modern stylizations.) But Burchfield would have said that he distorted appearances to get at what Zorach called "that inner feeling which something in nature or life has given me."

Burchfield, who was born in Ashtabula Harbor, Ohio, studied briefly, as a young man, at the National Academy of Design, New York. During his two months in the East he felt himself being compellingly drawn back to the Midwest of his childhood and boyhood:

> Surrounded by the familiar scenes of my boyhood, there gradually evolved the idea of re-creating impressions of that period, the appearance of houses, the feelings of woods and fields, memories of seasonal impressions, etc. . . . As I progressed with this idea I went further back into childhood memories and it became such an obsession that a decadence set in. I tried to re-create such moods as fear of the dark,

[21] James Thrall Soby, "Peter Blume's *Eternal City*," *Museum of Modern Art Bulletin* 10 (April 1943): 1–6.

the feelings of flowers before a storm, and even to visualize the songs of insects and other sounds.[22]

So, he painted decaying wooden buildings and the houses and churches of small Ohio towns, evoking the aura of something picturesquely ugly preserved by the narrow, insular society set forth by Sherwood

Charles Burchfield: *Church Bells Ringing, Rainy Winter Night.* 1917. Watercolor on paper. 30″ x 19″. The Cleveland Museum of Art, Ohio; Gift of Mrs. Louise M. Dunn in Memory of Henry G. Keller.

[22] Charles Burchfield, "On the Middle Border," *Creative Art* 3 (September 1928): xxvii–xxviii.

Charles Burchfield: *Night Wind.* 1918. Watercolor and gouache. 21½″ x 21⅞″. The Museum of Modern Art, New York; Gift of A. Conger Goodyear.

Anderson (1876–1941) in his novel *Winesburg, Ohio* (1919).[23] There is something at once fearsome and satirical in Burchfield's distortions of these buildings. In his *Church Bells Ringing, Rainy Winter Night* (1917), the windows of the church have become faces—perhaps the

[23] Edgar P. Richardson found the novel on Burchfield's shelves—along with William Butler Yeats, Whitman's *Leaves of Grass, Moby Dick,* Richard Henry Dana's *Two Years Before the Mast,* Romain Rolland's *Jean Christophe,* the writings of the great nineteenth-century Russians, etc. Burchfield was not a hayseed in the reading he chose. Edgar P. Richardson, "Charles Burchfield," *American Magazine of Art* 37 (October 1944): 210.

congregants of bygone days—and the steeple a grotesque, hawk-shaped head. The whole church quails before the sound of the bells, the sound that has perhaps shaken those faces loose. The falling rain appears as drops of blood, or tears. Nothing has disappeared, nothing is finally dead; rather, the very walls and windows of buildings contain in their fabric the living lineaments of the past. Burchfield also painted figments of the invisible forces of nature—the sounds of insects, the fermenting power of the soil and the warmth of the air, the blowing of the wind. Of his *Night Wind* (1918), in The Museum of Modern Art, New York, he wrote: "To the child sitting cozily in his house the roar of the wind outside fills his mind full of strange visions and phantoms flying over the land."[24] The wind in this painting is expressed in patternings that are vaguely organic, suggesting hunched figures, protruding fingers, peering heads perched over the roof of the house.

By the early 1940s the dominant avant-garde trend in American painting was Abstract Expressionism. Its exponents, who came to New York from far and wide,[25] built upon European Cubism and Surrealism to turn out canvases of an inordinately large size in which the nonobjective and nearly nonobjective configurations were put down with a freedom and vehemence that precluded tastefulness and pleasing design. Especially the Gestural group of the Abstract Expressionists, who after World War II came under the influence of French Existentialist thinking, saw the large canvas as a kind of arena where the painter, without preconceptions or concessions to any stylistic limitations, could act out his impulses. These painters valued the unconscious unpremeditated gesture. To release their impulses, Jackson Pollock (1912–1956), Franz Kline (1911–1962), Philip Guston (b.1912), Willem de Kooning (b.1904), and to an extent Arshile Gorky applied the paint in impetuous fits and starts, at times jabbing, pushing, and throwing it at the canvas; not only brushes but fingers and sticks were sometimes used as a means to working as quickly and directly

[24] Quoted in *Charles Burchfield, Early Watercolors, 1916 to 1918, April 11–26, 1930,* catalogue (New York: The Museum of Modern Art, 1930), p. 5.

[25] Arshile Gorky came from Armenia, Willem de Kooning, from the Netherlands; Hans Hofmann, from Germany; Jackson Pollock, from Wyoming; Franz Kline, from Wilkes-Barre, Pennsylvania; Clyfford Still, from North Dakota; Mark Rothko, from Russia (originally); Philip Guston, from Montreal; Ad Reinhardt, from Buffalo, New York; and Bradley Walker Tomlin, from Syracuse, New York.

as possible. Many of their canvases look unfinished and indeterminate because there was to be no thought, no conscious process, between the original impulse and the actual application of the paint. We can see for ourselves on these canvases the movements of the artist's hand, the hesitations and gropings, the very dynamics of the creation of the painting.

What applies to visionary painting is the first phase of Abstract Expressionism, lasting in some cases until the mid-1940s and in some until the late 1940s, when the heritage of European Surrealism was most strongly felt and some imagery relating to a mythic tradition was discernible. This was before the influence of the Existentialists, when the writings of Carl Gustav Jung (1875–1961) concerning the existence of universal archetypes and myths not culturally determined but shared by the unconscious of all peoples gained currency, especially with Mark Rothko (1903–1970), Pollock (who took on a Jungian analyst in 1939), and Adolph Gottlieb (1903–1974). In 1943, in a joint radio broadcast and in a published letter to *The New York Times,* Rothko and Gottlieb affirmed the relevance of primitive myths to modern man:

> That these demonic and brutal images fascinate us today is not because they are exotic, nor do they make us nostalgic for a past which seems enchanting because of its remoteness. On the contrary, it is the immediacy of their images that draws us irresistibly to the fancies and superstitions, the fables of savages and the strange beliefs that were so vividly articulated by primitive man.[26]

Between 1942 and 1947 Jackson Pollock, drawing pictorially from André Masson's (b.1896) fantasies of fighting fish and Joan Miró's (b.1893) and Pablo Picasso's (1881–1973) ferocious females, found amenable sources in Greek and Roman mythology. His *She-Wolf* (1943) evokes the wolf suckling Romulus and Remus. And a work of 1943 titled *Pasiphaë* evokes, in the licentiousness of its color and the savagely rendered supine female, the ancient Greek myth of Pasiphaë, who mated with a bull to produce the Minotaur. At this time Adolph Gottlieb, drawing pictorially from Paul Klee (1879–1940), Piet Mon-

[26] Adolph Gottlieb and Mark Rothko, *The Portrait of the Modern Artist,* script of a broadcast on "Art in New York," WNYC, New York, October 13, 1943. Adolph Gottlieb and Mark Rothko (in collaboration with Barnett Newman), joint letter to the editor of *The New York Times,* June 13, 1943.

Adolph Gottlieb: *Voyager's Return.* 1946. Oil on canvas. 37⅞" x 29⅞". The Museum of Modern Art, New York; Gift of Mr. and Mrs. Roy R. Neuberger.

drian (1872–1944), and Joaquin Torres García (1874–1949), but even more than from these Europeans from American Indian petroglyphs and totems, painted in colors of clay and earth series of what he called pictographs. These consisted, as can be seen in the *Voyager's Return* (1946), of crude abstract shapes and human heads and other anatomi-

cal parts set within compartments. There is no sequential order to the "pictographs." Gottlieb asserted in 1945: "It's a primitive method, and a primitive necessity of expressing, without learning how to do so by conventional ways. . . . It puts us at the beginning of seeing."[27] Do

Arshile Gorky: *Garden in Sochi.* c. 1943. Oil on canvas. 31″ x 39″. The Museum of Modern Art, New York; Lillie P. Bliss Bequest. Photograph: Geoffrey Clements.

we have here something completely new? The answer is yes in terms of pictorial solutions but no in terms of the concern with ancient myths. The subterranean visionaries Vedder and Rimmer conceived of a number of hybrids—sphinxes and winged humans—such as occur in the literature of many ancient peoples. If the Abstract Expressionists were unaware of these nineteenth-century American artists, their precedence as illustrators of mythic creatures cannot be denied.

[27] Adolph Gottlieb, *Untitled Edition—Mkr's Art Outlook* 6 (December 1945): 4, 6.

For another example of the precedence of the nineteenth-century visionary, there is the same impulse behind Edward Hicks painting his *Residence of David Twining, 1787,* and Arshile Gorky his "Garden in Sochi" series (1940–1943): In both cases the artist searched his memory to re-create a far-off time and place of his childhood that was warmer and safer than his present situation. Hicks, becoming obsessed with the sinfulness of his fellowman and his own sense of unworthiness, remembered back to a time of perfect biblical piety (it seemed to him) when he was seven. Gorky, overburdened by his struggles in the greatest metropolis of the country, to which he had immigrated in 1920 at the age of sixteen,[28] remembered back to his native Armenia and to a certain garden, which, he said with remarkable exactitude, was "about 194 feet away from our house on the road to the spring" and was known as "the Garden of Wish Fulfillment." The garden was called this because the women of the village believed that they could ensure their fertility by rubbing their bare breasts on a designated rock and tying strips of their clothing to a Holy Tree that stood in it.[29] In the series, where the biomorphic forms were inspired by Miró, the vertical in the center is the Holy Tree, the fluttering shapes (suggestive of blood-filled organs) probably began as the strips of clothing, and other shapes could well have been meant as rocks and animals. The myth of the Garden of Sochi's magical fertilizing properties has universal significance; thus, there is a correspondence with the mythic archetypes of Pollock, Rothko, Gottlieb, and others. But to Gorky it signified especially a protected place in an unrecoverable past.

Between 1943 and his death, Gorky packed his multireferential forms more densely together and enriched his color considerably until it seemed to throb. The forms could simultaneously suggest sections of a landscape, bodily organs (frequently male and female genitalia), and exotic flowers. These paintings were remarkably charged, serving

[28] Besides poverty, he had difficulties with English. His unbounded enthusiasms for Miró, Cézanne, Matisse, and Picasso during the 1930s was in part a strategy to combat his own self-conscious provinciality. He probably changed his name from Vosdanig Adoian to Arshile Gorky to make it sound more artistic. (Irving Sandler, *The Triumph of American Painting: A History of Abstract Expressionism,* New York: Praeger Publishers, 1970, p. 48). His servile dependence on his modern sources during the 1930s indicates his lack of confidence during that period.

[29] This is from a statement written by Gorky in June 1942, in the archives of The Museum of Modern Art, New York. Much of the statement is quoted in Sandler, *The Triumph of American Painting,* p. 58.

as psychic inscapes of a kind. A favorite motif of his in 1947 was a rounded form, seemingly swelling and pulsating, "hanging" taut at the end of a fragile line that was like a nerve that was being stretched tight to the snapping point (something we conjecture of our bodies). The motif related to the painful and tragic events of the last two years of Gorky's life leading to his suicide: After twenty-seven of his paintings and many of his drawings were destroyed in a studio fire in January 1946, Gorky was afflicted by cancer in 1947. (Finally the combination of his sexual impotence, a broken neck, and the paralysis of his painting arm, brought on by an automobile accident in June 1948, compelled his wife to leave him.)

The all-enveloping reverberations of Gorky's late paintings lead me to see in them a kinship with the paintings of the cosmic visionaries Ryder and Blakelock, unsimilar as the styles are. One of Gorky's paintings most revelatory of his torment, *Agony* (1947), was begun as a picture of a room in the Virginia home of his wife's parents. From preliminary, fairly realistic drawings we know that the room contained a fireplace, rocking chair, and crib. In the final painting the fireplace is no longer indicated, but everything is permeated with the color of fire, a smoldering, fiery red—an obvious reaction to the studio fire of the year before. There is still some indication of the rocking chair at the left and of the crib in the smaller form at the right, but the old identities of the objects have been almost entirely sloughed off, and the world of plantlike and biomorphic forms has replaced them. What is here besides, in purples and blacks, are large circular spots like the holes of wounds or lacerations, a coded rendition of his own suffering.

A handful of those twentieth-century artists who remained unrelated to movements and groups and steered a more independent course assumed in their behavior, as well, something of the isolated stance of the eccentrics. This is not to say that they reached anything of the bizarreness and egomania of Eilshemius. Morris Graves (b.1910), who was born in Fox Valley, Oregon, after three trips to the Orient on Main Line steamers, became a devotee of Zen Buddhism and Taoism and settled, in 1938, in the tiny town of La Conner (population, 100), some forty miles north of Seattle, Washington. He craved to be alone. He built his house with his own hands, deep in the woods among hundred-foot trees on Fidalgo, one of the San Juan Islands in Puget Sound nearest to La Conner; the walls are bare except for quotations from Chi-

nese painters of the Sung period (for example, "Zen means for a man to behold his own fundamental nature"[30]). Later some of the windows of the main room were covered with Japanese shoji paper to capture the shadows of the tall pines.[31] Still, we must be aware of how Graves was different from the eccentrics. He wanted to be isolated in the ways he chose. From 1940 to 1942 he was attached to the Seattle Art Museum (it has a superb Oriental art collection) and willingly accepted a Guggenheim Fellowship in 1946 for study in Japan.[32] Unlike the eccentrics, who, except for Inness, did not try to sway anyone to a system of beliefs, he reached out to the world from his woods through printed statements. Completely sure of himself, these statements have an aggressive ring to them: "We need art to guide our journey from partial to full consciousness. I have attained to the conviction that it is my purpose through creative painting to convey to man that he has the ability for instantaneous as well as for his usual knowledge of his cosmic significance. I seek for painting that miraculous union where the Seer and the Seen are one."[33]

Graves frequently used wrinkled rice paper. His paintings have the look almost of fossil rubbings. They appear to be themselves very old, from before recorded history and incredibly preserved. The paintings of Ryder and Blakelock, too, in their wrinkled, weather-beaten look, attained an atavistic, mysterious character simply through their surface appearance. In this connection, the San Francisco poet Kenneth Rexroth (b.1905) reported that Graves told him that when he had been in Chartres in 1948 he painted, along with details of the cathedral and

[30] Frederick S. Wight, *The Morris Graves Retrospective Exhibition,* catalogue (Berkeley and Los Angeles, Calif.: University of California Press, 1956), p. 2.

[31] *Morris Graves: A Retrospective, February 8–March 13, 1966,* catalogue (Eugene, Ore.: University of Oregon Museum of Art, 1966), pp. 6–7.

[32] His military permit for a civilian to enter Japan was withheld, so Graves stayed in Honolulu. There he met with the Japanese painter Yone Arashiro and studied Oriental objects in the Honolulu Academy of Art.

[33] Quoted in Duncan Phillips, "Morris Graves," *Magazine of Art* 40 (December 1947): 308. Graves quite plainly, following Eastern thinking, sought to alter man's consciousness. In a letter of 1950, he distinguished among the space of the inner eye ("subjective, yet there is the absolute feeling that they are outside your head"); phenomenal space, involving the world of nature's phenomena, the space "outside" us; and the space of consciousess, "within which is 'revealed' (made visible upon subtle leads of the mind) the abstract principles of the Origin, operation, and ultimate experience of consciousness." Reprinted in *Morris Graves: A Retrospective,* p. 41.

fragments of statues, bits of lichened masonry—obviously for the worn textures.[34]

Graves's most persistent subject from the early 1930s was the bird (gulls, eagles, crows, ganders, shorebirds, doves). They rarely fly,

Morris Graves: *Moon-Mad Crow in the Surf*. 1943. Tempera. 26″ x 30½″. Collection of Mr. and Mrs. Milton Lowenthal, New York. Photograph: Willard Gallery, New York.

never nest or feed (sometimes they fish), and are almost always shown singly. They do stand as resolute guardians of some unseen treasure or secret, or as dreamers gazing at the moon, as in the *Moon-Mad Crow in the Surf* (1943; in the collection of Mr. and Mrs. Milton Lowenthal,

[34] Kenneth Rexroth, "The Visionary Painting of Morris Graves," *Perspectives USA* 10 (Winter 1955): 64.

New York) or singing in the moonlight, as in a gouache of 1938–1939 (in The Museum of Modern Art, New York), or, defying all logic, are petrified within a rock. Sometimes they are blind (not piteously so, but as creatures whose attention is drawn inward, as birds of the inner eye). On the one hand, Graves depicts his birds fairly accurately, and on the other, he manages to endow them with certain human emotions and mental states. Herein lies the strange, visionary aspect of these birds. Often they stand with craned necks, straining off into the distance, as they meditate, reflect, or watch and wait—it is uncertain which. They may be enshrouded in a cloud or mist. That is probably an effect of the Pacific mist, which does, in fact, commonly cover the western part of the state of Washington. Graves loved this mist, and he must have been thinking of it when he said: "Our weather is the most remarkable phenomenon: the thing which brings me back to the Northwest. The way weather occurs here—you get into it like an old coat."[35] In 1938, however, the mist or the mottled background turned into a filigreelike skein of white lines of impenetrable complexity, which surrounded the bird in a localized area like an aura or occupied most of the canvas like a shining net. The light of the skein comes from within itself, like the light from within a diamond. It was a device inspired by the so-called "white writing" of Mark Tobey (1890–1976), another West Coast artist twenty years Graves's senior, who, like him, was drawn to Eastern philosophies and who was a student of Japanese calligraphy besides. But Graves also related the device to the pattern of trembling sunlight reflected onto a ceiling from a rain barrel used as a "water catchment."[36] Thus, while for Tobey the skein filled all the painting, Graves saw it as a kind of nesting place for his birds.

Edwin Walter Dickinson (b. 1891) set himself by the side of the other ocean, some three thousand miles away, in Provincetown, Massachusetts, staying for four winters, when the place was nearly deserted, from 1913, and then year-round from 1920 until 1939, when he moved to nearby Wellfleet. When he started living there, Provincetown had not yet become a famous art colony; like Graves, Dickinson wanted isolation. Unlike Graves, though, he subscribed to no set of mystic precepts. He was interested in Polar explorations, using them as subjects, and above all in fossils and would search for them in the Finger

[35] Quoted in Wight, *Graves*, p. 7.
[36] *Ibid.*, p. 31.

Lakes region of upper New York State, where he was born, at Seneca Falls.[37] Among artists, his greatest admiration was always for the Spanish visionary El Greco, whom he discovered on a European trip in 1919 after his discharge from the U.S. Navy. He told Elaine de Kooning: "When I saw the *Burial of Count Orgaz* (1586), I knew where my aspirations lay."[38]

Dickinson's painted world is a nocturnal one. Or perhaps—one cannot be sure—the figures are situated in a room where the shades have been drawn or deep within a forest where little light is admitted. At any rate, the light is unearthly and fitful, picking out in a disquieting way portions of figures and objects. As in El Greco, there is the drama of light and shade, sumptuous surfaces, a sense of spectacle, and the ambiguous location of the figures and objects in relation to one another and within the entire space. A superb draftsman with an unerring sense of perspective, to heighten the mystery, he has incorporated within the same painting a number of different perspectival systems. More than this, as with Peter Blume, unrelated subjects (ostensibly), or different and unrelated time-spaces, become juxtaposed —though not in as utterly clamorous a fashion. The *Woodland Scene* (1929–1935), at Cornell University, Ithaca, New York, is a good example of these incongruities. A stately woman (she had been assumed by some observers to be a man and does have a masculine appearance; but it is a portrait of an old Portuguese woman from Provincetown) sits within a dark forest behind a crumbling brick wall, a rotting plowshare, and a cartwheel.[39] To the woman's right and behind her is an unconscious or sleeping young woman swathed in a rich gown and lying facedown—and floating within the forest. To the old woman's left is a nude female figure brightly illuminated by the fire in the un-

[37] One of his largest paintings (a little over eight feet in height), *The Fossil Hunters* (1926–1928), in the Whitney Museum of American Art, grew out of these explorations. Dickinson related that "previous to, and at the time of painting the piece, I was interested in certain fossils, brachiopods and trilobites, and I spent considerable time during visits to my native country looking for them; I found many, some of which appear in the piece." Lloyd Goodrich, *Edwin Dickinson* (New York: Praeger Publishers, 1966), p. 8.

[38] Quoted in Elaine de Kooning, "Edwin Dickinson Paints a Picture," *Art News* 48 (September 1949): 50. He would keep a copy of El Greco's *View of Toledo* (1597–1599) in full view.

[39] Dickinson kept in his studio all sorts of paraphernalia—kettles, fossils, plaster casts, books, musical instruments, etc. *Ibid.* Presumably also some of the objects that appear in the *Woodland Scene*.

Edwin W. Dickinson: *Woodland Scene*. 1929–1935. Oil on canvas.
71⅜″ x 68½″. Herbert F. Johnson Museum of Art, Cornell University, Ithaca,
New York; Gift of Esther Hoyt Sawyer.

derbrush beneath (which seems to be in the time-space of the brick
wall rather than in hers). There is not, as there is to Blume's *Eternal
City*, an overall meaning that could encompass the images. The seated
woman is an enigma. In terms of the picture, she has no identity, and
she is equally unaware of everything about her, just as everything
about her is unrelated to her. No matter how one delves, the scene
makes for mystery, and yet it comprises a world that is strangely
inviolate and integral on its own terms, within its own illogicality.

Loren MacIver: *Hopscotch*. 1940. Oil on canvas. 27" x 35⅞". The Museum of Modern Art, New York; Purchase.

Loren MacIver (b. 1909) is an independent visionary who has as little to say about herself as Dickinson and is, besides, not known to have sought isolation or to have indulged in any sort of shocking behavior or to have held to strange beliefs. From 1931 for ten years she would regularly summer with her husband on Cape Cod at North Truro Beach and spend the rest of her year in New York. Her art has a modesty and even a shyness to it. Nothing grotesque or startling, no pulling of things out of context to fashion newly invented combinations. She is thus as far as can be from the visionaries of the spectacular and the bizarre creations of the subterranean visionaries, as well as from the confessional art of Gorky and the stylistic innovations of Dove, Zorach, and O'Keeffe. Nor is she as disturbing and unsettling as such visionaries of "the normal" as Newman and the early Ryder. What she has done is to build for herself a niche of a special kind of quietness within visionary painting.

In keeping with her reticence, MacIver chose as her subjects things that are humble—and, in a sense, "invisible" since they are so ordinary as to be hardly noticed: a window shade, a puddle, some oil splatters and fallen leaves, some seaweed in an aquarium, a pair of old shoes (belonging to a clown), and—in probably her best-known painting, *Hopscotch* (1949)—chalk markings on and cracks in an asphalt street somewhere in a city. In *Hopscotch* there is more than the startling focus upon one of these "invisible" things. The patterns made by the asphalt's crackings and blisterings, however accurately rendered, call to mind something other than what they are. They look a little like a strange mountainous terrain seen from the air; and so, there are unsettling disruptions of our sense of scale between these miniscule patternings suggesting something in reality large and the larger numbers of the chalked hopscotch game connoting something set down by children.

The visionaries were artists who created an imaginary world of their own musings. They found the undifferentiated reality about them too prosaic and uninteresting, so they became poets of the inner mind. In this last chapter I have presented something of the great scope and diversity of visionary painting in this century, but it is to the twelve eccentrics that I have devoted most of this book. Except for Ryder, they were sadly unknown or unappreciated even by those in this century who continued in the path they laid down. But in spite of this and in spite of the fact that these twelve men did not endanger their lives or change the visible face of America, to me they were still dauntless adventurers in their own right, as much as the sailor who plots uncharted seas, the scientist who discovers a cure, the engineer who builds a machine.

If it is sad that the visionaries of the twentieth century did not know or appreciate those of the nineteenth, it is sadder still that in the 1950s visionary painting comes to an end in America. This is why I ended my account in 1950. A word of qualification is in order. I do not mean that nowhere in America, from the mid-1950s on, is there painted a canvas that can be considered visionary. What I mean is that the painters considered leaders and most influential, those who have attracted the most critical attention, have produced an art that is not only nonvisionary but antivisionary.

Those familiar with American art of the past two decades will have

to agree with me. The visionary painter adds to the world he depicts; he makes of it something poetic, sometimes something frightening; he finds myths where in reality myths are simply inventions. Jasper Johns (b.1930) removes myths even where they are most commonly found: He has demythologized even the American flag, making us see it for what it is—nothing but a pattern on a cloth. Andy Warhol (b.1930) has used as his subjects the surfaces of mass-produced cans and boxes and has presented these in so bold and stark a fashion, in so iconic a way, that we are led to feel that there is no meaning or reality beyond those surfaces. Indeed, Warhol tells us: "If you want to know all about Andy Warhol, just look at the surface of my paintings and films and me, and there I am. There's nothing behind it."[40] The Photorealists of the past ten years have persistently presented without comment, in a dry and understated fashion, motorcycles, huge bland faces (Chuck Close, b.1940), and urban interiors of neon signs and hamburger stands. Their defenders have deplored "the need . . . to see everything in human terms [that] has resulted in a romantic anthropomorphism that clouds our perception of real things."[41]

I would not for a moment deny that Johns, Warhol, and the Photorealists have made us see things for what they are, and that the absence of illusion is something desirable. But so, too, is fantasy and imagination (and the individualism that comes with it). To have the two in suitable proportion may be an ever-elusive dream. Myths may have shattered lives and even brought ruin to nations, but there is still that lack of illusion in America today that has to do with blandness and boredom. If for no other reason than this, the virtual disappearance of the visionary from the forefront of American painting is to be lamented.

[40] Remarks printed in the catalogue of his exhibition in Stockholm, 1968. Quoted in *Andy Warhol* (3rd ed.; Boston: Boston Book and Art Publisher, 1970), pages unnumbered.

[41] Linda Chase, "Existential vs. Humanist Realism" in *Super Realism: A Critical Anthology*, ed. Gregory Battcock (New York: Dutton, Paperbacks, 1975), p. 88.

Selected Bibliography

GENERAL SOURCES (partial listing)

BARKER, VIRGIL. *American Painting.* New York: The Macmillan Co., 1950.

BAUR, JOHN, I. H. *Revolution and Tradition in Modern American Art.* Cambridge, Mass.: Harvard University Press, 1951.

BLACK, MARY C., and LIPMAN, JEAN. *American Folk Painting.* New York: Potter, 1966.

CAFFIN, CHARLES H. *The Story of American Painting.* New York: Frederick A. Stokes, 1907.

CORN, WANDA M. *The Color of Mood: American Tonalism 1880–1910,* catalogue. San Francisco: M. H. De Young Memorial Museum, 1972.

CORTISSOZ, ROYAL. *American Artists.* New York and London: Chas. Scribner, 1923.

DAVIDSON, ABRAHAM A. *The Story of American Painting.* New York: Harry N. Abrams, 1974.

DILLENBERGER, JANE, and TAYLOR, JOSHUA C. *The Hand and the Spirit,* catalogue. Berkeley, Calif.: University Art Museum, 1972.

DUNLAP, WILLIAM. *History of the Rise and Progress of the Arts of Design in the United States.* 3 vols. Rev. ed. New York: Benjamin Blom, 1965.

FLEXNER, JAMES THOMAS. *Nineteenth Century American Painting.* New York: G. P. Putnam's Sons, 1970.

————. *That Wilder Image.* New York: Dover Publications, 1970.

GOODRICH, LLOYD. *Three Centuries of American Art.* New York: Praeger Publishers, 1967.

HARTMANN, SADAKICHI. *A History of American Art.* Rev. ed. Boston: L. C. Page, 1932.

ISHAM, SAMUEL, and CORTISSOZ, ROYAL. *The History of American Painting.* 3rd ed. New York: The Macmillan Co., 1968.

KAROLIK, M. and M. *Collection of American Paintings, 1815 to 1865.* Foreword by John I. H. Baur. Cambridge, Mass.: Harvard University Press, 1949.

LARKIN, OLIVER. *Art and Life in America.* rev. ed. New York: Holt, Rinehart & Winston, 1960.

LIPMAN, JEAN, and FRANC, HELEN M. *Bright Stars: American Painting and Sculpture Since 1776.* New York: E. P. Dutton, 1976.

MCCOUBREY, JOHN W., ed. *American Art, 1700–1960: Sources and Documents.* Englewood Cliffs, N.J.: Prentice-Hall, 1965.

———. *American Tradition in Painting.* New York: George Braziller, 1963.

MENDELOWITZ, DANIEL M. *A History of American Art.* New York: Holt, Rinehart & Winston, 1970.

THE METROPOLITAN MUSEUM OF ART. *19th-Century America: Paintings and Sculpture.* New York: The Metropolitan Museum of Art (distributed by New York Graphics Society), 1970.

MILLER, DOROTHY C., and BARR, ALFRED H., JR. *American Realists and Magic Realists.* New York: The Museum of Modern Art, 1943.

MUMFORD, LEWIS. *The Brown Decades: A Study of the Arts in America, 1865–1895.* New York: Dover Publications, 1955.

NOVAK, BARBARA. *American Painting of the Nineteenth Century: Realism, Idealism, and the American Experience.* New York: Praeger Publishers, 1969.

PROWN, JULES DAVID. *American Painting.* Vol. 1. New York: Skira, World Publishing Company, 1969.

RICHARDSON, EDGAR PRESTON. *American Romantic Painting.* New York: E. Weyhe, 1944.

———. *Painting in America: The Story of 450 Years.* Rev. ed. New York: Crowell, 1965.

SOBY, JAMES THRALL, and MILLER, DOROTHY C. *Romantic Painting in America.* New York: The Museum of Modern Art, 1943.

SWEET, FREDERICK A. *The Hudson River School and the Early American Landscape Tradition.* Chicago: The Art Institute of Chicago, 1945.

TUCKERMAN, HENRY T. *Artist Life; or, Sketches of Eminent American Painters.* New York: D. Appleton, 1847.

———. *Book of the Artists: American Artist Life.* Rev. ed. Edited by James F. Carr, New York: G. P. Putnam's 1965.

WALKER, JOHN. and JAMES, MACGILL. *Great American Paintings from Smibert to Bellows, 1779–1924.* New York: Oxford University Press, 1943.

WILMERDING, JOHN. *American Art.* New York, The Viking Press, 1976.

SOURCES FOR INDIVIDUAL ARTISTS (partial listing)

ALLSTON, WASHINGTON

Allston, Washington. *Lectures on Art and Poems.* New York, 1850.

Flagg, Jared B. *The Life and Letters of Washington Allston.* London, 1892.

Johns, Elizabeth. "Washington Allston's Library," *American Art Journal* 7, no. 2 (November 1975): 32–41.

Richardson, Edgar Preston. *Washington Allston: A Study of the Romantic Artist in America.* New York: Apollo Editions, 1967.

Ware, William. *Lectures on the Works and Genius of Washington Allston.* Boston, 1852.

BARNES MATTHEW

P. T. "Exhibition at the Jackson Gallery." *Art News* 54 (December 1955): 55.

BLAKELOCK, RALPH ALBERT

Daingerfield, Elliott. *Ralph Albert Blakelock*. New York: F. F. Sherman, 1914.

Gebhard, David, and Stuurman, Phyllis. *The Enigma of Ralph A. Blakelock 1847–1919*, catalogue. Santa Barbara, Calif.: University of California Art Galleries, 1969.

Goodrich, Lloyd. *Ralph Albert Blakelock Centenary Exhibition in Celebration of the Centennial of the City College of New York (April 22–May 29, 1947)*, catalogue. New York: Whitney Museum of American Art, 1947.

Young, J. W. *Catalogue of the Works of R. A. Blakelock and Marian Blakelock*. Chicago, 1916.

BLUME, PETER

Peter Blume, February 20–March 9, 1968, catalogue. New York: Kennedy Galleries, 1968.

Peter Blume, January 10–February 29, 1976, catalogue. Chicago: Museum of Contemporary Art, 1976.

Peter Blume in Retrospect, 1925–1964; Paintings and Drawings, catalogue. Manchester, N.H.: Currier Gallery of Art, 1964.

Soby, James T. "Peter Blume's Eternal City." *Museum of Modern Art Bulletin* 10 (April 1943): 1–6.

BURCHFIELD, CHARLES

Baur, John I. H. *Charles Burchfield*. New York: The Macmillan Co., 1956.

Charles Burchfield; Catalogue of Paintings in Public and Private Collections. Utica, N.Y.: Munson-Williams-Proctor Institute, 1970.

Charles Burchfield: Retrospective Exhibition of Water Colors and Oils, 1916–1943, catalogue. Buffalo, N.Y.: Albright Art Gallery, 1944.

COLE, THOMAS

Annual 2: Studies on Thomas Cole, An American Romanticist. Baltimore, Md.: The Baltimore Museum of Art, 1967.

Merritt, Howard S. *Thomas Cole*, catalogue. Rochester, N.Y.: Memorial Art Gallery, University of Rochester, 1969.

Noble, Louis Legrand. *The Course of Empire, Voyage of Life, and Other Pictures of Thomas Cole, N. A.* Edited by Elliot S. Vessell. Cambridge, Mass.: Harvard University Press, 1964.

DAVIES, ARTHUR BOWEN

Arthur B. Davies: A Centennial Exhibition, catalogue. Utica, N.Y.: Munson-Williams-Proctor Institute, 1962.

Burroughs, Alan. *The Art of Arthur B. Davies*. New York, 1923.

Burroughs, Bryson. "Arthur B. Davies." *Arts* 15 (February 1929): 70–93.

Huneker, J. G. *The Pathos of Distance*. New York: Chas. Scribner, 1913.

Price, F. Newlin, ed. *The Etchings and Lithographs of Arthur B. Davies.* New York: Ferargil Galleries, 1930.

DEWING, THOMAS WILMER

Boyle, Richard J. *American Impressionism.* Boston: New York Graphics Society, 1974.
Cortissoz, Royal. *American Artists.* New York: Chas. Scribner, 1923.
Tharp, Ezra. "T. W. Dewing." *Art and Progress* 5 (March 1914): 155–161.
White, Nelson C. "The Art of Thomas W. Dewing." *Art and Archaeology,* 27 (June 1929): 253–261.

DICKINSON, EDWIN WALTER

Clark, Eliot. "Edwin Dickinson." *Studio* 162 (October 1961): 138–140, 155.
Goodrich, Lloyd. *Edwin Dickinson.* New York: Praeger Publishers, 1966.
Kooning, Elaine de. "Edwin Dickinson Paints a Picture." *Art News* 48 (September 1949): 26–28, 50–51.
Smith, Jacob Getlar. "Edwin Dickinson, American Mystic." *American Artist* 21 (January 1957): 54–59, 73–75.

DOVE, ARTHUR GARFIELD

Haskell, Barbara. *Arthur Dove, November 21, 1974–January 5, 1975,* catalogue. Boston: New York Graphics Society, 1975.
Johnson, Dorothy Rylander. *Arthur Dove: The Years of Collage, March 13 Through April 19, 1967,* catalogue. College Park, Md.: University of Maryland, 1967.
Wight, Frederick S. *Arthur G. Dove.* Los Angeles: University of California Press, 1958.

DURAND, ASHER BROWN

Durand, John. *The Life and Times of Asher B. Durand.* New York, 1844.
Sweet, Frederick, A. "Asher B. Durand." *Art Quarterly* 8 (1945): 141–160.

EILSHEMIUS, LOUIS MICHEL

McBride, Henry. "The Discovery of Louis Eilshemius." *Arts* 10 (1926): 316–330.
Masterpieces of Eilshemius. New York: The Artists Gallery, 1959.
Schack, William. *Biography of Louis M. Eilshemius: and He Sat Among the Ashes.* New York: Ryerson Press, 1939.

FIELD, ERASTUS SALISBURY

Black, Mary C. "Erastus Salisbury Field and the Sources of His Inspiration." *Antiques* 83, no. 2 (February 1963): 201–206.
———. "Rediscovery: Erastus Salisbury Field." *Art in America* 54, no. 1 (January–February 1966): 49–56.
Field, Erastus S. *Descriptive Catalogue of the "Historical Monument of the American Republic."* Amherst, Mass., 1876.

FULLER, GEORGE

Centennial Exhibition of the Works of George Fuller, April 9 Through May 20, 1923, catalogue. New York: The Metropolitan Museum of Art, 1923.

Downes, William Howe. "George Fuller's Pictures." *International Studio* 75 (1922): 264–273.

Millet, J. B., ed. *George Fuller, His Life and Works: A Memorial Volume.* Boston, 1886.

Sherman, Frederick Fairchild. "Four Pictures by George Fuller." *Art in America* 7 (1919): 84–91.

GORKY, ARSHILE

Jordan, Jim M. *Gorky: Drawings*, catalogue. New York: M. Knoedler & Co., 1969.

Levy, Julien. *Arshile Gorky.* New York: Harry N. Abrams, 1968.

Rosenberg, Harold. *Arshile Gorky: The Man, the Time, the Idea.* New York: Horizon Press, 1962.

Schwabacher, Ethel. *Arshile Gorky.* New York: The Macmillan Co., 1957.

Seitz, William C. *Arshile Gorky: Painting, Drawings, Studies.* New York: Arno Press, 1962.

GOTTLIEB, ADOLPH

Doty, Robert, and Waldman, Diane. *Adolph Gottlieb.* New York: Whitney Museum of American Art and The Solomon R. Guggenheim Museum, 1968.

Friedman, Martin. *Adolph Gottlieb, April 28–June 9, 1963*, catalogue. Minneapolis, Minn.: Walker Art Center, 1963.

Seckler, Dorothy Gees. "Adolph Gottlieb Makes a Façade." *Art News* 54, no. 1 (March 1955).

GRAVES, MORRIS

Rexroth, Kenneth. "The Visionary Painting of Morris Graves." *Perspectives USA*, no. 10 (Winter 1955): 58–66.

Wight, Frederick S. *The Morris Graves Retrospective Exhibition*, catalogue. Berkeley and Los Angeles, Calif.: University of California Press, 1956.

HAMILTON, JAMES

Baur, John I. H. "A Romantic Impressionist: James Hamilton." *The Brooklyn Museum Bulletin* 12, no. 3 (Spring 1951): 1–9.

Jacobowitz, Arlene. *James Hamilton.* New York: The Brooklyn Museum, 1966.

HICKS, EDWARD

Ford, Alice. *Edward Hicks, Painter of the Peaceable Kingdom.* Philadelphia: University of Pennsylvania Press, 1952.

Held, Julius S. "Edward Hicks and the Tradition." *Art Quarterly* 14 (Summer 1951): 121–136.

Hicks, Edward. *Memoirs of the Life and Religious Labors of Edward Hicks, Late of Newtown, Bucks County, Pennsylvania, Written by Himself.* Philadelphia, 1851.

Mather, Eleanore Price. *Edward Hicks: A Peaceable Season*. Princeton, N.J.: The Pyne Press, 1973.

———. "A Quaker Icon: The Inner Kingdom of Edward Hicks." *Art Quarterly* 36 (Spring–Summer 1973): 84–99.

INNESS, GEORGE

Cikovsky, Nicolai, Jr. *George Inness*. New York: Praeger Publishers, 1971.

Inness, George, Jr. *The Life, Art, and Letters of George Inness*. New York: Century Co., 1917.

McCausland, Elizabeth. *George Inness, An American Landscape Painter, 1825–1894*. Springfield, Mass.: American Artists Group, 1946.

Monks, John A. S. "A Near View of Inness." *Art Interchange* 34 (June 1895).

Schuyler, Montgomery. "George Inness: The Man and His Work." *Forum* 18 (November 1894).

LA FARGE, JOHN

Cortissoz, Royal. *John La Farge, A Memoir and Study*. Boston and New York: Houghton Mifflin, 1911.

La Farge, Henry A. *John La Farge, Oils and Watercolors*, catalogue. New York: Kennedy Galleries, 1968.

———. "La Farge and the South Sea Idyll." *Journal of the Warburg and Courtauld Institute* 7 (1944): 34–39.

La Farge, John. *An Artist's Letters from Japan*. New York: Century Co., 1897.

———. *Reminiscences of the South Seas*. Garden City, N.Y.: Doubleday, Page & Co., 1912.

MACIVER, LOREN

Baur, John I. H. *Loren MacIver and I. Rice Pereira*. New York: The Macmillan Co., 1953.

NEWMAN, ROBERT LOFTIN

Boime, Albert. "Newman, Ryder, Couture, and Hero-Worship in Art History. *American Art Journal* 3 (Fall 1971): 5–22.

Brumbaugh, Thomas B. "Letters of Robert Loftin Newman, a Tennessee Artist." *Tennessee Historical Quarterly* 32 (Summer 1973): 107–123.

Landgren, Marshal E. *Robert Loftin Newman, 1827–1912*. Washington, D.C.: Smithsonian Institution Press, 1974.

Loan Collection of Paintings by Mr. R. L. Newman, March 1–15, 1894, catalogue. New York: Knoedler & Co., 1894.

Sherman, Frederic Fairchild. "Robert Loftin Newman, an American Colorist." *Art in America* 4 (April 1916): 177–184.

O'KEEFFE, GEORGIA

Goodrich, Lloyd, and Bry, Doris. *Georgia O'Keeffe*, catalogue. New York: Whitney Museum of American Art, 1970.

O'Keeffe, Georgia. *Georgia O'Keeffe*. New York: The Viking Press, 1977.
Rich, Daniel Catton. *Georgia O'Keeffe*, catalogue. Chicago: The Art Institute of Chicago, 1943.
Wilder, Mitchell, ed. *Georgia O'Keeffe, An Exhibition of the Work of the Artist from 1915 to 1966*, catalogue. Austin, Tex.: University of Texas Press, 1966.

PAGE, WILLIAM

Page, William. "The Measure of a Man." *Scribner's Monthly* 17 (1879): 894–898.
Taylor, Joshua C. *William Page: The American Titian*. Chicago: University of Chicago Press, 1957.
Tuckerman, Henry T. *Book of the Artists, American Artist Life*. New York, 1882.

PEALE, REMBRANDT

Catalogue of an Exhibition of Portraits by Charles Willson Peale and James Peale and Rembrandt Peale, April 11–May 9, 1923. Philadelphia: Pennsylvania Academy of the Fine Arts, 1923.
Elam, Charles H., ed. *The Peale Family: Three Generations of American Artists*. Detroit: The Detroit Institute of Arts and Wayne State University, 1967.
Peale, Rembrandt. *Peale's Court of Death*. 1845.

QUIDOR, JOHN

Baur, John I. H. *John Quidor*. Utica, N.Y.: Munson-Williams-Proctor Institute, 1965.
Rohdenburg, Ernest. "The Misreported Quidor Case." *American Art Journal* 2, no. 1 (Spring 1970): 74–80.
Smith, Irving Jerome. "All Dressed Up Like a Fire Engine." *Art in America* 44 (1956): 54–57, 69–70.
Sokol, David M. "John Quidor, Literary Painter." *American Art Journal* 2, no. 1 (Spring 1970).
Thorpe, T. B. "New York Artists Fifty Years Ago." *Appleton's Journal* 7 (1872): 574.

RIMMER, WILLIAM

Bartlett, Truman H. *The Art of William Rimmer: Sculptor, Painter, and Physician*. Boston, 1882.
Goldberg, Marcia. "William Rimmer's *Flight and Pursuit:* An Allegory of Assassination." *Art Bulletin* 58, no. 2 (June 1976): 234–240.
Kirstein, Lincoln. *William Rimmer 1816–1879*, catalogue. Foreword by Juliana Force. New York: Whitney Museum of American Art, 1946.
Rimmer, William. *Art Anatomy*. Boston, 1877.
———. *Elements of Design*. Boston, 1864.
Sarnoff, Charles A. "The Meaning of William Rimmer's *Flight and Pursuit*." *American Art Journal* 6, no. 1 (May 1973): 18–19.

RYDER, ALBERT PINKHAM

Goodrich, Lloyd, *Albert P. Ryder*. New York: George Braziller, 1959.
Hyde, William H. "Albert Ryder as I Knew Him." *The Arts* 16 (May 1930): 596–599.
Mather, Frank Jewett, Jr. "Albert Pinkham Ryder's Beginnings." *Art in America* 9 (April 1921): 119–127.
Milliken, William M. "The Race Track, or Death on a Pale Horse by Albert Pinkham Ryder." *Cleveland Museum of Art Bulletin* 15 (March 1928): 65–71.
Price, F. Newlin. "Albert Pinkham Ryder." *International Studio* 81 (July 1925): 282–288.
Robinson, John. "Personal Reminiscences of Albert Pinkham Ryder." *Art in America* 13 (June 1925): 176, 179–187.
Ryder, Albert P. "Paragraphs from the Studio of a Recluse." *Broadway Magazine* 14 (September 1905): 10–11.

VEDDER, ELIHU

Reich, Marjorie. "The Imagination of Elihu Vedder—as Revealed in His Book Illustrations." *American Art Journal* 6, no. 1 (May 1974): 39–53.
Soria, Regina. *Elihu Vedder: American Visionary Artist in Rome (1836–1923)*. Rutherford, N.J.: Fairleigh Dickinson University Press, 1970.
———. "Elihu Vedder's Mythical Creatures." *Art Quarterly* 26, no. 2 (Summer 1963).
Vedder, Elihu. *The Digressions of V. Written for His Own Fun and That of His Friends*. Boston and New York: Houghton Mifflin, 1910.

WEST, BENJAMIN

Evans, Grose. *Benjamin West and the Taste of His Times*. Carbondale, Ill.: Southern Illinois University Press, 1959.
Galt, John. *The Life, Studies, and Works of Benjamin West, Esq.* 1820. Reprint. Gainesville, Fla.: Scholars' Facsimiles and Reprints, 1960.
Meyer, J. D. "Benjamin West's Chapel of Revealed Religion: A Study in Eighteenth-Century Protestant Religious Art." *Art Bulletin* 57 (June 1975): 247–265.

ZORACH, WILLIAM

Baur, John I. H. *William Zorach*. New York: Praeger Publishers, 1959.
Hoopes, Donelson F. *William Zorach: Paintings, Watercolors, & Drawings, 1911–1922*, catalogue. New York: The Brooklyn Museum, 1968.
Zorach, William. *Art Is My Life*. Cleveland and New York: World Publishing Co., 1967.

Index

Page references for illustrations are in **boldface** type.

197